THE HAMLYN
BASIC GUIDE TO
DARKROOM
-TECHNIQUES-

HAMLYN
London · New York · Sydney · Toronto

Picture Credits

Caroline Arber: 86 (1)
Jon Bouchier: 15 (tl, tr), 16 (t, b), 18, 19, 21/2, 23, 32, 34, 39,
49 (b), 51, 52/3, 54/5, 58, 59, 60, 61, 71, 73 (1), 74, 76, 79,
84/5, 89, 92, 97.
Julian Calder: 54, 55
Raul Constancio: 78 (t)
Henry/Explorer: 96
Pauline Gentry: 98 (t), 99 (t)
Sam Haskins: 4, 82
Frank Herrmann: 27 (bl)
Anne Hickmott: 99 (b)
Dave King: 1, 6/7, 17 (tl, tr, bl)
Peter Laishley: 45
S. K. Lanzon: 87 (b)
Barry Lewis/Network: 24, 25 (br), 26 (b), 28 (b), 90
Ian McKinnell: 77 (t)
Neil Menneer: 80
Lesley Nelson: 42 (1)
Gwendoline Patmore: 27 (br), 47 (b), 48
Chris Peberdy: 43 (t)
Clay Perry: 29, 30
Popperfoto: 44 (b)
Martin Procter: 87 (tr)
James Ravilious/Beaford Archive: 25 (t)
Robinson/Brown: 66, 67
David Robinson: 70
Kate Salway: 73, 75
R. V. Smith: 86 (r), 87 (tl)
Julian Stapleton: 44 (t)
Tim Stephens: 83, 88, 91, 100, 101, 102, 103
Ron Sutherland: 98 (b)
John Walmsley: 25 (bl)
John Ward: 38 (t, b), 40, 41, 43 (b), 46, 47 (t), 49 (t), 85 (bl)
Victor Watts: 10, 11, 12, 13, 26 (t)
Julian Weidel: 27 (t)
Paul Williams: 8/9
Geoff Winkley: 93, 94

Editor: John Farndon
Art Editor: Eddie Pitcher

Published by
The Hamlyn Publishing Group Limited
London New York Sydney Toronto
Astronaut House, Feltham, Middlesex, England

Produced by Marshall Cavendish Books Limited
58 Old Compton Street
London W1V 5PA

© Marshall Cavendish Limited 1985

ISBN 0 600 50164 7

INTRODUCTION

The prints turned out by commercial processing laboratories nowadays are so good that there often seems little incentive to bury yourself away in a darkroom for hours, only to emerge two days later with half a dozen rather shabby prints. Some people will tell you that doing your own darkroom work will save you money. This is rarely true. To compensate for the enormous cost of setting up a darkroom, buying an enlarger, processing dishes and so on – not to mention materials – you would have to take a vast number of photographs. (The only exception, perhaps, is making high-quality prints from colour slides. This is such a labour-intensive process that commercial laboratories will charge heavily). No, the reasons for going into the darkroom are more subtle.

First of all, processing and printing your own photographs gives you complete control over the way the picture appears. You can make changes, subtle or dramatic, to give a photograph maximum impact – bear in mind that commercial prints from the same negative will vary widely. Second, and perhaps more important, you have the sense of satisfaction of creating the photograph yourself, from start to finish.

So this book is geared towards getting the most out of your darkroom work rather than introducing a wide range of flashy, but not very valuable, techniques. And the emphasis is very much on solving the problems that prevent you achieving top quality results. For all the basic techniques, the principle steps are covered in separate step-by-step sequences while the main text concentrates on what those techniques mean in practice.

CONTENTS

Chapter 1
SETTING UP A DARKROOM
Darkroom layout

Surprisingly, perhaps, you do not actually need a darkroom for every kind of darkroom work. Films can be processed, for instance, by loading them into a tank in a small lightproof 'changing bag' or failing that, under the bedclothes—though this is not recommended. And even colour prints can be made in daylight in special enclosed enlargers. But there is no doubt that to make the most of all the techniques described in this book and to ensure consistent, high quality results you need a proper darkroom.

Some people are lucky enough to be able to convert a room into a permanent darkroom: others have to make do with a room that doubles as a bathroom most of the time. But whether your darkroom is permanent or temporary, the same meticulous planning is needed. With a temporary set-up, you should try to meet as many of the following recommendations as possible.

Any permanent darkroom must have mains services such as electricity and water supply. If these have to be laid on specially, you may find the cost prohibitive. An existing sink, light, and power point can mean that conversion is fairly straightforward.

Also important is the room's ambient temperature. All processing solutions have to be kept at fairly constant temperatures when in use, and a naturally cold room can make this difficult. Avoid too rooms which are very dusty or damp.

Lights and lightproofing
A darkroom need not be a pit of darkness. If you choose the correct type of safelighting, a surprisingly high level of safelight illumination can be used for general purpose work with bromide paper. Safelights can be placed directly on the bench for localized illumination, but are better located on the walls or facing upwards, directed on to the ceiling where they can give very diffused lighting. Some types can be ceiling mounted to give both direct and indirect illumination.

The golden rule for darkroom safelighting is to locate the lights at a safe distance from any surface where sensitive material may be handled. Follow the manufacturer's recommendations on this point. It is more important to have good illumination when you are processing

prints than when you are exposing them. So, if possible, mount the safelight over the wet bench rather than the dry bench but make sure sufficient light spills on to the dry bench for you to see to locate paper on the easel.

If prints are to be judged in conditions which closely approximate to daylight, fluorescent lighting fitted with a 'daylight' type tube should be used. Locate the switch for this a safe distance from the safelight switch to avoid accidents. A cord switch arrangement for both is probably the best solution. Professional darkrooms often have a warning light outside the door wired into the safelight circuit, so that people know the room is in use.

The lightproofing arrangements you use can vary from the truly permanent where windows are sealed and doorways extensively baffled, to more temporary efforts employing removable but heavy-duty blinds constructed to fit windows which are cleaned and opened from time to time.

The doorway baffle arrangement you choose can make a great deal of difference to the ease of getting into the room. A two-door arrangement and 'U' shaped tunnel that forms a light trap both permit ready access when the darkroom is in use. But each method may cut down the amount of available space within a darkroom. A single door arrangement, regardless of how well it is baffled at the edges, cannot be opened safely if someone is working in the darkroom. Heavy black curtains over the outside of the door are another alternative, but these can be a nuisance when carrying equipment in and out.

Work surfaces
The more work surfaces you provide, the more comfortable you will find working in your darkroom. Always provide more than you think you need to allow for the amount of printing and processing equipment you are likely to acquire as your interest in darkroom work grows.

Work surfaces and benches are generally classified as being either 'wet' when used for processing, or 'dry' when used for printing operations. Water and process solutions on the wet bench must not come into contact either with the power leads, plugs and sockets of

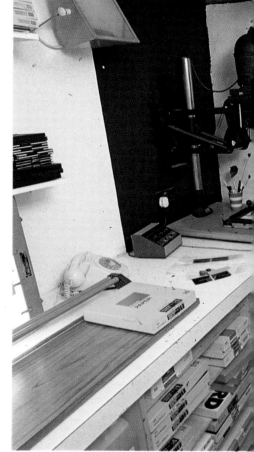

the enlarger and other items of the dry bench, or with dry negatives and printing paper normally to be found there. Ideally, therefore, 'wet' and 'dry' areas should be kept physically separate. But an aisle between the two of more than one metre is an unnecessary waste of valuable floor space.

If you are starting from scratch and can afford to include one in your design, think about installing a really large but fairly shallow sink. This could act as your wet bench, and anything and everything to do with film and print processing could be arranged neatly either within the sink, or very close to it. Dishes can be spread along the length of the sink for print processing, and water in the sink could act as a water bath for temperature control. When needed after film and print processing, used utensils can simply be hosed down and left in the sink to dry—which greatly lessens the

chore of cleaning operations. Professional darkroom sinks are often stainless steel, but porcelain is adequate. Large sized darkroom sinks are commercially available, or you can construct your own. Each can be custom made to your precise requirements to fit existing plumbing arrangements.

The dry bench should consist of a large area worktop at least 60 cm deep, with outward opening cupboards beneath. All nearby walls can be fitted with shelving. Plastic laminated surfaces are ideal as these clean easily and resist chemical stains. If the ceiling height is too low for the maximum extension of your enlargers, consider fitting a dropdown

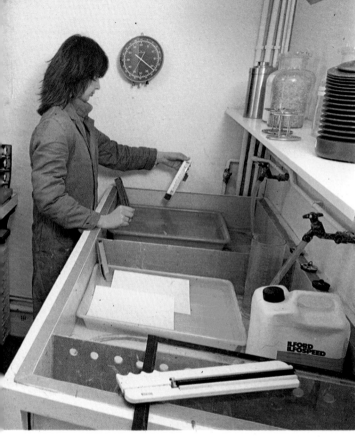

top to the dry bench.

Although the layout and size of the available room inevitably influences the arrangement, plan your wet and dry areas according to the printing and processing routine you use. For instance, you may prefer an L-shaped arrangement of the two areas rather than have one each side of a long dividing aisle.

Storage

On the spot storage provided by customized shelving and cupboards is one of the most apparent 'luxuries' of a permanent darkroom. Locate shelving for items such as processing tanks and spirals near to the wet bench, for example. And you will want a cupboard near where you plan to do your enlarging, to act as a temporary store for paper and a home for filters and other enlarging accessories. But try to arrange a system, once again, where anything to do with

the wet side of operations is kept clear of anything on the dry side to prevent damage and accidents. For example, if your dry and wet benches abut, the dry side should be higher than the wet.

All chemicals must be locked in a cupboard—if you have children, simply keeping the chemicals out of reach is not adequate. Sensitive material such as film and paper must be stored away from chemical fumes, and preferably somewhere much cooler than normal room temperature. The ideal method is to use an old refrigerator kept exclusively for this task. Fit a lock and padlock for safety, and for long term storage, place material in airtight plastic bags.

Compact design
Even a small room can be converted into a professional type darkroom providing you arrange equipment and work surfaces to maximize space. The wet bench area of this darkroom is simply one large sink and dishes and processing accessories can be spaced out in the sink and simply hosed down after use. A large light box is vertically mounted to conserve space on the dry bench

Work heights *If you are making your own work benches remember that the dimensions of these must take account of the job being done and whether you are standing or sitting*

Ventilation
Confined spaces, chemicals and vapours yield a combination which makes life uncomfortable unless suitable arrangements are made to have the room properly ventilated during the time printing and processing takes place.

Ventilation is always essential for comfortable working conditions and to discharge obnoxious fumes given off by chemicals nearing exhaustion or those which have been contaminated. Some of the darkroom processes such as toning make use of rather smelly chemicals, which are particularly unpleasant—and sometimes harmful—in a confined space. Even if these have to be used in the darkroom, try preparing them elsewhere to lessen the effects.

Permanent darkrooms can be provided with efficient extractor fans (some are available specifically for use in darkrooms) but simple light-trapped vents can perform just as well for the smaller darkroom. A suitable ventilation baffle can be built into a door, and this must be installed if an extractor fan is used, especially if windows and doors are tightly sealed for light trapping purposes. If you cannot provide adequate throughflow ventilation for your darkroom, make a special point of airing the room at regular intervals simply by opening the door and taking a break.

Running water
Although it is quite possible to make do without a mains or tapped water supply, running water is clearly a tremendous asset in any darkroom. Hot and cold supply is a major—and potentially expensive—requirement for a proper, permanent darkroom.

The alternative to a sink and a tapped water supply is to use bowls of water that have previously been transported to the darkroom. A rinse bath at the end of the fixing period is normally sufficient until such time as processing ends and the whole output may then be transferred to the bath for the final, all-important wash.

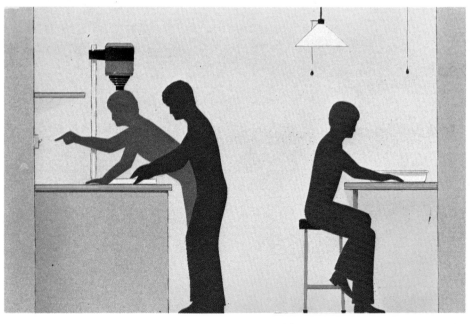

Waste outlet

All chemicals used in photography are potentially harmful to other substances and some care must be taken over the disposal of used solutions. It is generally considered that copper piping is adversely affected in this way: this may rule out some existing plumbing systems. Lead and plastic piping are less affected by the action of chemicals used in black and white processing.

If you are in doubt, the WC and its subsequent flushing is the best method of waste disposal, but seek advice from your local authority if this is drained into a cesspool or a septic tank. If you need to work away from a suitable waste outlet, a 'dump' such as a large plastic dustbin is all that is required. Used solutions may be transferred to this for convenience if fresh stocks are to hand—but any chemical action between discarded solutions could lead to unpleasant fumes.

If you are planning the plumbing for a more permanent darkroom, arrange for a large-bore plastic waste system for direct disposal of waste to the soil stack of your home. But do ensure that the traps in the piping are adequate and readily accessible so you do not have to dismantle fixed benches. Always seek the assistance of a plumber.

Discarded test strips, cleaning cloths and wrappings can quickly mess up the floor of a darkroom unless waste buckets are provided. Cardboard boxes, are unsuitable for collecting wet test strips—you need large plastic buckets or small dustbins for the job. Locate one near the enlarger, another near the wet bench for direct disposal of discarded prints.

Mains electricity

A number of items of equipment used in connection with the various printing operations require mains electricity supply, and for safety's sake it is preferable to use something more than a single ring-main socket for this. A spur from the existing ring main can provide up to three additional sockets, but this is strictly a job for the competent electrician—and a legal requirement in some countries..Electricity and water are a lethal combination at worst so observe this safety checklist:

- Do not allow the various dishes of process solutions to come near to wires or equipment.
- Mop up spills right away, particularly those near.electrical appliances.
- Never overload the mains socket by using a series of adapters.
- Keep sockets well away from main wet bench areas. As a rule, it must not be possible for you to touch or switch any electrical appliance when standing and working at the wet bench or taps unless cord switches are used.

Darkroom layout *Separate wet and dry work areas eliminate many of the messy problems associated with a temporary darkroom. Many of the design ideas can be used in a temporary set-up*

wires are also easily tripped over.
- Use fused appliances or sockets.
- Make sure that all connections are electrically correct, particularly if equipment is repeatedly unplugged.
- Do not allow wires to trail loose on the floor where spills are likely—trailing

Room finish

Perhaps the most popular misconception concerning the word darkroom is that it needs to be painted completely black—in fact the best paint finish is white or yellow. Use semi-matt for walls and ceiling in good condition, and a cement base paint for previously unpainted brick or cement walls.

To cut out reflections the area of wall near to your enlarger should be painted matt black to minimize lamphouse light reflections, but for temporary set-ups this is usually impracticable. Matt black cartridge paper performs the same function with the significant advantage that it is both removable and disposable should it become soiled. The rest of the room can be as lightly coloured and reflective as you like—in fact the more so

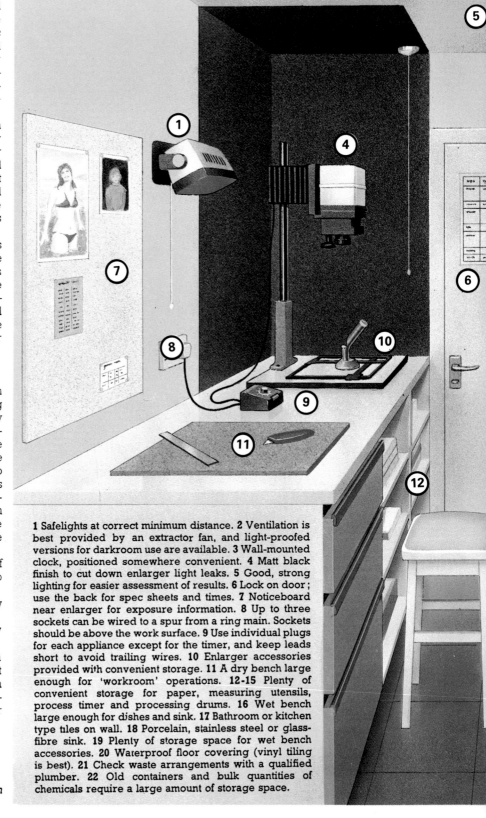

1 Safelights at correct minimum distance. 2 Ventilation is best provided by an extractor fan, and light-proofed versions for darkroom use are available. 3 Wall-mounted clock, positioned somewhere convenient. 4 Matt black finish to cut down enlarger light leaks. 5 Good, strong lighting for easier assessment of results. 6 Lock on door; use the back for spec sheets and times. 7 Noticeboard near enlarger for exposure information. 8 Up to three sockets can be wired to a spur from a ring main. Sockets should be above the work surface. 9 Use individual plugs for each appliance except for the timer, and keep leads short to avoid trailing wires. 10 Enlarger accessories provided with convenient storage. 11 A dry bench large enough for 'workroom' operations. 12-15 Plenty of convenient storage for paper, measuring utensils, process timer and processing drums. 16 Wet bench large enough for dishes and sink. 17 Bathroom or kitchen type tiles on wall. 18 Porcelain, stainless steel or glass-fibre sink. 19 Plenty of storage space for wet bench accessories. 20 Waterproof floor covering (vinyl tiling is best). 21 Check waste arrangements with a qualified plumber. 22 Old containers and bulk quantities of chemicals require a large amount of storage space.

the better. Use tiling near the wet bench to prevent splash damage and enable easy wiping down.

Take a look at the floors next. Chemicals can damage most types of floor covering. Carpets must be avoided. Linoleum flooring suffers from prolonged contact with chemicals and moisture, so spills must be wiped up immediately to prevent seepage to the flooring beneath, as this may lead to structural damage in the long term. PVC flooring is the most resistant of the modern floor coverings and is the best

choice for a permanent set-up. When laying this, seal joins with waterproof tape and turn up the edges where the floor covering meets the work tables and walls. This should minimize the seepage problem. At slippery spots, near the wet bench, a rubber mat can be added.

Temporary set-ups

A permanent darkroom is, sadly, beyond the reach of many. But with careful planning, a temporary set-up can provide many of the benefits of a proper darkroom. The only real difference in a

makeshift set-up is the temporary nature of the blacking-out arrangements—and the real need for somewhere safe to store chemicals, materials and equipment after each session.

Baffles or blinds can be used to make almost any room light-tight while you work, but it is best to choose somewhere small and clean—like a boxroom—to start with if a temporary arrangement is needed as only a door and a window will need attention. You may, however, decide that permanent blacking-out is preferable to temporary arrangements where a spare room can be converted into a temporary darkroom.

For temporary set-ups where blacking-out is complicated and not particularly efficient, consider waiting until nightfall before beginning work. Often a thick curtain is all that is then required to cut out weak streetlighting and moonlight at the window. For doors, simply pin a blanket over the frame but, if you do not wish to mark the door frame, use weather strip or draught excluder in the door frame cracks. Fit the door with a lock to prevent accidental entry.

Whatever arrangements you make, always test the efficiency of your blacking-out operations. Switch off all lights and allow your eyes to adapt fully to the darkness. If, after several minutes, you still cannot see a hand waved in front of your face, conditions can be considered safe. Any light leaks should be easily traceable and a strip of black masking tape is all that is needed to cure many of these. However, take care not to create an airtight space—which is especially important in small rooms.

Although you may not have the luxury of being able to custom-fit your benching, you may be able to move tables and other work surfaces around until you have created a suitable arrangement of work surfaces. A sink and draining board, for example, could act as a wet bench, and a table nearer to power sockets could be used as a dry bench. Again beware of trailing leads—and avoid the potentially lethal combination of electricity and water. This is why it is best to disregard the popular suggestion of converting the bath and bath top for use as a combined wet and dry work area in a temporary darkroom set-up.

Of course, almost any form of bench or table can be used for the wet side if a sink and running water are not available, but one which has an easily wiped down surface—such as Formica or melamine—would be preferable. Otherwise protect the worktop—and nearby flooring—from the inevitable spills of processing solution, using old newspaper, plastic sheeting or towels.

Whether you establish a permanent or a temporary darkroom, it is important to plan all the details carefully, and it is always worth taking a little extra time to do things properly—such as mounting equipment or providing drains—rather than taking shortcuts. If you do this, your darkroom should be a pleasant place to work in.

Planning a permanent darkroom

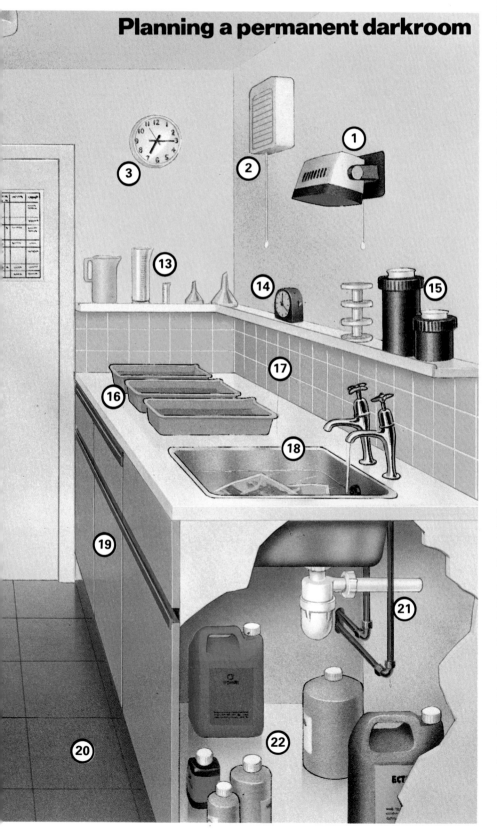

Basic equipment

Setting up a home darkroom requires a large range of equipment besides printing paper and chemicals. Most of it is cheap and simple, and it is tempting to buy the first things you see in the shop. But for even the most basic items there are alternatives, and making the right choice makes life in the darkroom much easier and can make the difference between consistently good and variable results from your negatives.

Some manufacturers market 'complete' darkroom kits and many of these are good value for money. Not all of them, however, offer all the equipment or quality you require, and a few offer too much. To evaluate each kit and decide which is best for you, it is essential to know a little about each individual item. Indeed, you may find that the only way to obtain the extact range you want is to purchase each item separately.

Essential darkroom equipment falls into three main areas: film processing equipment, print processing equipment, and equipment for monitoring time or temperature and for measuring and storing the chemicals for both processes.

Processing film

Rather than plunge in at the deep end with enlarging and printing, many photographers start off in the darkroom by processing film only. To save expense, some photographers process film with a bare minimum of purpose-made equipment and improvise the rest from things around the house. Quality often suffers from this casual approach, however, and it is better to buy the proper equipment. The most important piece of equipment, the developing tank, cannot be improvised.

Developing tanks Although an important and often expensive piece of equipment, the developing tank is simply a container to hold the film and chemicals during processing. Unfortunately, the perfect developing tank has yet to be invented. It must, obviously, be completely light-tight to allow development in normal room light. It must also be water-tight, except when

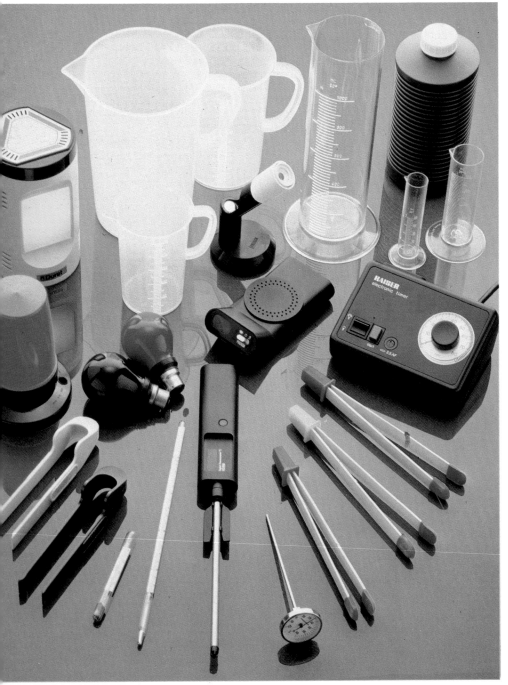

Darkroom essentials *Key to photograph*
1 *Measuring cylinders*
2 *Safelights and safe bulbs*
3 and 4 *Print tongs, plastic and bamboo*
5 *Thermometers*
6 *Timers, with seconds bleeper at left*
7 *Focusing magnifier*

you want to change chemicals during processing and then it must be possible to empty and fill it very quickly.

Tanks are usually made of black plastic or stainless steel. Stainless steel tanks conduct heat well and are easier to warm up in a water bath. But they also lose heat very rapidly as soon as you remove them from the bath. A plastic tank, though harder to heat up, retains heat for longer. Since with fast modern processing times many photographers dispense with a water bath and rely on prewarmed chemicals retaining sufficient heat during processing, the extra insulation of a plastic tank might be an advantage.

Stainless steel tanks are unbreakable, but they may bend when dropped heavily so that the lid will not fit properly. Plastic tanks, on the other hand, are very robust, but can be cracked if mistreated. They are also very sensitive to heat and some crack even if washed in hot water. On the other hand, you can even dry out a stainless steel tank in the oven if you wish to re-use it in a hurry.

When starting out, most people buy a tank that has a single film spiral, but if you frequently have many films to develop, you may find a *multi roll* tank more useful. Multi roll tanks will take three or more spirals and allow you to develop a number of films together.

Plastic tanks usually have nylon spirals; metal tanks have metal spirals, although they are sometimes interchangeable. Neither has any marked advantages over the other. Some people find it easier to load metal spiral: others find it easier to load a plastic spiral. The best way to decide which suits you best is to take a fogged film with you when choosing a tank, and try out a number of spirals. The methods of loading each type are shown on pages 18 and 19.

An important feature of plastic tanks is that they generally fill and empty very quickly. This is an advantage when it comes to timing processes—many stainless steel tanks take 15 to 20 seconds to drain and fill, and when judging development times you must remember this. The most recent colour processes use very short development times, and drain and fill times might well account for 20 per cent of the whole development time if you are using a steel tank.

Since it is impractical to check the leakproof qualities of different tanks in the shop where you buy—some tanks dribble large quantities of solution when inverted—we ran a test ourselves. Fill and drain times were also tested, as was the minimum quantity of solution needed to develop one roll of 35 mm film. Tank brands are named, but the tanks may be sold under different names by different suppliers (see page 12).

An interesting variation on the standard tanks that may attract those who have no darkroom, but find it difficult to load film onto the spiral in a changing bag is the 'daylight tank'. This has a special spiral that allows the film to be drawn straight from the cassette inside the tank in daylight. The disadvantage is the tank's small capacity for film but high thirst for chemicals.

Washing film When a film has been processed it has to be washed and dried. Although it is possible to wash a newly developed film in an open tank under a stream of running water, specially designed film washers do the job more efficiently and more quickly.

The simplest kind of washer is a short length of rubber or plastic tubing that takes water from the tap to the inside of the developing tank. This forces water to flow under pressure from the bottom of the tank upwards, past the film and out through the top of the tank. Manufacturers of some of the more expensive types claim that their washers will wash films in as little as five minutes.

Some washers use water pressure from the tap to spin the spiral holding the film round and round. Another, called a *turbo-washer* mixes air with the water and so sends bubbles as well as water through the developing tank. This is supposed to speed up the washing process still further.

Drying film Film dries much more quickly if surplus water is removed before hanging. You can do this lightly with your fingers, with a piece of chamois leather, a sponge, or a pair of specially designed film wipers. Whatever you use, it must be kept scrupulously clean, because dirt can make tram line scratches down the film.

The blades of most film wipers, which look like car windscreen wiper blades, are often heavy and stiff. If you decide to buy a pair, look for the kind with very lightweight flimsy blades. Despite their fragile appearance, they work well, and are less likely to scratch the film.

You can use clothes pegs to hang up the film, but they tend to leave drying marks and dirt. It is worth spending a little extra to buy a pair of film clips. One type is weighted to prevent the film from curling, and most clips hold the film in such a way that no water is retained. This more or less eliminates streaks and marks in drying.

Print processing

After leaking developing tanks, poorly made masking frames are probably the greatest source of irritation in the darkroom. To work well, a masking frame must hold the paper perfectly flat, and in exactly the right position. Many cheap masking frames fail to do either of these things, and the result is unsharp prints with crooked borders.

The basis of a masking frame is simple. It is a flat wood or metal board with a hinged framework that lifts up for the insertion of printing paper. It has adjustable arms to accommodate different paper sizes and to vary the width of border. When lowered, the framework

Thermometer choice *A simple spirit thermometer is cheap and is more accurate than floating or dial types. Electronic models are very precise*

holds the paper flat and it should be impossible to slide the paper around underneath it. A masking frame that does not hold the paper firmly flat is not worth having.

The more you pay for a masking frame, the more solidly it is likely to be built. The large sized, heavy duty models can cost as much as an enlarger. Cheaper frames have non-adjustable border widths, and only take small sizes of paper. However, if you rarely make very large prints, and trim off borders after printing, a cheap frame should be adequate.

Besides the basic frame, there are several special types on the market. The most common are designed for making borderless prints. Professional printers use a *vacuum easel* for this purpose—a pierced board attached to a suction pump, which sucks the paper down flat. Unfortunately, these are very expensive. Manufacturers have adopted a number of cheaper systems, as a result, though some of these may prove to be less than satisfactory.

One type uses a *low tack* adhesive which is supposed to hold the paper flat. This is not very satisfactory, as the adhesive layer collects dust and has to be renewed periodically. A second system holds the paper flat under glass, but this collects dust which shows up on the print. A third alternative holds the paper by the corners, but this often fails to keep the paper flat. The best solution is probably to print with white borders, then trim them off.

Focusing devices It is not always easy to focus the enlarger, particularly when a dense negative is in the carrier. Focusing magnifiers make this task easier. They stand on the masking

Tank test *We tried out six different tanks, testing them for filling and draining times, and checking the minimum volume of solution needed to cover a 35 mm film. No tank was leakproof, but some were more watertight than others*

Dixons stainless
Fill time—7 secs
Drain time—8 secs
Min vol—293 ml
Solidly made 'own brand' tank for 120 and 35 mm, but leaked badly

Jobo daylight tank
Fill time—12 secs
Drain time—6 secs
Min vol—393 ml
This tank needed no darkroom for loading film, but filled very slowly indeed, leaked a lot during processing and used more chemicals than any other tank

Kaiser
Fill time—5 secs
Drain time—5 secs
Min vol—323 ml
Neat looking tank that was reasonably watertight and filled and emptied quite quickly

Paterson Universal
Fill time—5 secs
Drain time—4 secs
Min vol—290 ml
Very popular brand of tank with wide mouth, making pouring easy and quick. It leaked a lot of solution when we tested it

Durst
Fill time—8 secs
Drain time—5 secs
Min vol—267 ml
Almost watertight tank—it only leaked one drop. It also used the absolute minimum volume of solution

Ilford 72 tank
Fill time—8 secs
Drain time—6 secs
Min vol—353 ml
This was a special tank for Ilford's 72 exposure film. It leaked badly, but frame for frame it used less solution than any other tank

frame, and consist of a small mirror, which reflects the image of the negative up to an eyepiece—actually a simple microscope. The eyepiece is adjustable to suit the eyesight of the user, and when the enlarger image is correctly adjusted, a clear picture of the grain of the negative snaps into focus in the eyepiece.

A second type of focusing aid is simply a mirror which reflects the image of the negative onto a ground glass screen where it is easier to see than on the paper itself. These devices are not as precise as enlarging magnifiers.

The wet bench Developing trays are one type of darkroom equipment where it is possible to make economies without adversely affecting picture quality. Many photographers successfully improvise trays from greenhouse seed trays, cat litter trays or window troughs.

Proper darkroom trays do have a number of points in their favour, however. They are rigid, making spillage less likely when they are full of chemicals, and they have spouts for pouring solutions. The better ones have small indentations in the bottom and sides to hold a thermometer in place.

Purpose built troughs come in several

colours—usually red, grey and white—and most photographers buy three colours and use the same solution in each one every time they are used. Clear plastic trays are also available, and these are useful when processing certain types of sheet film—you can shine a red light through them to see how development is progressing.

Print tongs are a good idea, even for a beginner, because they avoid chemicals coming into contact with your skin and stop cross contamination of the processing solutions. Two pairs are needed: one for the developer, and one pair shared between stop and fix.

Whatever kind of tongs you use, they must have a firm enough grip to hold large slippery sheets of paper, and yet not scratch the surface of the paper. Plastic tongs range from poor to reasonably good, but even the best of them break very easily. The most resilient tongs are rubber tipped, and made from stainless steel or bamboo strips. Bamboo tongs stain quite quickly, but they are colour coded like trays, and the staining does not seem to do any practical damage to processing solutions.

Safelights Black and white printing

paper is sensitive only to blue light, and can be handled quite safely by dim yellow or red light. Consequently, darkroom lights are usually of these colours.

In their simplest form, they consist of ordinary light bulbs dipped in a special red dye—ordinary decorative red light bulbs must not be used. They have a rubber ring where the glass meets the metal cap to stop light leaks. These bulbs are much cheaper than even the least expensive safelight, and are perfectly adequate for most purposes.

There are many other designs for safelights and most of them are quite satisfactory. The only point to look for is the light seal. A safelight that leaks white light will ruin your prints. Some safelights have interchangeable coloured filters, but if you buy a red safelight, this should be unnecessary because it can be used both with paper and orthochromatic film. A yellow light can be used only with paper.

Measuring equipment
For good results in the darkroom, both film and print processes must be measured accurately. Solutions must be made up to the right concentration,

processes must take place at the right temperature and development must be timed accurately.

Measuring Cylinders To mix up solutions in the correct proportions and to ensure that exactly the right amount of solution is used in the process, you must have some way of measuring liquids. Some photographers improvise with cheap kitchen measuring jugs but these are not sufficiently accurate—many films have been ruined by such crude methods. Indeed, using kitchen containers for mixing chemicals is to be positively discouraged since someone may accidentally use a contaminated container for food.

Proper measuring cylinders are generally made either of semi-opaque polyproplylene or transparent polystyrene. The semi-opaque cylinders are almost unbreakable but stain easily and their markings become difficult to read.

Clear plastic measuring cylinders are cheap and fairly durable. But you should check that the graduations are moulded into the plastic and not just printed on the outside, as these may be scratched off or fade. Some clear plastic beakers are not resistant to the concentrated acetic acid found in some stop baths. The acid etches the inside of the cylinder, making the graduations difficult to read. As a result, it is worth buying a small cylinder purely for stop bath concentrate.

Although it is possible to measure any quantity of liquid in a large cylinder, small quantities cannot be measured accurately and it is necessary to buy a range of sizes. A very small cylinder is particularly important if you use concentrated negative developers like Kodak HC-110 or Paterson Acutol. A good choice is 1000 ml, 250 ml, and 50 ml flasks.

Measuring temperature Accurate temperature measurement is important because the temperature of almost all the solutions used affects the rate at which the chemical processes take place. If the developer is too warm, film will be overdeveloped even if the processing time is correct.

The cheapest thermometers are filled with a thread of alcohol, often coloured blue so that it can be clearly seen under the safelight. Although a cheap thermometer is better than none at all, it is worth spending a little extra for something more accurate. Most spirit thermometers are accurate to within about half a degree Centigrade, which is quite adequate for black and white work, though not for colour.

Greater precision is obtainable from mercury thermometers, though these are generally expensive. They are often accurate to within 0.2°C. Since thermometers are easily broken, some

Masking frames *Large masking frames are very costly so, if you rarely make big prints, a smaller model should be quite adequate. Look for solid construction, adjustable borders, and the ability to hold the paper perfectly flat*

photographers keep a mercury thermometer safely locked away to provide a check, and use cheap spirit thermometers for their darkroom work.

There are several other types of thermometers apart from the traditional straight glass variety. Some are crooked, so that they do not roll around in the bottom of a dish, and some thermometers float—this can be useful when you are mixing large quantities of chemicals. *Dial* thermometers have a clock-like dial about 5 cm in diameter attached to a long metal stem. Although they are very easy to read, dial thermometers are not usually as accurate as straight mercury thermometers, and are often expensive.

Electronic thermometers have been used for many years in processing laboratories. These are ideal for a club or for a semi-professional photographer because they have a large digital display which indicates the temperature with great precision. Unfortunately, they tend to be expensive compared to ordinary thermometers.

When buying a thermometer, do not forget to check the range of temperatures that it covers, particularly if you anticipate developing colour films, which frequently need to be processed at temperatures in excess of 41°C. Even some black and white developers have to be mixed from crystals at similar temperatures.

Measuring time Although a clock with process timing a sweep second hand is adequate, it is not sufficiently accurate for short print exposures of less than 15 seconds. When printing pictures, it is a great help to have one of the many

electronic timers that are on the market, and if you are printing a number of identical copies from one negative, a timer is essential.

Most timers can be preset to the required exposure time, and when a button is pressed, the enlarger light is switched on for the required period. The most modern type, which has a digital readout of the time that has elapsed since the enlarger was switched on is particularly useful, as it makes dodging of a print much easier—you know when to start and stop without having to look at a separate clock.

Basic timers only switch the enlarger on and off, but the more sophisticated models also do other things. Some turn the darkroom safelights out while the enlarger light is on. This makes it easier to see the image on the baseboard and shading the picture is made simpler. A very useful point to look for is a footswitch—turning the enlarger on with your foot leaves you with both hands free.

Try to avoid the type of timer that has two ranges, such as one to nine seconds and 10 to 90 seconds. It is easy to forget to change the range and this can waste a lot of paper and time. Timers that have one continuous range eliminate this simple mistake.

A lot of photographers do not use a timer at all, but time prints using a metronome or an electric bleeper. This saves them looking at the timer while performing complex print exposures. Although these are not suitable for short exposures they are sufficiently accurate for exposures exceeding 12 seconds.

The enlarger

If you decide to set up your own dark-room, whether it is improvised or a permanent arrangement, its' central feature will be an enlarger. As your skill increases, many hours will be spent using this piece of equipment. To ensure that your time is not spoiled by irritating minor frustrations arising from awkwardly placed controls or badly designed features, it is advisable to take a particularly close look at the alternative enlargers on the market.

All enlargers work on the same principle. They have a light source which illuminates a piece of film. The emerging rays are focused by a lens, which forms an image of the negative on a sheet of light-sensitive printing material. In most enlargers these components—the light source, negative stage and lens—are incorporated within an 'enlarger head' which is supported by a metal column. The column is fixed to a baseboard on which the printing paper can be placed.

The light source

For high quality prints, the image projected on the enlarger baseboard must be brightly and evenly lit. The two main types of enlarger light system, *condenser* and *diffuser*, each achieve this in different ways.

Condenser enlargers were traditionally considered the best for black and white printing, and many simple 35mm enlargers are of this type. The light source is generally a 75W or 15W opal bulb, and a pair of large lenses called condensers focus the light through the negative and on to the enlarger lens. For maximum efficiency, the condensers must be set up to suit the film format and the focal length of the enlarger lens.

The light from a condenser enlarger is bright and gives brief exposure times. It is also highly directional and picks up grains in a black and white negative to project a crisp, contrasty image. Unfortunately it shows up any dust or scratches on the negative as well. It was widely believed once that a condenser enlarger

actually gave a sharper image than a diffuser, but this is probably just an illusion created by the extra contrast—printing on a harder grade of paper would give the same effect.

Because colour films (and chromogenic black and white films) have no grain—the image is formed by dyes—the directional light of a condenser enlarger has no enhancing effect on contrast and the tendency to show up blemishes is a major

disadvantage. Enlargers for colour are therefore generally of the diffuser type. In these, there is no condenser but a sheet of frosted or opal glass that diffuses and scatters the light to give very even, but less efficient illumination. A tungsten-halogen bulb focused by a reflector into a light mixing box above the diffusing screen ensures that the image is sufficiently bright. The big advantage of this system is that it is relatively easy to

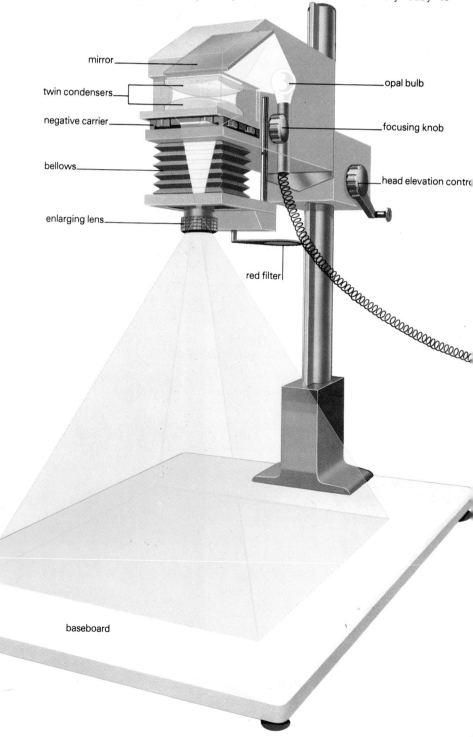

mirror

twin condensers

negative carrier

bellows

enlarging lens

red filter

opal bulb

focusing knob

head elevation contro

baseboard

Enlarger construction *All simple black and white enlargers work in much the same way. This cutaway picture shows the path of the light from the lamp, via a mirror (omitted from some enlargers) through condensers and negative, and finally through the lens to form an image on the printing paper*

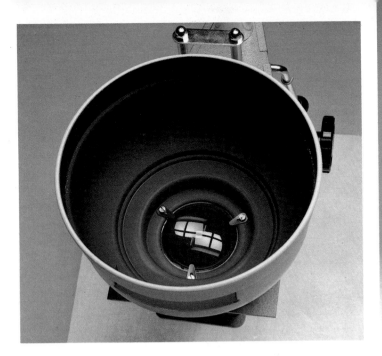

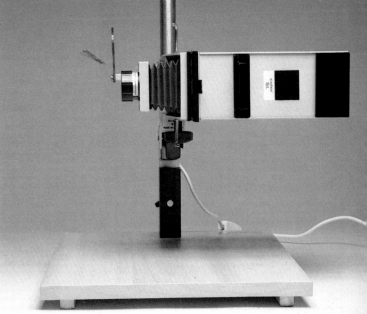

arrange 'dial-in' colour filters in the light mixing box to give a proper colour head (see below). However, there is absolutely no reason why a diffuser enlarger should not be used for black and white, even though exposure times may be increased. Indeed, many experienced printers actually prefer a diffuser for b & w because it does not show up blemishes.

The column and chassis
The purpose of the column is to support the enlarger head above the baseboard. It should be constructed so that the head is completely free of vibration during exposure of the paper.

The columns on the simplest enlargers are usually single tubes of plated steel. The height of the column varies considerably from model to model but is usually from 60 cm to one metre. The height of the column is important, because it dictates the maximum print size that can be made. If you intend to make a lot of large prints, buy an enlarger with a long column.

Other types of column include double tubes, which give a firmer support, and box columns, which are usually rectangular in cross section and give a very firm support.

As the enlarger head is heavy and carried clear of the column, the bracket that supports it must be robust. This bracket normally incorporates a mechanism by which the head is positioned at the selected height. On most enlargers this is a friction brake. It is secured by either a locking screw or a spring loaded lever. More advanced models sometimes use a rack and pinion mechanism which raises the head up the column when a crank is turned. This method of head elevation is the most positive and secure, and allows the most accurate positioning of the head.

For occasional large prints, many enlargers allow the column to be swivelled to project onto the floor, and

a few have an adjustable bracket that lets the head turn so that the image falls on the wall of the darkroom. Both these methods produce larger images, but are inconvenient if many giant prints are to be made.

The negative carrier
The negative to be printed should ideally be held perfectly flat, and parallel to the printing paper. This is usually achieved by placing the film between two plates of metal, hinged together at the back. This arrangement is called a *bookform carrier*, because inserting the negative into the carrier is rather like putting it between the pages of a book. The carrier slides into a slot in the enlarger head where a spring mechanism, or the weight of the head presses the film flat.

Rectangular holes are cut into the metal plates, and registration pins hold the negative in position so that the negative to be printed is visible through the holes. Some carriers have pieces of glass over the hole, which press the film flat. Others—*glassless carriers*—hold it flat without using glass. Glassless carriers have the advantage that they accumulate less dust, but they do not hold the negative quite as flat as those carriers which use double glass plates. A good compromise is the use of just a single glass plate. This holds the

Inside the head *Large glass lenses, called condensers, collect the light from the bulb, and channel it down to the negative, which is held in a carrier located directly below*

Turning the enlarger *The largest size of print that an enlarger can produce need not be limited by the height of the column—often the head turns to project the negative on to the wall*

Negative carrier *Some carriers can be used with several different film formats, and this one has four sliding masks which allow the printer to mask off those areas of the negative that are not going to appear in the print*

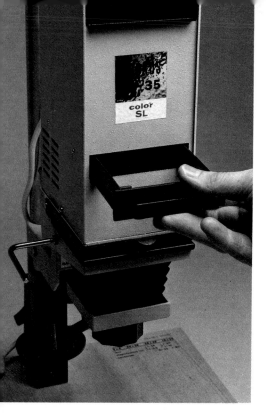

Filter drawer *You do not need a colour head to print colour pictures on your enlarger, because you can insert individual filters into the small drawer that is found on almost all enlargers, above the condensers*

negative flat but does not gather as much dust as two sheets of glass.

A further difficulty with glass carriers is that where the negative is pressed closely into contact with the glass, a pattern of concentric rings appears in the picture. These are called Newton's rings, after the scientist who first noticed them. They will show up on the print, and if they appear in the sky, or some other area of flat tone, they can be very unsightly. The glass plates of the carrier can be acid etched to prevent Newton's rings, and such glass is called *anti-Newton glass*. This is expensive, and many enlarger manufacturers opt for the cheaper alternative of glassless carriers.

Not all carriers are of the bookform type. A few enlargers use a simple plate upon which the film is placed and held flat with the weight of the lower condenser. This is not just a cheap alternative—some of the best enlargers ever made have used this system.

When buying an enlarger, it is a good idea to pay particular attention to the negative carrier. A good carrier is a pleasure to use, but some of the worst ones can make darkroom work a nightmare. A few carriers have useful features that will improve the quality of your prints. The most important of these is a system of sliding masks, which move across the frame just below the film. When printing a small section of a negative, the masks can be moved to block off those areas of the picture that are not going to appear in

the final print. The purpose of this is not to compose the picture—the masks are not usually quite in focus—but to block off scattered light that would otherwise be reflected back onto the print, thereby reducing contrast.

Things to avoid in negative carriers include fiddly methods of construction—some carriers consist of four plates of metal which have to be assembled in the correct order each time the carrier is removed from the enlarger. This can be very annoying. Another point to watch is the area of the aperture through which the film is visible. If the hole in a glassless carrier is too big, the film will not be held flat, and light will spill into the picture from the edges of the negative. If it is too small, not all of the negative will be visible, and you will not be able to print the whole frame. If the carrier is glassless, a few minutes work with a file will cure this, but if it is not, there is very little that can be done.

Lenses and mounts

Most enlarging lenses are attached into the head of the enlarger by a screw thread fitting. This is generally a standard size—39 mm—so most enlarging lenses are interchangeable.

The lens is threaded into a mounting plate. On a single format enlarger, for example, designed to be used with 35 mm film only, the plate is usually fixed permanently into the head. When the enlarger is made to print more than one size of negative the lens screws into a special plate which is then fixed to the enlarger, often with a quick release device. There is a simple reason for this—different lenses must be held different distances from the film, so that while the lens mount for a lens that covers the 120 roll film format will simply be a flat plate, the mount for 35 mm is recessed so that the lens sits closer to the negative.

If you print your own photographs, then the quality of the final picture will be limited by the weakest link in the image forming chain. If you buy a cheap enlarging lens, then however good the lens on your camera is, the print quality will never be first rate. The quality of lens is therefore of great importance.

Enlarging lenses are generally much cheaper than camera lenses because they are much simpler in construction both optically and mechanically. The diaphragm mechanism is simpler, and the job of focusing is done by the enlarger, not the lens. Enlarging lenses come in a variety of maximum apertures, just as camera lenses do, but in the darkroom maximum lens aperture is less crucial. The only virtue of a lens with a wide maximum aperture is that it makes focusing easier because the image is brighter. Unless you plan to make a lot of giant enlargements with

Changing heads *With some enlarger systems, you can replace the black and white condenser head with a dial-in colour head in minutes.*

images that are dim and hard to focus, the extra cost of a lens with a wide maximum aperture is not justified.

For a 35 mm negative, the normal focal length of the enlarging lens is around 50 mm. For roll film, it is 80 mm. Although these focal lengths are standard, it is possible to buy wide angle lenses for enlargers. These will produce a larger image on the baseboard than the standard enlarging lens when the head is a fixed height up the column, but are usually specially computed for big enlargements, and do not give their best performance on prints smaller than 25 to 30 cm wide. The apertures on enlarging lenses are marked by click stops. When a lens is used in a recessed mount, this might be the only way of determining which aperture is in use, since the markings are frequently difficult to see. For this reason, it is essential that the click stops are firm and positive.

Enlargers for colour

If you want to make colour prints regularly, you must have some means of controlling the colour of the light passing through the negative. This allows you to not only compensate for differences between types of film or paper, but also to adjust the colour balance of a print. You can either convert your black and white enlarger for this purpose or you can buy a special colour enlarger.

All but the simplest or oldest black and white enlargers have a filter drawer, which can take different combinations of coloured filters. This is the simplest and cheapest way of controlling the colour of light. If the lamp house or *head* of the enlarger is interchangeable, you can convert a black and white enlarger by fitting a *colour head,* which has a built in facility for colour filtration. Alternatively, you can buy a complete colour enlarger with a colour head already fitted. Such enlargers are, of course, expensive, but the saving in time and effort justifies the outlay if you do a lot of colour work—buying secondhand may help

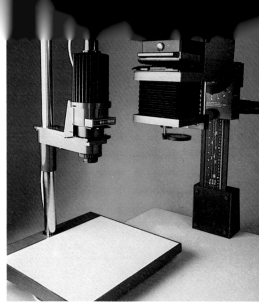

Filter details *Most colour heads use dials to control the amount of cyan, yellow and magenta light transmitted*

Head and drawer *The cheaper model on the left has a filter drawer, giving a simpler and more compact design*

Using filters

The filter drawers of black and white enlargers usually accept filters 75 mm or 100 mm square. These can be bought as coloured sheets in sets comprising the three subtractive primary colours—yellow, magenta and cyan. The sets include filters of different strengths, and in printing a *filter pack* is made up to produce a given colour correction. The disadvantage of this method is that you cannot have a continuous variation of strength and are limited to the steps available from your set of filters.

On most enlargers, the filter drawer fits between the lamp house and the film carrier. Where the design of the enlarger does not permit this, you can still introduce filtration by fitting a filter holder below the enlarging lens. This is not the ideal situation, though, because filters in this position can effect the sharpness of the projected image. Another possibility is to put filters on top of the condenser lens—though this is only feasible if the lamp house is easily removable to allow filter changes.

The major advantages of this system

are cheapness and simplicity—filters cost no more than a couple of rolls of film and you do not need to worry about converting the enlarger.

Colour heads

Some colour heads, known as filter bank heads, have a set of built in filters, mounted already to slide into position. Only magenta and yellow are incorporated usually, because they are used most frequently when printing negatives. On those occasions when a cyan filter is needed, it can be inserted in a separate filter drawer, as can extra filters needed for printing certain negative films. If you usually print only negatives, rather than transparencies, which require cyan filtration, this type of head may be adequate. The Paterson Color 35 enlarger has this type of head.

Most colour heads, however, have 'dial-in' filtration. Instead of many different filters, they have three very pure, deep coloured filters which are gradually introduced into the light path to change the intensity of a given colour. This is controlled by means of dials marked in units, one dial for each colour. A diffusing or mixing chamber incorporated in the head mixes the different colours of the light thoroughly and avoids patchy illumination.

Most heads of this type—also known as dial-in heads—use *dichroic* glass filters, which do not fade and give very pure colours. Some cheaper models use dyed glass or plastic—one model, for example, has only two plastic filters, yellow and magenta.

A third method of controlling the colour of light is to have three coloured light sources in the colour head—red, green and blue. These primaries give the required colour when mixed in the right proportions. This system is convenient because brightness is electron-

ically controlled, and remains constant irrespective of the colours used in the combination. This means that you do not need to make any exposure compensations when using this system. The Philips Tri-One enlarger is an example of this type of head.

If you already own a good quality black and white enlarger, you can convert it for colour use by exchanging the existing head for a colour one. A great choice is available, but which you buy depends to a great extent on which heads fit the black and white model you already own.

'Dedicated' colour heads or conversion kits usually fit only one model—the C35 conversion for the Durst B35 black and white enlarger, and the colour module for the Leitz Focomat V are examples. Multi-mode heads, on the other hand, usually fit the range of only one maker, but several models in that range. One of the Durst colour heads fits all the 6 x 6 cm models, another all the 6 x 9 cm ones, and a third all the 5 x 4 inch ones. Some types fit the whole range by a given make—the Meochrom head for the Czechoslovakian Meopta enlargers, for example.

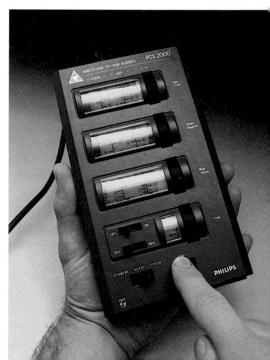

Remote control colour *(right) With some of the most sophisticated colour enlargers, the colour of the light can be adjusted by remote control*

Chapter 2
PROCESSING BLACK & WHITE FILM
Basic film processing

Loading a centre-loading spiral

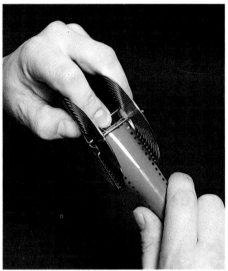

1. *With a centre-loading spiral prepare the film as with a self-loading spiral (see panel opposite). Then orient the spiral in one hand and hold the film firmly in the other, so that it adopts a 'U' section prior to loading. This ensures that the film slots in between the grooves easily*

2. *Various methods are used for anchoring the film to the hub of the spindle. This spiral has a sprung wire clip. Force the film end home beneath this, or hook the end on the lugs provided. Give a firm tug to see that film is properly anchored*

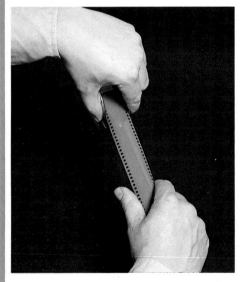

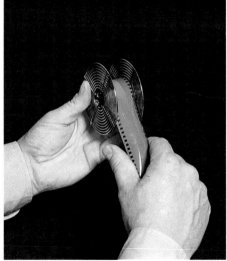

3. *Good technique is especially important when loading a centre-load spiral. The first part of each cycle of movement is to draw out a short length of film from the spool safely contained in the palm of your hand. Maintain the 'U' section at all times*

4. *The second part of the cycle is to twist the spiral round, in the process taking up the free length of film. In effect, the spiral moves towards a static film spool, in a sort of 'bending' or 'breaking' movement of the hands. When you reach the film end, remove the spool*

Processing a black and white film is the simplest of all photographic processing techniques. You need little in the way of equipment and the whole procedure, apart from loading the film in the tank, can be carried out in normal room lighting—the checklist on the right shows exactly what you will need to start with. The key to success with black and white film processing is meticulous care over every stage and the establishment of a precise routine. Thorough preparation of equipment and materials is vital.

Before you use any equipment, check it to make sure that it is clean enough for use and that it has not suffered any damage during storage. Plastic storage bottles and containers can crack—so can the body section of a plastic developing tank. Check these against the light. Make a point of rinsing out the measuring cylinder and solution containers before use. Other equipment should only need a quick wipe down with a damp cloth prior to use if it was clean when put away, as it should have been.

Use common sense when force-drying any plastic equipment. A fan heater or hair dryer can be a real time-saver, particularly for spirals which cannot be dried with a towel. Never attempt to load film in to a wet spiral or tank: not only do you face the prospect of a jammed or damaged film, but there is also the risk of marking or splashing the film so causing processing faults which will mar the quality of your negatives.

If you do have to rinse the tank spiral before use, you can speed up drying by removing any water trapped in the spiral grooves. The easiest way to do this is to run a corner of a fold of cloth or tissue along the grooves. Once surplus water is removed, you can use a fan heater for drying the spiral.

Black-out conditions
Because film is extremely sensitive to light of all colours, you must load it into the developing tank in total darkness. If light strikes the film before or during processing, fogging may occur. In the case of b & w film, even small amounts of fogging—evident as perhaps only a slight greying of the negative—can significantly impair image quality. Negatives become difficult to print, and it may be impossible to get a good, rich black in the print.

If you are loading in a darkened room, check that it is indeed dark. Eyes are

surprisingly sensitive if you give them time to adapt to conditions of darkness, so wait a few minutes when you put out the light. If, after this time, you cannot see your hands in front of your face, conditions are suitable for loading film.

Never attempt to load if it is possible to distinguish the shapes of objects, particularly by reflected light. Very slight light leaks can be shielded by your body, but anything stronger must be masked off with suitable tape or baffles.

If you wait till nightfall to load films, bear in mind the presence of street and traffic lights. Warn others in the household not to switch on lights near to where you are loading if the light-proofing is suspect.

If you have to use a changing bag for film loading, shake it out well to remove dust and film debris which may cause problems during loading or processing. Check the seams from time to time, particularly in the sleeve regions where wear

and tear is most likely. Check also for small pin-pricks and tears in the outer layer, and tape them over.

Loading film

Impatience is the cause of many of the problems associated with film loading. Everybody experiences problems of this sort at some time or another, no matter how many 'dry runs' they have done in full lighting. Always anticipate hold-ups or more severe problems, and keep a light-tight container at hand so that a troublesome film can be put aside while you collect your thoughts in the light and fresh air. Never lose your temper with a film—as well as risking further damage to it, you will probably aggravate the problem.

Before turning out the lights, arrange the equipment and tank components in a logical order—the spiral nearest to you, followed by the tank body and the tank lid, and have scissors and any other items ready nearby. Standardize this layout and you should have no difficulty locating items in the dark. You can see the importance of having a suitable work

Loading a self-loading spiral

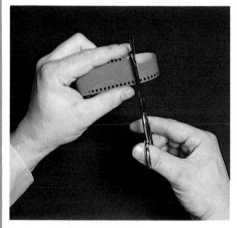

1. *In complete darkness remove the spool of film from its cassette opening it by tapping the protruding end on a bench. Run a forefinger along one edge of the film and the thumb along the other and use these as cutting guides*

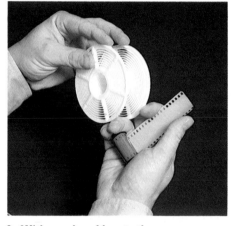

2. *With one hand locate the groove opening lugs at the start of the self-load mechanism of the spiral. It helps if the spiral is correctly oriented before the light is switched off. Hold the film firmly, but by its edges, in the palm of your hand*

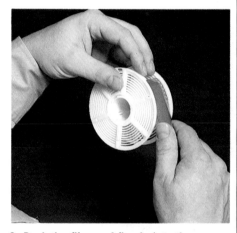

3. *Push the film end firmly into the groove beneath the opening lugs, so it safely engages the self-load mechanism (usually a ballbearing or ratchet arrangement). Continue pushing the film into the spiral until you feel it take up*

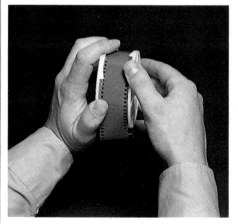

4. *When you are certain that take-up is satisfactory, rock the two sides of the spiral alternately backwards and forwards. Take up should be smooth and require little effort—a dirty or damp spiral can cause considerable difficulties*

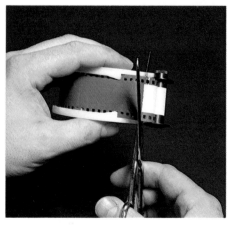

5. *When you reach the end of the film, run opened scissors up against the spool and carefully snip this away. If you can, retrieve the spool, remove the fixing tape and use this to tape down the loose end of the film on the spiral*

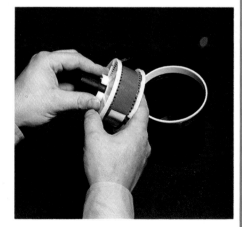

6. *Carefully reassemble the components of the tank. Normally this means placing the spiral on to a centre spindle before loading it in the tank. To engage a screw lid properly, turn the lid anti-clockwise briefly before tightening*

surface for loading film but do make sure this is kept scrupulously clean and dry.

Before handling the film, wash your hands to remove chemicals, sweat and body oils which can transfer to the emulsion side of the film. Always try to handle film only by its edges so that handling faults such as fingerprints and smears can be prevented.

Before loading the film into the spiral, the end of the film must be cut square. With practice this can be done in the dark, but it can cause problems for the beginner, since it is necessary to make the cut between perforations. You may therefore find it much easier to prepare the film end in normal room lighting. So when you have removed the end cap, take out the spool and feed the leader back through the cassette light trap, replacing the spool and end cap afterwards. Switch on the light and cut off the leader just before it reaches full width. Then round off the corners so the film slides easily along the grooves of the spiral.

You can then switch out the light, break open the cassette again and proceed to load the film. Alternatively—providing you have taken the added precaution of cleaning the cassette light trap to prevent tramline scratches—you can load the film straight from the cassette in darkness of course.

The one main advantage of this method is that you do not have to handle any more than the beginning of the film, which is worth bearing in mind if your hands tend to sweat a lot. The cassette also provides additional protection from light seepage and physical damage.

You will need both hands to see-saw the two sides of the spiral, leaving the spool of film to cascade to its full length and perhaps on to the floor unless you provide a suitable support—or unless you load the film directly from the cassette. This is another good reason for choosing to unload film somewhere with a work-top. The alternative is your lap unless you cup the spool.

Never exert too much pressure on the sides of the spiral, particularly if a film begins to stick. If you use too much force you risk stressing and tearing the film. Carefully respool the film and try again. If the problem still occurs, respool the film a second time and place it in its cassette or other suitable container while you examine and rectify the problem with the spiral. It is likely to be damp or dirty which causes sticking.

Centre-load spirals are much easier to load once the all-important technique of forming the 'U'-shaped cross-section has been mastered (see page 18). If your make of spiral does employ a special loading chute, learn to fit and use this properly. If you are loading solely by hand, it helps to keep your fingers and

thumb rigid at all times so a constant 'U' is formed as the film runs through on to the spiral.

Most 35 mm film is taped to the take-up spool. To prevent the film unfurling during processing, use this tape to hold the trailing end of the film in place against the film below, if possible.

Now place the loaded spiral in to the developing tank and make sure the lid is correctly fitted before turning on the light. With push-on lids, first remove the filler cap as air-pressure within the tank may prevent it from closing properly.

If, in spite of all these precautions, you continue to experience difficulties in loading, examine your technique closely. Once again, practise the various loading stages in full lighting to re-establish a feel for the job. Then do it with your eyes closed, and repeat it in darkness for as long as it takes to gain faultless familiarity. If necessary, buy an old outdated film to practise with, rather than risk ruining a film you have already exposed.

Processing the film

You can get a good print only if you have a good quality negative to start off with. In negative–positive work the nega-tive *is* the picture, and so it is especially important to see that nothing goes wrong during processing.

Failure to maintain a constant process temperature is one of the commonest

Preparing solutions

The main difference between 'one-shot' concentrate chemicals and those made up from powder form is that the latter are nearly always reusable.

The mixing procedure for making up powder solutions (right) starts with measuring off warm water that accounts for about two-thirds of the eventual volume of liquid. Powder is added to this, and stirred until fully dissolved, whereupon the stock solution is topped up to the full volume. The stock solution is then stored. If this is a reusable solution already at working strength dilution (and correct temperature) it can be poured straight into the tank for use, and back again afterwards.

By comparison, the mixing procedure for liquid concentrates (below) is based purely on demand: the required amount of concentrate is measured off accurately and water of about the correct processing temperature added to make up the correct amount of working strength solution. This can be brought to the correct temperature, used, and then discarded.

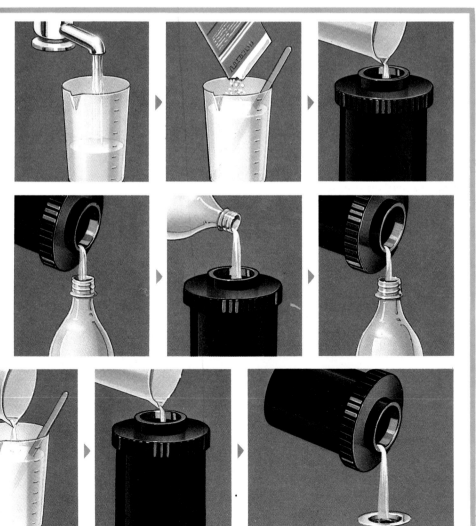

Processing a black and white film

1. *Start any processing sequence by first loading the film. Then mix the process chemicals. Bring these all to the same temperature by using a water bath. The normal temperature for b & w is standardized at 20°C/68°F*

2. *Check the developer temperature just before beginning the process. Use a funnel to pour it quickly into the tank, holding the tank at a slight angle (increase this to 45° if a funnel is not used). Start timing the development*

3. *When all the developer has been poured in to the tank, fit the cap and then tap the base sharply on the work top. This dislodges air bubbles which may have formed on the film surface and so helps prevent uneven development*

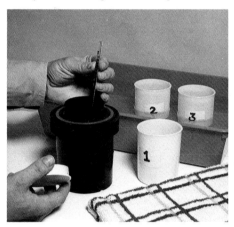

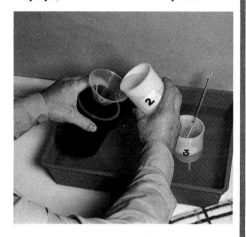

4. *Straight away up-end the tank two or three times. This inversion agitation is repeated once every half minute for the remaining development time. Tap the tank base afterwards. Standardize your agitation procedure to ensure development consistency*

5. *A minute or so into development remove the cap and check the actual working temperature of the developer (it can be affected by a tank which is unduly hot or cold). Make adjustments to development time for other temperatures*

6. *At the end of development, pour away the used developer and replace this with the water rinse. Although this step is optional, it helps arrest development and also lessens the degree of fixer exhaustion. Agitate the tank continually for one minute and discard the rinse*

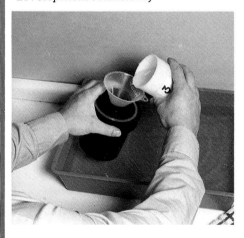

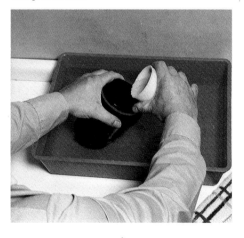

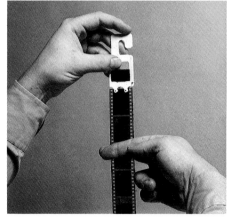

7. *Pour in the fixer solution, replace the cap and agitate for the first minute of the fixing period. Make sure you never use over-worked fixer. At the end of the fixing period (which depends on the type of fixer used) pour it off*

8. *Wash the film thoroughly for half an hour. If you are working away from running water, start the wash using water from the water bath. This can also be used to precede washing under a cold running tap*

9. *Hang the film to dry in a warm and dust-free place. You can use special film clips or improvise—but keep the film taut. Wipe away excessive surface moisture with your fingers, dampened slightly beforehand, as shown*

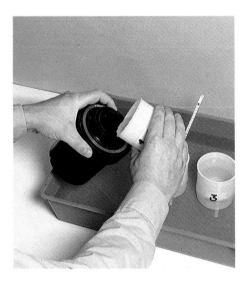

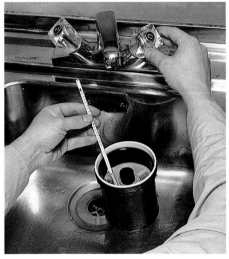

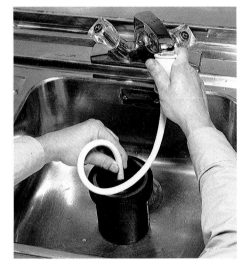

Timing is important *Development continues for just as long as the solution remains active in the tank, so time the pouring stage and include this in the total process time especially when this is brief*

Temperature drops *Avoid sudden temperature changes, especially by going straight to a cold wash, as this stresses the emulsion, so causing 'crazy paving' cracks (a fault called reticulation)*

Washing efficiency *You can use a hose arrangement to increase the flow rate of water over the whole film area, thus improving wash efficiency and reducing the time washing is necessary*

reasons for poor quality negatives. For most b & w work, the process temperature is 20°C (68°F), and if the room temperature matches this, there is normally no need to bother with temperature control techniques.

If, however, the room temperature is significantly different, the easiest remedy is to place all the solution containers in a bowl or sink of water at the correct temperature. Do this several minutes before processing begins to allow the solutions time enough to warm up (they must always be stored in fairly cool conditions), adding a little hot or cold water to the bowl or sink as necessary.

It is particularly important to avoid sudden variations from one solution and the next, so include all solutions in the water bath—including a quantity of rinse-water to start the washing phase.

Always pour developer into the loaded tank as quickly as possible, but without causing undue turbulence. Hold the tank at an angle of about 45° and guide the stream of liquid into the baffle

arrangement of the lid.

As soon as the tank is filled, level it and tap the base quite firmly against the work top to dislodge any air bubbles that may have become trapped on the film or within the spiral and tank. Push the lid on firmly, immediately invert the tank two or three times, and then tap the base again. Do this every time you pour a solution into the tank.

Invert the tank once or twice every half minute (or as recommended) to provide sufficient agitation. Standardize the amount and method of agitation to ensure development consistency. Check the temperature of the solution a minute or so into development and make any necessary adjustments to development time when you have consulted the developer instructions.

Remember that development continues until ended by a water rinse or, if this is not used, by the fixer itself. Begin emptying the developer 15 to 20 seconds before the end of the development time if development times are so short that this

precision is needed. A long development time has its drawbacks too—correct agitation technique is particularly important, and temperature control assumes a new significance.

When the developer is out, pour in the intermediate rinse water straight away. It is important to agitate the film thoroughly for a minute before discarding the rinse in favour of fixer.

You can of course jump straight to the fixing stage but developer carry-over tends to exhaust the fixer bath more rapidly—and, unless your technique is tip-top, with certain types of film and developer there is a risk of chemical fog or staining.

The use of a *stop bath* instantly arrests development and, by neutralizing the alkalinity of the developer, helps prolong the activity of the fixer bath which immediately follows. You use stop bath in exactly the same way as a water rinse: one minute with continual agitation. You can make up your own from a 3% solution of glacial acetic acid or buy ready-

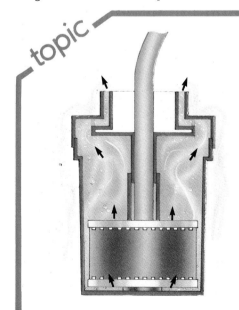

topic

Fixing does not simply prevent film from going black in the light. The problem is that unexposed, undeveloped silver halide —the light sensitive ingredient of film— normally does not dissolve in water. The fixer's job is to turn it into a compound that will do so. Having done this, it is necessary to wash away all traces of the compound so that there is no risk of further action taking place. A badly fixed film (or print) runs the risk of turning yellow after a while, with the image eventually bleaching away.

The washing time is affected by several different factors. Washing efficiency depends on the rate of change of water which comes into contact with the emulsion layer, and the best method is to use a hose attachment to force water into the base of the tank so the overspill carries away the waste. The whole film is washed in this way. If you do not have a hose attachment (and not all tanks can be fitted with one) leave the opened tank in a sink beneath a running tap but make a point of turning the

spiral over during the course of washing.

Alternatively, remove the spiral from its tank and adjust the flow of tap water to the discharge rate of the overflow of the sink. Be particularly careful to see that the film remains on its spiral for the duration of the wash by taping down the end or encircling the spiral with an elastic band. A loose film can easily be damaged by a plug chain, and there is always a danger that it could enter and block the overflow pipework.

If you cannot provide a running water wash use ten or more individual baths over a corresponding time agitating the spiral and film forcibly in each.

Increase the period of wash slightly if you live in an area which has a particularly 'soft' water supply as there is a good chance it may be slightly more acid than normal. Wash efficiency is better where water is 'hard' and alkaline, as this more quickly neutralizes the acid nature of the fixing baths in use today.

Wetting agent *After washing, add a few drops of wetting agent (not detergent) to the final rinse water. This helps the film to dry evenly*

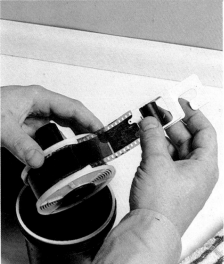

Avoid damage *Attach film clips for drying the film as you remove film from its spiral. An unwound 36-exposure film is about 1.5 m long—and easily damaged*

Use wetting agent at the end of the wash to encourage even drying and to discourage the formation of scum marks. Add 1 ml of wetting agent to each 200 ml of the final rinse. You can do this more easily by diluting your bottle of wetting agent with nine parts of water and adding 10 ml of this to each 200 ml.

Do not use washing-up liquid instead of wetting agent—it is too concentrated and often contains additives which leave smears on the film after drying. Even if these are easily removed by wiping, it does mean more handling of the film so increasing the risk of scratches.

At the end of the final rinse, shake the spiral to get rid of excess liquid then remove the film and hang it up to dry in a dust-free place, using a weighted clip or clothes peg at the bottom to keep the film taut at all times.

Ideally, leave the film to dry overnight in such a place as the bathroom when there should be little domestic traffic. If you are worried about dust—and remember the film is particularly susceptible to dust at this stage—run the shower, if you have one, for a few minutes beforehand. Do not smoke as ash is particularly harmful.

If you have used wetting agent, there is no need to use a squeegee, or for that matter your fingers, to wipe down the film. The latter method is to be preferred as minute grit particles can become trapped in the rubber blades of a squeegee, and cause very severe tramline scratches unless the blades are carefully cleaned.

When the film is dry, cut it into strips and put these away safely. The best means of storage is in purpose-made sleeves or envelopes. Mail envelopes are suitable only for temporary storage.

In summary, consistent negative quality depends on consistent and clean working methods. Establish a system of working and stick with it. Use the same combination of film and developer, and get to know what you can do and what can be done with this combination.

prepared concentrate which needs considerable dilution. The commercial product is likely to contain an indicator chemical which changes colour when the stop bath is nearing exhaustion. Always mix stop bath in a well-ventilated room.

Pour in the fixer and agitate the tank continuously for half a minute, and subsequently invert the tank two or three times each half minute. If the film is still slightly milky in appearance at the end of the claimed fixing time, replace the spiral in the tank and continue fixing for no more than, say, twice the claimed fixing period. Better still, discard what is obviously well-exhausted fixer and prepare a fresh batch for immediate use.

Wash and dry

Washing is an important part of any process as it removes potentially harmful salts and by-products which can greatly affect the permanence of an image. Washing time depends on the type of fixer used—a *hardening fixer* requires at least half an hour under conditions that provide for a continual change of water, while *non-hardening fixer* needs about half that.

If you do not have access to running water and a sink with an overflow, use ten or so separate changes of water over the same duration and vigorously shake the spiral during each.

If you cannot resist the temptation to peek at your film after fixing, make sure it is reloaded properly before washing commences—a sink plug chain can do irreparable damage to the film emulsion, which is particularly delicate at this stage of the operation.

The temperature of the washing water is also important. If the water is at 15°C instead of at about 20°C, increase the washing time by at least 50 per cent. If washing times do present a problem, consider using a hypo clearing agent solution manufactured specifically for this task—but follow the instructions on use carefully. A brief wash follows.

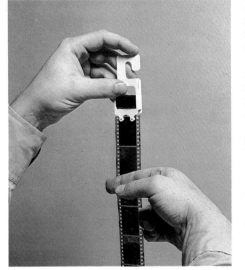

Finger wipe *If water does form streams and droplets when you hang the film up to dry, dampen your fingers and wipe down the film to remove the excess*

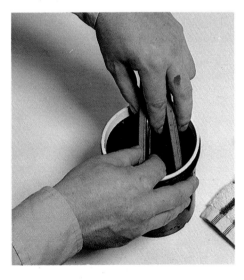

Prevent scratches *Rubber-bladed wipers can be used to remove almost all surface moisture but you must inspect and clean the blade each time before use*

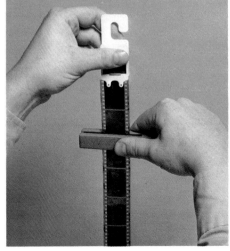

Wipe down *Always start at the top of a film and restrict the wipe to a single, continuous stroke for the whole length of the film*

23

Matching film and developer

Some photographers prefer to use a single type of universal developer for all black and white processing, rather than varying the developers to suit the film. This is certainly a cheaper and simpler approach and normally gives satisfactory results. However, by using a particular developer for a particular film you can often improve the quality of your negatives or alter the characteristics of the film to produce a desired effect.

Although modern 'standard' developers produce remarkably good results over a wide range of films, essentially they produce a compromise. No single developer can give the finest possible grain, the sharpest looking negatives, ideal contrast and any desired film speed change on every film. Nonetheless, a standard developer maintains a good balance between all these characteristics and is simple to use. But there are times when you may want to emphasize or play down one characteristic, and for this you need to buy a special purpose developer.

It is important to remember that the performance of any developer depends to a considerable extent on the way you use it. If you want to make the most of these solutions, then, it is essential to keep your processing technique consistent; so that you can make positive changes from your routine to achieve specific effects. In particular, there are four facts that can influence the way a developer acts: the duration of development; the temperature of the developer; the way you agitate the film during development; and the life of the developer if you are using a reusable developing solution. With these factors constant for your standard developer, you can judge precisely the effect of special developers.

Most black and white film developers consist of either three or four main components dissolved in water. These are: developing (or *reducing*) agents which reduce the exposed halides of the film emulsion to metallic silver; an *accelerator* to provide the alkaline environment in which most developing agents work best; a *preservative* to prevent the developing agents from oxidizing and becoming inactive; and, sometimes, a *restrainer* to ensure that the developer acts only on exposed grains and thus prevents a fog from building up.

By using different chemicals or combinations of chemicals for each of these components, manufacturers can produce the precise qualities they want in a

A problem shot *With a difficult negative, top quality is only possible if you are thoroughly familiar with the capabilities of your chosen film and developer combination—here, a fast film and a speed increasing developer*

developer. Some developing agents, for instance, are very soft working and are ideal for high contrast subjects with plenty of fine detail. Others have a more vigorous action and can be used to accentuate contrast or to increase film speed.

Special purpose developers fall into three main categories according to the film characteristic they bring out. They are: *fine grain developers; high acutance developers* for sharp looking negatives: and *speed-increasing developers.* Changes in the contrast range are also possible, but few special high or low contrast developers are available. You can make up your own if you want, but the changes are usually effected by altering the way you use a normal developer.

Fine grain developers
Graininess is rarely desirable in a negative and, for many photographers, a good developer should above all keep grain to a minimum, particularly with

35 mm film. As a result, standard developers are usually fine grain developers.

Fine grain developers do not, of course, actually reduce grain size—you can, in any case, only see individual grains under a powerful microscope. Instead, they work softly and only partially develop the image so that there is a minimum of visible *clumping* of grains of silver. Unfortunately, the restricted development means that some fine grain developers cause some loss in effective film speed.

Among the better known fine grain developers are Kodak D76 and Ilford ID-11. These have proved so successful that they are now regarded as standard developers. They are commonly available and are very easy to use with a wide range of films without any loss in effective film speed.

The formula for both ID-11 and D-76 contains the developing agents metol and hydroquinone, which work better together than they do separately. Many

developers (known as MQ developers) contain metol and hydroquinone but, unlike other MQ developers, D-76 and ID-11 contain a low alkalinity accelerator, borax. A highly alkaline environment is needed to promote development, so the use of a low alkalinity accelerator gives a reduced rate of development. These developers are therefore soft working and give reduced clumping. The result is a fine grain negative.

Paterson Aculux is another easily used developer that gives fine grain results without any loss of film speed. In fact, Aculux produces an effective increase of about one third of a stop. Two particular advantages of this developer are the excellent range of tones it gives, especi-ally with slow and medium speed films, and its effect in minimizing the grain of fast films.

When you want really fine grain results for very large prints, revealing texture and detail, you should be prepared to use an extra fine grain developer. This will cause some loss in film speed, however. Perceptol, for instance, may bring FP4 down to ISO 64/19 from its normal ISO 125—a loss of one complete exposure stop. If you want to use an extra fine grain developer, therefore, you must remember to allow for this loss of speed when exposing the film. Providing there is plenty of light on the subject, this should not prove difficult.

Whether you are shooting on slow, medium or fast film, extra fine grain developers like Perceptol give remark-ably grain-free negatives. Of course, for the highest quality results you should use a slow, fine grain film and a good lens, but extra fine grain developers can coax fine grain results even out of fast emulsion, while maintaining a full tonal range.

High acutance
Modern fine grain films are capable of considerable enlargement without detail in the image 'breaking up', and modern camera lenses are capable of resolving extremely fine detail. Nevertheless, there are occasions when you may want

Standard combinations

Standard combinations use commonly available developers and film, and there is good reason why these remain popu-lar. The films are established favourites because each is arguably the best in its speed range. The matching developer in each case is Ilford ID-11 or its exact equivalent, Kodak D76. These make the best all round use of the characteristics of the films. There is the additional advantage that considerable leeway is possible in processing. Other 'standard' developers include May & Baker 320, Paterson FX-18 and Agfa Final, all of which are made up from powder form. Those in liquid concentrate form include Paterson Aculux and Unitol

Market day *for general purposes Ilford FP4 + ID-11 is a difficult combination to beat. Normally used in the form of a reusable stock solution, good results are also possible by diluting fresh stock and using this once before discarding*

Potter *If you have to photograph under poor lighting conditions, your standard combination ought to include a fast film such as Tri-X*

In the wood *For really fine grain and sharpness, you can simply change to a slow speed film such as Panatomic-X and keep using a standard developer such as ID-11 for a crisp grain pattern with no speed loss*

Combinations for maximum sharpness

Covered market *The impression of sharpness conveyed by FP4 + Acuspecial is achieved by the 'adjacency effect' which emphasizes the boundary between light and dark detail—shown clearly in the blow-up above*

A slow or medium speed film is essential if you want really sharp, almost grain-free results. Where fine grain is of paramount importance, use a special developer which inhibits the clumping of silver grains within the image. True fine-grain developers are essentially soft working. This sometimes means a slight loss in effective film speed. Although most standard developers give fine grain, better results are obtained from developers such as Kodak Microdol-X, Agfa Atomal, Tetenal Ultrafin and Ilford Perceptol. An essential part of the combination is the film: consider using a slower than normal film in conjunction with one of these developers.

Acutance developers may also be used as they increase the apparent sharpness of an image. Some developers, such as Paterson Acuspecial have marked acutance properties. Others, including Paterson Acutol, Neofin Blue and Red, Definol and Agfa Rodinal offer characteristics between this and standard developers

Scrapyard *A stunningly sharp print from the sort of negative you could expect from a combination such as Panatomic-X + Paterson Acutol*

the picture to look exceptionally sharp. Shots of machinery, for instance, may need to be pin sharp to retain their impact. In this case, it is worth using a high definition/acutance developer.

Modern high definition developers retain detail by concentrating development near the surface of the emulsion to ensure that clumps of grains are kept as distinct as possible and do not merge vaguely into each other. This is usually achieved by using a highly active developing agent and a high alkaline accelerator.

High acutance developers also help to create an illusion of sharpness by emphasizing edges in the image. In the past, this was achieved by using a very dilute solution and minimum agitation. This caused a localized exhaustion of the developer wherever dark and light met, giving an impression of sharpness but resulting in a scompressed range of tones. With modern high acutance developers, however, boundaries between dark and light are emphasized chemically to give a very sharp looking picture with little tonal compression.

Many modern film developers have some high acutance properties but special high acutance developers will produce particularly high definition. These developers work well with slow and medium speed films up to about ISO 200. There is little point in using them with fast films because the extra grain more than offsets the extra edge definition. With slower films, however, the overall look of sharpness achieved means that you only notice the increased grain at the major tonal boundaries by peering very closely.

Two bath developers

Many developers have a 'compensating' action which can handle excessive subject contrast quite well. Two-bath developers offer this as a principal characteristic and also have other equally appealing 'extras'. As the name suggests, these consist of a two-part solution, and the film is developed in two stages, spending part of the overall development time in each solution. Most of these solutions are reusable and last indefinitely without losing their strength. Some, like Baumann Diafine, offer the enormous speed increase of three stops.

Increasing speed

If a film has been inadvertently under-exposed, or it was knowingly under-exposed because of poor lighting conditions, there are several methods for salvaging the shots. These include slightly extending the developing time, changing to a different type of developer, increasing time and temperature, or any combination of all of these.

While various developers give an effective increase in film speed by increasing the development (push processing), you cannot increase the developing time and temperature without increasing contrast and overall density as well. With greatly extended development, contrast may become unmanageable. Special speed increasing developers are designed to make the fullest use of the exposed grains in the shadow areas of the image without producing excessive contrast, although some increase is inevitable.

Some developers, not designed specifically to increase film speed, give an extra half to one f/stop increase because of their chemical make-up.

Paterson Acuspecial is one such developer. Used in combination with a slow or medium speed film it gives an effective increase of half an f-stop, combined with enhanced image edge definition and fine grain.

On the other hand, Paterson Acuspeed has been formulated for raising film speed. Acuspeed gives an effective speed of ISO 1250 with ISO 400 films such as Ilford HP5 and Kodak Tri-X. The resulting negative has slightly more grain, but is still fairly sharp.

Another speed-increasing developer is Ilford Microphen. When it is used with Ilford HP5, for example, effective speeds of ISO 1600 or even ISO 3200 can be achieved by extending the developing time. This developer has excellent keeping properties and may be diluted 1:3 when maximum image sharpness is required.

Getting the most out of your film

Some speed-increasing developers are designed to extract every last bit of speed from an emulsion. They are 'energetic' in action and tend to produce images with comparatively high contrast, so they should not be used in combination with slow films. Sharpness, however, is often good. Other speed-increasing developers actually offer sharpness as a secondary characteristic, but their speed increase is not nearly so marked. Except for these, speed-increasing developers inevitably increase the graininess of an image, and in some cases promote an excessive level of fog unless care is taken during is better than a standard developer

Steam *For just a small speed increase in a situation where a fast film can be used close to its normal rating, try a combination such as Ilford HP5 + Ilford Microphen to retain quality. This yields a rating of ISO 650*

Portrait *If far more speed is required, try a combination such as Tri-X + Paterson Acuspeed. This gives a rating of ISO 1250—a useful figure for available light photography. Use a stop bath between developer and fixer to prevent fog*

Dancers *Where you are confronted with unpredictable and very low lighting conditions, try a combination such as Tri-X + Baumann Diafine—a two-bath developer which offers great speed increase (ISO 3200) and good quality*

Push processing

The problem is a common one: you look through the viewfinder of your camera and find that, even with your lens aperture wide open, you cannot set a shutter speed fast enough for a hand-held photograph. There simply is not enough light.

There are many solutions to the problem, most of which call for extra equipment and have attendant disadvantages. You can add extra light with a flashgun—and quite possibly destroy the visual mood that you want to capture. You can fit a faster lens—if you can afford one. You can put your camera on a tripod—and hope that your subject holds still. Or you can use a faster film—if you are not already using the fastest film you can find.

This last course is probably the best since it calls for no extra bulky equipment, yet leaves you mobile and relatively inconspicuous. For this reason, ISO 400/27° black and white film is regarded as standard by most press photographers and others who want to take pictures in poor or unpredictable lighting.

But when the light is too dim even for ISO 400 film, there is still one more thing that can be done: you can increase the ASA number of the film and compensate later by changing the development you give the film.

Pushing

When film is given different development to increase its effective speed this is known as *push processing* or, more simply, *pushing*. Like other methods of taking photographs in poor light, pushing has some disadvantages, but quite often these are outweighed by the benefits.

There is nothing sacred about film speed and ISO numbers. They are no more than indications of the sensitivity of films under certain standardized circumstances. The ISO numbers of black and white films are established by the makers who process test rolls in a standard developer and compare the results with a standard degree of development that has been found to give prints that are acceptable to most people. This system has certain disadvantages. In the first place, many people do not actually use the film

maker's recommended 'standard' developer for normal photography. And in the second place, the picture quality that others may find acceptable may not be quite what you want for your photographs. By taking advantage of the different types of developer that are available, and by carefully deciding at what level to 'peg' the quality of your photographs, you may find that you can expose your black and white films at ratings which are appreciably higher than the quoted ISO numbers.

Generally, however, pushing film has certain disadvantages. The very best image quality can be obtained only by using the slowest film possible, and this must be developed correctly after exposure. Faster films are generally grainier and less sharp than slow ones, and pushing only makes graininess worse. In theory, sharpness also suffers when film is pushed, but in practice you may find that the higher shutter speeds

Way out landscape *For something just a little out of the ordinary, try push processing films used in full daylight*

Exposed at ISO 400

A complete length of Ilford HP5 film was exposed at a nominal rating of ISO 400 and sections of this were developed in different developers or for different times. Development time in ID-11 diluted 1+1 is normally 12 minutes. But for this shot, 18 minutes proved better. The neg (top) has more contrast than with normal development. The densest negative (Paterson Acuspeed, lower) is acceptable

12 ⟶ 12A 1

37 ⟶ 37A

Exposed at ISO 1600

Another roll of HP5 was exposed at ISO 1600 and sections of this were processed in ordinary and speed increasing developers. The most satisfactory print was obtained from film developed in Baumann Diafine (top) although comparable quality was obtained by using Paterson Acuspeed. About the only really unprintable negative (lower) came from film which received the ordinary 12 minute ID-11 (1 + 1) development

33 ⟶ 33A

Exposed at ISO 6400

This is a really testing lighting situation where available light photography poses immense difficulties. HP5 was exposed at a nominal rating of ISO 6400. Baumann Acufine yielded by far the best negative (top) in the printing used for these tests. Images from Paterson Acuspeed (normal time) and diluted ID-11 push processed for 24 minutes could be of some use, but negatives are very thin and require careful printing

33 ⟶ 33A 3

6 ⟶ 6A

XP1 and HP5 compared

XP1 exposed at ISO 400

HP5 processed in ID-11 for 12 mins.

XP1 exposed at ISO 1600

HP5 processed in ID-11 for 24 mins.

XP1 exposed at ISO 6400

HP5 processed in Acuspeed

To compare the performance of Ilford XP1 and pushed HP5, we took these three pairs of pictures. For each pair, both films were given the same exposure, but

while the process time for the HP5 was extended to suit the rate at which it was exposed, all the XP1 was given the standard ISO 1600 time. At ISO 400, XP1

gives good contrast but 'mushy' grain; at ISO 1600, it gives slightly better highlight detail than HP5; at ISO 6400, however— in very low light—XP1 is much weaker

and smaller apertures obtained with uprated film enables you to take pictures which appear to be sharper. But one significant disadvantage of pushing is that shadow detail is reduced. This gives pictures with flat areas of empty dark tone where, in the original you may have been able to see detail.

Extended development
The easiest way to extract more speed from black and white film is simply to develop it for longer. Although this has the effect of increasing the image contrast of the negatives, it does not normally pose too many difficulties at the printing stage, providing you avoid very long development times. When printing an underexposed but normally developed negative, most photographers encounter two problems. First, the negative is very thin, and calls for very short printing exposures. Second, it is usually difficult to make the deepest shadows print as rich blacks without affecting the balance of the important mid tones in the picture. A remedy is to print on a harder than normal grade of paper. This can be expensive if you have to buy a box of paper for just a film or two— and there is always the possibility that a hard enough grade for your needs does not exist, or is not readily available. But increasing negative contrast by extending development times enables you to print underexposed negatives with good dark tones on normal grades of paper.

Increased development also means much greater graininess, loss of high-light detail due to higher contrast, and a third problem—raised fog level. Just

because a pushed negative looks as if it has about the same overall density as a normally exposed and developed negative, this does not mean that it actually has as much printable photographic information recorded on it. When film is left in developer long enough, even the unexposed silver halides in the film emulsion begin to be developed. This produces what is called *development fog* in the shadow areas.

Fog can mislead you into thinking that you have recorded more detail than is the case, as well as being bad for your pictures. The main problem with pushing film is preserving the separation of tones corresponding to the shadow detail of the object. Lengthy development can cause such an increase in the fog level that the fog literally swamps the slight tonal separations that you are most anxious to keep. But as long as the development is not pushed too much, the gain in contrast will more than offset the fog effect, and details will be visible in the shadow areas.

So development time cannot be extended indefinitely to give higher film speeds. However, extended development is a simple, easy technique and is worth using when you only need a moderate increase in speed. The degree of extra development needed depends on the film and developer you customarily use, but as a guide, if you double your film speed you need to give 50 per cent extra development. Thus a ISO 400 film that normally requires eight minutes development should be given 12 minutes development if it is exposed at a rating of ISO 800.

Special developers
If you often have the need to rate your film at higher than its specified ASA rating, then you should investigate the potential of specially made speed increasing developers. These are usually compensating type developers which work less strongly on the fully exposed highlights of the negative than on the shadow areas. This means that they give shadows a lift while leaving highlights less affected. Because of this, compensating developers are useful when you are photographing subjects that are lit by dim but contrasty lighting. Not only do they improve shadow detail, they also retain the separation of highlight tones that are easily lost when pushing development in a normal developer.

Many developers are available that claim to produce an increase in film speed. Acuspeed, Diafine, Emofin, Microphen and many others all have their supporters. Most are used in much the same way as normal developers which provide little or no speed increase, but some—such as Diafine and Emofin—are particularly interesting since they are two-bath developers offering very high film speed ratings.

In these, the components of the developer are divided into two solutions. The first solution contains a slow working developing agent. The second solution contains an alkali.

When film is soaked in the first solution, very little happens. After the film has had long enough to absorb sufficient developing agent into the emulsion, the first solution is poured out of the developing tank and the second

solution is poured in. The activator immediately makes the developing agent start to work.

The first solution is formulated in such a way that the concentration of developing agent soaked into the emulsion is just sufficient to develop the negative highlights. So when the activator comes into contact with the film, the developer in the highlights—the dense, fully exposed parts of the image of a negative—is quickly exhausted whereas development continues in the shadow areas. The result is a considerable boost in the effective film speed and a reduction in contrast.

In addition, two-bath developers are particularly easy to use since the degree of development they give to film is governed primarily by the concentration of the first solution rather than by time or temperature. As long as the temperature and time are approximately correct, the film will be properly developed.

Chromogenic films
Although very high speed films have been available for some time, these have in the past been very grainy conventional type films such as Kodak 2475 Recording film and Kodak Royal-X. These can be processed in much the same way as ordinary high speed films.

Lately, however, the new chromogenic films such as Ilford XP1 and Agfa Vario-XL have become popular with photographers seeking more speed. Their manufacturers claim that these films give satisfactory results at any speed rating from ISO 125 to 1600.

With such a considerable reserve of speed, there is little point in push processing the film, and Agfa give no recommendations for pushing Vario-XL. Ilford, on the other hand, do give

extended processing recommendations for use when their XP1 film has been exposed at ISO 800 or ISO 1600. At its standard processing temperature of 38°C, XP1 should be developed for 6½ minutes at ISO 800 or for 9 minutes at ISO 1600.

This has advantages, since it enables an image to be produced that can be more easily printed, but it is not without its disadvantages. XP1 is designed to give optimum results at ISO 400, at which speed it behaves like a very sharp, fine grain film with unusually high speed. The emphasis of XP1 is on image quality rather than speed, and pushing this film tends to defeat its designed purpose. For this reason, Ilford suggest that for maximum speed you should use their conventional HP5 film developed in Microphen.

There is no recommended method for pushing Vario-XL. However, if you wish to experiment with increased development of this film, try giving a five minute development time instead of the recommended 3½ minute time in C41 chemicals. This should give about a one stop increase in film speed.

Making your own tests
If you intend to do a great deal of low light photography, it will be worthwhile making a series of tests to establish an accurate set of times for push processing, even if so-called speed increasing developers are used. These tests are straightforward, but you must take all the usual precautions to make sure that the processing conditions remain identical if results are always going to hold true.

The tests involve photographing the same subject at a range of exposures corresponding to different film speeds. This is done on several strips of film,

which are then push processed at different times.

Choose an even-toned subject such as a specially arranged still life or test target, and make exposures corresponding to a range of different ISO values. For ISO 400 film, start with a ISO 200 exposure, and progressively double this on each subsequent exposure so a range of, say, up to ISO 6400 is covered. Take careful note of your sequence of exposures so a particular ISO rating can easily be traced after processing. The ideal way to do this is to include a note of the rated speed in each frame.

Your camera meter may not operate at the higher end of the ISO speeds range, but it is a simple matter to continue halving the exposure once the limit is reached.

Repeat the series of exposures several times so you have enough strips of film for testing a range of development times, but these have to be 'split'—in darkness—before processing. You should be able to get at least two tests on each film so you have enough strips for testing a range of development times.

If you are being really thorough, the range of times should start with the development time you use for the normal ISO 400 rating—you can use this test to check whether your equipment, technique and methods of photography match the 'normal' rating. A better quality image at other than the ISO 400 exposure would suggest otherwise.

You can then use the remaining strips to gauge the effects of increasing the development time beyond the normal. If the film or developer maker gives suggestions for push processing, use these as a basis for your own experiments. Otherwise, set yourself a range of increases—say, an extra 25 per cent, 50 per cent, 75 per cent, 100 per cent, and so on—and progressively work through these until it is clear that the resulting quality of the image is no longer of use to you.

The test sequence can be repeated for any other film and developer combination but there is little point trying to push process films slower than ISO 400 for anything other than a rescue operation of a whole film length known to be underexposed.

If speed-increasing developers are push processed much beyond their 'normal' development times, you risk a rapid build up in the fog level. Nevertheless, you may find it an interesting experiment to conduct a test sequence using these special developers. The range of effective ISO values could then be increased considerably beyond the ISO 6400 mark used for standard type developers, but you will notice a rapid fall off in quality before these levels are reached.

You can establish which is the most effective ISO rating for a particular development time effectively only by printing your images. The ISO value which yields the most satisfactory print image can be checked from your notes.

How grain size increases

Sections of × 12 prints from HP5 exposed at ISO 400 and developed thus:
1 ID-11 (1 × 1): 12 mins. **2** 18 mins.
3 24 mins.
4 Acuspeed.
5 Diafine.
6 XP1 processed for ISO 1600

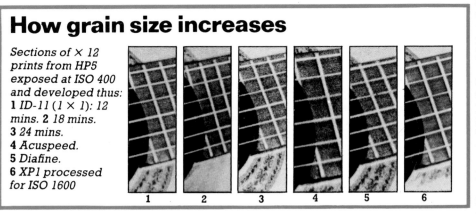

Fog level changes

Fog level goes up with film speed as well as grain size. HP5 has much less fog when processed normally (right) than when push processed (far right)

Chapter 3
PRINTING IN BLACK & WHITE
Basic printing

Black and white printing is an art that some people devote their lives to and a master printer is valued more highly by many photographers than almost anyone else. After all, it is the print that brings their work to life, and a good print can make or break a photograph. The quality of the print is especially crucial in black and white work.

The basic principles of b & w printing are outlined in the panels below and on page 36 but there is much more to quality printing than the basics.

Safelights

It may seem surprising that, although great care has to be taken to make sure that your chosen work place is properly dark, almost every form of b & w work may be done under fairly brightly lit conditions—but with lighting of a rather special nature.

Most b & w printing papers, and some film types used in darkroom work, are insensitive to light of certain specific wavelengths or colours. In other words, they may be handled in (and be exposed

to) light of a certain colour without being affected in any way. Such lighting is referred to as *safelight*.

For most general uses, including ordinary b & w printing, safelights of red, orange or yellow colouring are satisfactory. Normally only one safelight is necessary for a small, temporary darkroom. A safelight must be used a safe distance from sensitive materials, so make sure that you follow the manufacturer's recommendation.

You can test whether your safelights

Print exposure

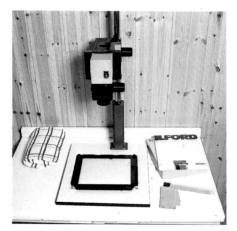

1 *Arrange a 'dry' work area which has room enough for the enlarger. A towel can be kept nearby—use this to keep your hands dry during enlarging stages*

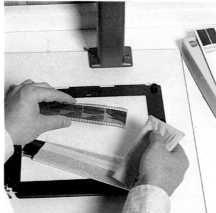

2 *Dust is a real problem in temporary darkrooms—especially if you have to black out using blanket material. Dust your negatives carefully*

3 *Turn on the safelight and switch off other lighting. Allow your eyes to adapt, and check for light leaks. Turn on the enlarger and adjust the image*

4 *When you are happy with the picture's composition, check the focus and close down the aperture by two stops to improve the image quality*

5 *Either swing the red filter beneath the lens or switch off the enlarger. Then place a sheet of printing paper on the enlarging easel*

6 *Make a trial exposure of 10 seconds by either swinging the red filter aside, if the enlarger is vibration-free, or switching on the enlarger lamp*

are really safe. Place a piece of printing paper on your enlarger baseboard with your safelight turned on and a piece of opaque card covering one half. Estimate how long it usually takes to remove a piece of paper from its box, make a printing exposure, develop and fix the print. Leave your test piece of paper on the enlarger baseboard for at least twice this time, then use it to make a print. If, when the print is processed you can see any difference at all between the half of the sheet that was covered with card and the half that was not, then lighting in your darkroom is not safe.

Getting started

Black and white printing is divided into two stages, exposure and processing, both of which can be performed under safelight. The basic procedure can be summarized as follows.

● To expose: load the chosen negative into the enlarger's negative carrier; adjust the enlarger controls to achieve the right composition, sharply focused; lay a fresh sheet of print paper on the easel; make the exposure established with a test print (see pages 40-43).

● To process: immerse the print in developer; transfer to stop bath; fix; wash; and dry.

Each of these stages is straightforward, but demands meticulous care. The rest of this chapter outlines the problems you may encounter and how you can solve them.

If you have any difficulty deciding which negative to print, make a set of contact prints from your film. Although the images, from 35 mm film, are still small, the positives are much easier to assess. Load your chosen negative into the negative carrier emulsion side (the dull side) down, preferably with the bottom of the picture towards the enlarger column. This is much easier to do with the carrier removed from the enlarger, since you can align the negative visually within its masking frame and inspect for dust and hairs. With 35 mm negatives, you can usually use a glassless negative carrier to reduce the chances of dust and Newton's rings spoiling the print (see page 15-16)—providing you do not leave enlarger switched on for any length of time; the heat from the light will make the negative 'pop' out of focus.

The next step is to wind the enlarger head up or down its column until the image is the right size. Set the masks on your easel slightly smaller than the size of your print paper (smaller to provide a rim to hold the paper in place) to mark out the boundaries of the image. No print paper size perfectly matches the 35 mm format exactly, so you will find the image must be cropped, or some of the paper wasted—it can be trimmed after processing. With the image roughly the right size, focus it carefully, with the lens at maximum aperture. Readjust the head to correct the composition and re-check the focus. Stop down the lens to f/8 or less for maximum sharpness and make your exposure.

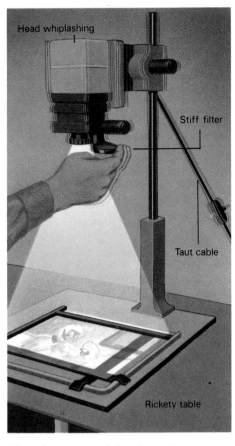
Head whiplashing
Stiff filter
Taut cable
Rickety table

How to prevent dust spots

The most annoying detraction from the quality of your black and white prints is dust. If your prints have a good range of tones and a clear, sharp image, viewers tend to 'look through' your prints and concentrate their attention on the subject you have photographed. A sprinkling of tiny white dust stops and hairs over the image automatically reminds your viewers that they are looking at just a piece of paper with a picture on it. You can retouch dust spots on your prints but it is much better to eliminate the problem at its source.

Checklist
● Enlarger with lens
● Darkroom safelight
● Masking frame
● Set of three dishes
● Print forceps/rubber gloves
● Scissors
● Two towels
● Waste bin/tray
● Photographic thermometer
● A large water bath or special dishwarmer will be necessary if room temperature is much different from 20°C
● Print developer, fixer, stop bath
● Printing paper
● Measures and storage bottles
● Watch or timer with seconds hand

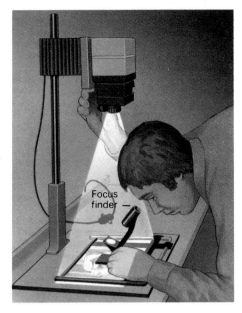
Focus finder

Sharp focus *If you have difficulty in focusing, a focus finder device may be just what you need*

Enlarger vibration *Take care not to encourage vibrations of the enlarger head during printing. Vibration or jogging causes loss of sharpness and multiple images*

Your darkroom must be really clean. Vacuum clean the darkroom and the enlarger regularly to prevent dust from accumulating. Keep a plastic dust cover over the enlarger when it is not in use. Your negatives should be stored in proper filing sheets or negative envelopes, handled only by their edges, and never left lying about.

Before you make a print, switch on your enlarger and hold the negative obliquely in the projected beam so that you can see if there are any specks of dust on the surface. If there are, flick them off with a soft, dry brush. Sometimes dust specks cling to negatives. If this happens, they can often be removed with the help of an *antistatic pistol.* Another useful accessory is a can of compressed air to blow away dust. Special blower brushes are also available, but the brushes on these tend to become dirty. It is better to use a separate brush washed occasionally with water and a little wetting agent, then rinsed and allowed to dry.

If your darkroom is a temporary set-up in a room that is used for another purpose, you can expect more problems with dust than would find in a permanent darkroom. Try to set your darkroom up in a room with a minimum of clutter, and preferably without carpets or thick upholstered furniture and curtains.

Sharpness

Your pictures can lose sharpness either at the taking stage, or when you come to print your negatives. Causes of unsharpness in the negative are usually the result of poor camera technique. To tell the difference between unsharpness caused in the camera and that caused at

Print processing

1 *Arrange a 'wet' work area that is separate from the 'dry' area. Mix suitable quantities of developer, stop bath and fixer at the correct temperature*

2 *When you have exposed the print, move to the wet area and immerse the print in the developer. Make sure that the whole print is soaked evenly*

3 *Drain the print at the end of the development time—one minute for resin-coated papers, longer for the old-type fibre-based papers*

4 *Transfer the print to the stop bath and agitate it continuously for a few seconds. If you use a water bath instead, rinse the print for a longer period*

5 *Now put the print in the fixer and keep agitating it for the first half minute, regardless of the type of fixer you are using*

6 *At the end of the fixing period—up to ten minutes with standard fixers, much less with active rapid types—drain off the print ready for washing*

the printing stage, examine the highlights and shadows of your print. In general, unsharpness in the camera will make the image highlights spread into middle and shadow tones. Unsharpness caused in enlarging looks more gloomy. The shadows are spread into the lighter tones, and the print usually looks greyer.

If your prints suffer from lack of sharpness, it may be that your enlarger vibrates. The columns of many less expensive enlargers do not hold the enlarger head steady enough especially when the head is taken to the top of the column for big enlargements.

To avoid this problem, try to touch the enlarger as little as possible when you make the printing exposure. Rather than beginning and ending exposures by swinging the red safety filter aside, block the beam of light by placing your hand between the lens and the paper. Then swing the safety filter aside, pause for a moment to allow vibrations to settle, and start the exposure by removing your hand without touching any part of the enlarger. You may find it easier to use a piece of opaque card to block the beam. If you use a conventional

on/off switch to give exposures, make sure the wire does not cause a 'whiplash' effect, especially when the enlarger head is raised for big enlargements.

A more convenient answer is to buy an enlarger timer and set this up far enough away from the enlarger to prevent any vibration from reaching the equipment during exposure. A timer also ensures better exposure consistency as well as leaving your hands free for other jobs such as dodging.

If your darkroom is near a busy road or a railway line, vibrations from passing traffic or trains can be transmitted through the foundations of your house to your enlarger. This can be a considerable problem. Printing at night when there is less traffic can help. Or you can set your enlarger up on a sturdy bench resting on small rubber feet to dampen out vibration. You may need to set up your darkroom in a part of the house that suffers less from transmitted vibration.

No matter how rigid your enlarger is, take precautions to avoid vibrations caused in its use—do not touch the enlarger or work bench during printing exposures, and do not move around the

darkroom unnecessarily if your floorboarding is at all suspect.

Another cause of overall unsharpness is poor focusing. It can be difficult with the unaided eye to focus the image projected by an enlarger. It is much better to use a focusing aid that lets you see a magnified image of the negative grain as you adjust the enlarger. These inexpensive devices are well worth including in your basic darkroom outfit.

Some enlargers incorporate optical focusing aids that work by projecting a line or coloured spot on the enlarger baseboard. These are not usually very reliable, and it is better to use a separate focusing aid. Other, usually more expensive, enlargers incorporate automatic focusing linkages that are intended to set the correct focus for a range of magnifications. These can work well, but if the linkage is old and worn they may automatically set the image slightly *out* of focus at all magnifications. Automatic focus enlargers only work properly with the lenses supplied, and they must also be adjusted to allow for the height of the masking frame you use to hold the printing paper.

Print processing

The actual number and type of processing stages involved in black and white printing does not differ greatly from those necessary for b & w film processing and it may be possible to use the same chemicals for both. But if you can afford to do so, buy a separate set of chemicals designed for print processing.

Processing stages begin by immersing the exposed print into a dish of developer. The print and solution is agitated continually for two minutes, during which time an image forms—development is monitored by inspection under suitable safelight conditions. The function of the developer is to render visible 'activated' silver bromide crystals contained in the emulsion of the printing paper, the principles being very similar to the exposure and processing of film.

At the end of development, the print is drained and briefly rinsed in water or a stop bath before passing on to the fixing bath where it remains, with occasional agitation, for up to ten minutes.

A long wash follows and, as with film, it is important not to skimp this if image permanence is required. After washing, the print can be wiped off, blotted and dried naturally. Drying can be forced using fan heaters or hot cupboards in certain instances (a treatment recommended in the case of some printing materials). Glossy-surfaced, paper-based printing materials can undergo a procedure termed *glazing* in order to obtain a really gloss finish.

Print handling

Prints must be put into the developer dish so that the whole of the print is covered by developer almost at once.

Always use tongs to handle prints during processing. Developer and stop bath can cause skin irritation, and you are much more likely to leave chemical stains on your prints if your fingers are contaminated with processing solutions than if you use tongs. Be careful, however, with resin coated (RC) papers—these have a more delicate emulsion than fibre based papers and may be scratched by carelessly used print tongs, fingernails, or even by scraping the print against the sides or base of a dish.

Agitate your prints properly when they are in the chemical trays, and follow the manufacturer's recommendations for minimum processing times. When you transfer prints from one dish to another, allow a few seconds for chemicals to drip from the print. Reducing the amount of chemical transferred from one dish to the next helps you to get the most from your chemicals.

Print tones

Developing negatives so that they match standard, normal contrast grade printing paper greatly reduces problems with print tonality. Assuming that your negatives are properly processed, you can make sure of getting the best from your printing paper by monitoring the processing carefully.

The correct way to immerse a print

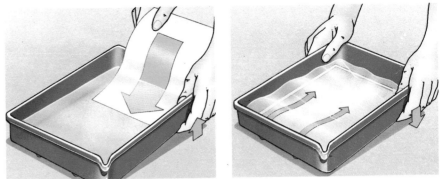

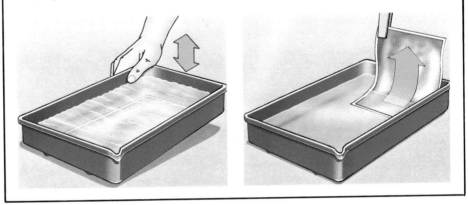

To ensure that the whole print surface is covered uniformly and quickly by the developer, raise the dish and slide the print, face upwards, into the shallow end. Immediately lower the dish so the resulting wave covers the print. Agitate the developer continuously by raising the dish corners in a random sequence

A preliminary test using two small pieces of printing paper can be helpful. Expose one piece to ordinary room lighting, so that it is completely fogged, then develop and fix in the normal way. Place the other piece in your fixing dish without exposing it at all. You now have two pieces of printing paper in your fixer, one as black as the maximum possible with your paper, the other as white as possible. When you fix your prints, compare them with the two pieces of paper: if the darkest tones in your prints are noticeably less black than the maximum possible, or if the palest print highlights are slightly grey, then there is something wrong with your print exposure or processing.

Less than fully black shadows are a sign of print underdevelopment or of printing a flatter than normal negative on too soft a grade of paper. If your print shadows still look grey after you have changed to the right paper grade, check that your developer is at the right temperature.

To make the most of its characteristics, printing paper *must* be developed for the full recommended time at the correct temperature. You cannot compensate for overexposed prints by snatching them from the developer dish before the shadows have developed to their full richness, and you cannot develop prints in solution that is too cold. If your darkroom is kept a degree or two warmer than the recommended chemical temperature, your developer is likely to stay warm enough. But if you prefer to work in a darkroom that is cooler than 22°C, you should consider buying a thermostatic dish warmer to heat your developer.

Grey highlights are usually caused by fogging. Safelight fogging is explained earlier in this chapter (page 37). There are

Processing stages	time
1 Development (using matched 'high speed' developer	
with RC paper)	1 minute
(using conventional print developer)	2 to 2½ minutes
2 Intermediate rinse or stop bath (optional)	Up to ½ minute
3 Fixing (using rapid action type)	½ to 2 minutes
(using conventional fixer bath)	2 to 10 minutes
4 Washing (RC paper; running water)	Up to 2 minutes
(conventional papers; running water)	At least 30 minutes*
5 Drying (RC paper; fan heating)	Several minutes
Otherwise, all papers	Several hours

Note: Although each print has to complete a minimum of four separate stages, this does not mean that just one print at a time is all that can be handled.
*Washing time can be substantially reduced by using a 'speed wash' agent.

other causes of print fogging, however; the commonest is poor paper handling. Do not leave boxes of paper open in the darkroom, even under the safelight. Boxes of printing paper usually have an opaque plastic or paper inner wrapper. Do not throw this away. Wrap up any unexposed paper and put it back in its box before you turn on normal room lighting. Alternatively, store your paper in specially designed paper-safes. These enable you to remove one sheet at a time while protecting the rest from light. These are available from photographic dealers. Another cause of highlight fogging is a developer that is too warm. Do not be tempted to try to compensate for cold chemicals by adding very hot water. Stay within the temperature limits recommended by the manufacturer.

Agitate your prints properly in the chemical dishes. With experience, you learn to tell whether your prints have been given approximately the correct exposure while they are in the developer. If the print is obviously much too dark or light, throw it away instead of wasting fixer solution on it. But do not be too hasty about assessing your prints while they are being processed. There are two factors that make it difficult to judge prints while they are wet.

To start with, prints usually look considerably darker and more contrasty under darkroom safelighting than under normal lighting. To estimate the degree of adjustment to printing exposure you need to give, inspect your prints in white light. Allow your eyes to re-adapt to the brighter light for a moment or two before you decide on exposure adjustments. Keep in mind the eventual conditions under which the print will be viewed when deciding on the correct print density. Prints intended to be viewed by ordinary room light may need to be lighter than those viewed under strong spotlighting.

The second factor that can affect the look of your prints is drying. Wet prints are usually a little darker than they are when dry. The difference is slight, and unless you want to make prints for display in exhibitions or galleries it can usually be ignored.

Stains and print washing
Staining or variations in image density are usually caused by poor processing. For example, a common cause of grey staining is underfixation combined with underagitation. On the other hand, extreme overfixation can lead to highlights being bleached out. Do not leave your prints in solution baths for less than the recommended time, but do not exceed these recommendations by more than a few minutes either.

Even if your prints are properly developed and fixed, staining can still occur if they are not washed properly. If you make your prints on RC paper, this is not a major problem. RC prints can be washed for as little as four minutes in running water at 20°C, and they air dry quickly if clipped to a line or placed in a

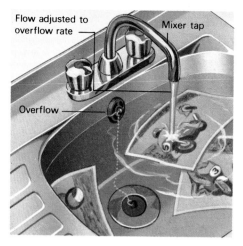

Washing in a sink *A simple, if risky, way to wash your prints, using running water adjusted to the overflow*

rack in a well ventilated room after excess water has been blotted or squeegeed off. An additional advantage of glossy finish RC paper is that it does not need to be glazed to dry to a shiny finish, although with some papers a better gloss can be obtained by heat drying using, for example, a fan heater. RC prints should not be washed at high temperatures or for too long. Too long a soaking can impair the finish and lead to seepage of water into the paper base at the edges of the sheet.

Fibre based papers need to be washed more carefully. Their absorbent base soaks up fixer, which causes print fading if it is not thoroughly removed by washing for at least 30 minutes. This time can be cut if you use a chemical washing aid or fixer clearing agent as an additional processing step before washing. A properly washed fibre based print is more stable and hence lasts longer than an RC print, so it is worth going to the extra trouble of making fibre based prints of photographs that are particularly important to you.

Whether you are printing on RC or fibre based paper, the main requirement for effective washing is a constantly changing flow of water to remove fixer and chemical by-products from the print. The simplest way to meet this requirement is to use a specially made print washer. The best of these devices ensure that each print is held separately from the others with water flowing over both sides.

Efficient washing systems using the cascade principle can also be set up, and a typical arrangement is shown. Water overflows from the top dish and into a lower one. Freshly fixed prints are placed in the lower dish and moved upwards at some midpoint during washing. The bottom dish is heavily contaminated with fixer, the top dish contains virtually clean water.

Most home printers wash their photographs in ordinary baths or sinks, but prints need more attention for good results. The sink should have an efficient overflow outlet so that the flow of water from the tap can be adjusted to

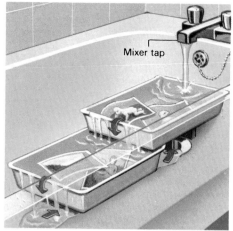

Cascade arrangement *Really efficient washing of a large number of prints is best done by using dishes in the bath*

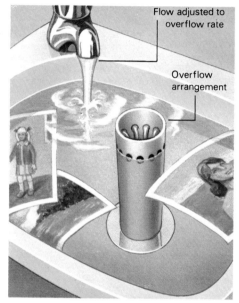

Improvised overflow *Plastic piping of suitable width can be cut and drilled to make a really safe plug overflow*

match the outflow. A rubber hose can be attached to the tap to ensure good circulation of water in the sink, but the prints should also be stirred periodically by hand to make sure that they are not sticking together or floating into corners of the sink away from the flow of fresh water.

The disadvantage of washing prints in a sink or bath is that fully washed prints are contaminated with fixer when more prints are added to the water. To be safe, time your print washing from the moment the last prints of a session's work are put in the water. And be especially careful to regulate incoming water with the overflow rate.

Drying prints
As already mentioned, RC papers are easy to dry. Apart from clipping them to lines or putting them on racks, RC prints can be left to dry face up on any clean level surface, dried in the hand with a hair dryer, or even squeegeed face out onto a smooth wall if the finish is water resistant. It is difficult to dry RC prints

badly—all these methods give flat un-marred prints quickly and with little fuss. Any problem with RC print drying is usually caused by excessive heat and trapped moisture.

Special professional RC print dryers are made that use radiant heat to dry glossy surface RC papers to a high glaze in seconds, but these are very expensive. Attempting to imitate the operation of these machines can lead to trouble. Too much heat applied to an RC print can melt the plastic coating.

You should never attempt to glaze glossy prints on RC paper by squeezing them onto a chromium plated or stainless steel glazing sheet. The water cannot escape through the impermeable base and if heat is used the resin coating is likely to melt and stick to the glazing surface. You can, however, use a glazer, either flat bed or rotary, for drying print material. Surplus water should be removed from the prints by blotting or squeegeeing and the prints should be placed with their backs in contact with the glazing or dryer surface with the fabric cloth of the dryer lightly in contact with the print emulsions. The temperature of the dryer must not exceed 90°C or the print will be damaged.

Heated dryers

A flat bed dryer and glazer is ideal for drying prints on fibre based papers and for other than a glossy surface the treatment is for RC material but there is less need to worry about the temperature.

Glossy surfaced fibre based papers do not give a deep glaze finish unless they are dried with the print surface squeegeed against a flat shiny sheet of metal or glass. Heated glazers use a sheet of plated metal or stainless steel. The wet print is squeegeed onto the sheet, which is then placed in the dryer. A cloth blanket holds the print and plate firmly together while a built in heater gently evaporates the moisture. Large professional dryers are also available that use a rotating plated drum to dry a con-

tinuous stream of prints by the same method. With either small or large heated dryers, it is easy to produce prints that do not have a high glaze. Simply put the prints in the dryer with the picture side facing the cloth blanket instead of the glazing plate.

A problem encountered when drying fibre based prints with heated dryers is that of print curl. Prints emerge from the dryer with a pronounced curl but are easily flattened enough to be mounted in an album or a picture frame when they have been allowed to cool. Most drying methods are likely to produce fibre based prints with a pronounced curl. The problem is inherent in the construction of the paper. Both print emulsion and paper base absorb moisture and swell slightly. But the amount of swelling is slightly different for each, leading to prints that are curled inwards towards the emulsion side. Prints that are hung to dry on lines or placed in racks are usually very curly and need to be flattened. One way to do this is to carefully draw the print over the edge of a table, taking care not to crease or crack the emulsion. If you use this method to flatten prints, make sure that your print is not so dry that the emulsion is brittle and easily cracked.

Air drying prints *An arrangement of plastic netting, battening, hooks and eyes used to make a drying hammock*

A simple way of drying prints that gives minimum curl is to air dry them gradually on screens made of plastic mesh. Suitable mesh is obtainable from gardening suppliers. The mesh can be stretched over frames or made into a hammock with battens at each end. The secret of preventing curl is to place the prints on the mesh *face down*. Surprisingly, the mesh leaves no marks on the surface of the print. Instead, the damp emulsion stays in contact with the mesh until the print is almost completely dry. Drying is finished when the print springs away by itself from the mesh with a slight curve. The adhesion of the wet emulsion to the mesh for some of the time prevents the curve becoming too great. An additional advantage of this method is that it is easy to keep the mesh screen clean. The cloth blankets used in heated dryers easily absorb fixer contamination from poorly washed prints and can pass it on to more thoroughly washed prints and cause staining on these. Plastic screen mesh only needs a quick rinse to be made clean enough for further use.

Drying racks *Using simple components, a handyman can easily construct a purpose made drying rack incorporating removable trays. Details on the right show the alternative runner constructions*

Making a test print

Only the most experienced of printers can produce top-quality enlargments by simply looking at a negative and guessing the treatment needed. Without learning the background skills, the newcomer faces hopeless odds in trying to make good first-time prints. The exercise is likely to be wasteful and expensive if tried—the most reliable way to success is to make *test prints* first.

The main purpose of a test print is to enable you to work out printing times for your negatives in a methodical manner. It is, in fact, another stage to go through before making the main print, but you do not need a new test print for each enlargement.

Test prints help you to decide on and check a number of other points also:

First of all, they can be used to check the sharpness of the actual image, the graininess of a print at any enlargement, and the presence or extent of negative damage. A quickly made test print can also be your first idea of what sort of print a negative will actually give, helping you to decide whether or not to proceed with a full scale enlargement.

Usually, however, a test print is used specifically to help you decide the correct printing exposure by showing the effects of different print exposure times. A variety of exposures can be made on a single piece of paper and

you select the appropriate exposure for your final print. An economy tip is to make your tests on strips cut from a large sheet of paper. This is why test prints are often referred to as *test strips*. You can also use these sets of different strips to determine a suitable choice of paper contrast grade, or even to compare the reproduction of tones from the negative between any two paper grades.

Another use of the test print is to assess the evenness of enlarger illumination, both to prevent printing faults (such as *hot spot* or *vignetting*), and to set up an enlarger properly by checking its stability at the chosen extension. Image sharpness may also be checked.

On each processed film, every frame may have been exposed differently and some negatives may be very dark (dense) while others are very light (thin). Each one needs slightly different exposure. Fortunately, you can divide them simply but carefully by eye into three broad groups—dense, normal, and light negatives. You can then make a single test strip for each group from a typical negative.

Effective tests

A great deal of print paper can be wasted by incorrect exposure, but mistakes can generally be rectified since you still have the negative and can try again. Waste can be expensive, however, and you should try to precisely duplicate the procedure you will adopt with the main print when you make the test strip. For example, make sure you give it exactly the correct development time.

As you will probably be making a test print just before the main print, there is usually no need to remove the negative from its carrier in the interim. So, before placing the negative in the carrier, ensure that both are free of dust and hairs. Check the test print for dust specks that may be on the negative.

Making a test print

With equipment and chemicals prepared and room lighting switched off in preference to safelighting, you are ready to make a test print. The procedure for making a test of five different exposure steps is as follows:

Switch on the enlarger and extend the enlarger column to give the desired image size. Focus and compose the image on a border masking easel frame. Set the lens at its maximum aperture to focus, since it is easier to see

Test accuracy
A test is only effective if the strip of print covers a representative area of the negative image. A test print of a landscape has to embrace sky, middle and foreground detail (as above). This one covers exposures of 5, 10, 15, 20 and 25 seconds. Horizontal strips (left) are useless

Test print sequence

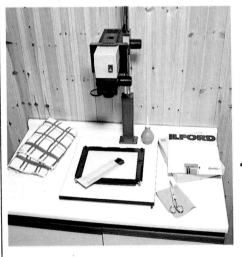

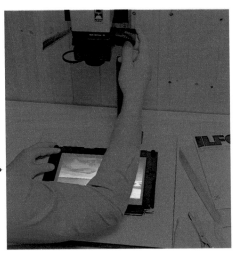

1 *Lay out your equipment in the 'dry' work area then prepare developer, rinse and fixer baths. Carefully select and clean your negative*

2 *Put the negative in its carrier and adjust the height of the enlarger head to give the required image size. Focus and compose the image at full aperture*

3 *Close down the lens by two settings of the aperture ring. Stopping down like this reduces small focus errors and improves image sharpness*

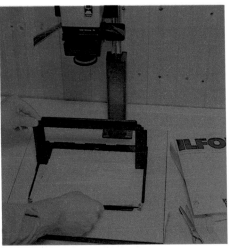

4 *With dry, uncontaminated hands, carefully remove a sheet of paper from the supply packet and place this in the masking frame. You may prefer strips to prevent wastage*

5 *To make a straightforward test, use an arithmetic time progression. Start by exposing the first segment for the chosen time unit (five seconds). Time each exposure accurately*

6 *If your enlarger is sturdy, you can use the red swing filter to end each exposure and to observe the uncovering of the print or use the on/off switch on the lamp lead*

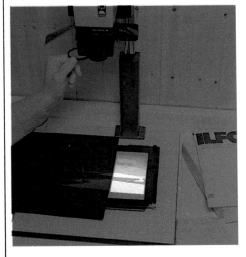

7 *Expose the next segment for the chosen time (another five seconds), and continue until each of the remaining three segments has been exposed*

8 *Fully immerse the print in the developer. Agitate the print properly and make sure it receives full development before rinsing and fixing it*

9 *After a minute or so in fixer, you can inspect the print in white light and determine accurately the best time for the main print (15 seconds here)*

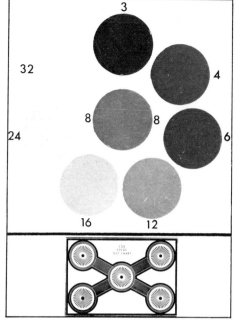

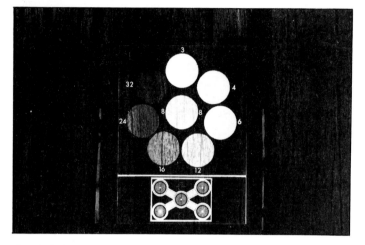

Easy method *You can buy prepared exposure test wedges. Place the test wedge (above right) on top of a piece of print paper so as to cover an even-toned part of the image. Then expose this test print for one minute (left) to determine the best time for the main print (above)*

the brighter image on the enlarger baseboard. Then switch off.

Stop the lens down to two settings less than its maximum (widest) aperture. This covers up small errors in focusing, and gives better sharpness across the width of the image. Check that the developer temperature is correct. It must remain constant—as close to 18°C/68°F as possible—while you make both test and final prints. If the temperature does vary, the test strip may not show the correct exposure properly.

When the enlarger is set up and the dishes of developer, rinse and fixer are in place, remove a sheet (or strip) of paper from its box or packet and place it in the masking frame or easel. Make sure the test print or strip covers a representative part of the image.

What is needed is to expose the paper in segments with a progressively increasing exposure. With experience, you will be able to judge the right range, but to start with try a range of 5 to 80 seconds—change this if it is obviously wrong.

Start by exposing the whole strip for 5 seconds. Then cover a fifth of it and expose the uncovered area for another 5 seconds. Cover a further fifth and give the remaining uncovered area 10 seconds exposure. Again, cover a

further fifth of the strip, but this time give 20 seconds exposure to the remaining area. Finally, cover a further section so four-fifths of the print is covered, and give an exposure of 40 seconds. Each segment will therefore have received twice the exposure of the previous one. Even under completely unfamiliar working conditions, a range of exposure times like this is almost certain to embrace the correct one.

When you have finished remove your test print from the enlarger easel, and push it into the developer. Once it is developed, fix the test print briefly and, with the box of paper safely sealed, turn on the light. If the test is satisfactory in at least one segment (where exposure seems 'correct'), you can use this as the basis of the exposure required for the main print. If not, repeat the test using different exposure time units—longer if the test segments are all too light; shorter if they are all too dark.

A well-judged test print should show some, often all, of the five separate exposure segments. One, perhaps two, of the exposure segments may closely match the density that you think is correct for the main print.

As a test print represents an exposure variation in even increments, over five segments in our example, it is not too

difficult to determine the length of the exposure given to each of them. For clarity, these were the exposures each segment received:

Total time for each segment (seconds)

Segments being exposed

	1	2	3	4	5	
First exposure (5sec; all uncovered):	5	5	5	5	5	
Second exposure (5sec; 1/5 covered):		5	10	10	10	10
Third exposure (10sec; 2/5 covered):		5	10	20	20	20
Fourth exposure (20sec; 3/5 covered):		5	10	20	40	40
Fifth exposure (40sec; 4/5 covered):		5	10	20	40	80

Following this example we obtain an exposure test strip of five steps ranging from 5 to 80 seconds. Suppose on inspection that it seems an 'ideal' exposure is between say 10 and 20 seconds: it is possible to be more precise? With a little experience it is possible to judge the exposure required if the 10 second segment is rather too light and the 20 second one a little too dark but, in case of doubt, a further test strip can be exposed covering a range of exposures between 10 and 20 seconds. This time the exposures can have the same time interval for each (*arithmetic progression*) and it is likely that three segments will be enough.

In such a case expose the whole test strip for 12 seconds, cover a third of it and give 3 seconds exposure and cover two-thirds and give another 3 seconds. The strip is tnus have been given 12, 15 and 18 seconds exposure and one of these is certain to be the right one.

If you are confused by the initial geometric progression test strip (the main benefit of which is to cover as large a range of times as possible), make one where the exposure steps follow an

arithmetic progression, but over a much broader range than that conducted for the precise times just outlined.

Select a time unit—five seconds is a good starting point for small size enlargements—and use this as the basis of an arithmetic progression.

When you make the test print or strip, uncover the first of, say, five segments and expose this for five seconds. Uncover another fifth of the print and expose this also for five seconds. Continue until each remaining segment has received an exposure of five seconds also. These are the exposures each segment received:

		Total time for each segment (seconds)			
Segment being exposed					
	1	*2*	*3*	*4*	*5*
First exposure (Segment 1 uncovered):	5	nil	nil	nil	nil
Second exposure (Segments 1 & 2 uncovered):	10	5	nil	nil	nil
Third exposure (Segments 1, 2, 3 uncovered):	15	10	5	nil	nil
Fourth exposure (Segments 1, 2, 3, 4 uncovered):	20	15	10	5	nil
Fifth exposure (All segments):	25	20	15	10	5

The test print therefore shows a range of 'coarse' times from 5 to 25 seconds, and one of the segments may be near to an ideal exposure if the time unit chosen is suitable for your negative. From this you can easily establish the more precise 'fine' times, over a much narrower band of exposures.

An occasional handicap of this more straightforward method is that, in certain instances, as the times increase, image density build-up becomes less and less obvious. This may reach a point where there is no perceptible difference in the density of, for example, a segment that has received a 20 second exposure, and one that has received 25.

With practical experience coarse time exposure test strips become unnecessary. Mental or written notes of coarse times applying to particular negative types and degrees of enlargement form the only necessary background to fine time tests. With further experience, there is often no need even to go to the lengths of a segment test. A guessed exposure time and a single test print exposure may be all that is required.

The easy method
The simplest way of achieving the same result is to make use of one of the proprietary step-wedge products sold

Final print *The test print (p38) shows that the best time is either 15 or 20 seconds according to preference. This negative (and others like it) can now be printed with no further waste*

specifically for this job. These take the form of processed film with an arrangement of differing densities, a typical one being shown on the page opposite.

The wedge is simply laid on top of the sheet of printing paper before exposing it to the projected negative image in the normal way. Most require that the print be exposed for a full 60 seconds. The lighter parts of the step-wedge permit more light to pass through them on to the paper than the darker parts and, after the test print has been developed and part fixed, you simply read off the exposure time corresponding to the step of the scale that appears to be the most satisfactory. A typical range of exposures (based on the overall 60 second exposure) is : 2, 3, 4, 6, 8, 12, 16, 24, 32 and 48 seconds.

For fine times, the overall exposure is reduced to convenient fractions. With a 30 second exposure, the indicated times can be halved, and so forth.

These items are inexpensive and convenient. They are not, however, capable of giving highly accurate fine times as easily as is possible when you adopt the standard methods of producing test prints, and it is sometimes difficult to get the step-wedge to straddle a representative part of the print image.

Making the test count
Use a full sheet of paper for exposure segment tests when you first start to make test prints. This however does tend to be uneconomical. Small off-cuts or pieces can provide just the same information and are less expensive.

With both, however, much the same problem exists—that of ensuring a representative area of the image appears in each exposure segment. If such an area does not appear in each, the correct test print exposure may not give a correctly exposed print.

To illustrate this point, take a typical shot where such a fault may occur—a

typical landscape where sky and land form half each of the image depth. A test print produced with horizontal segments results in two exposure segments covering the sky area only, and two covering the land area only. No segment is truly representative of the whole picture.

But if vertical segment strips are used, almost every segment caters for both land and sky areas of the image. And not only do we obtain a segment that provides a useful compromise in respect of the reproduction of both sky and land, but we can also see at a glance which time is best just for the land and which is best just for the sky—two points of information that can be used at a later stage for local manipulation of print exposure. For the time being, however, a compromise can be established if necessary.

For any negative there are lighter and darker parts, the former requiring less exposure than the latter. For generally distributed and small areas of each, one general test strip is usually sufficient. Where one area becomes segregated from another, make sure you include both in the same test strip segment.

With very large images, the physical size of the image itself makes it necessary to use two separate test prints—one for the darkest parts of the image, another for the lightest parts. Both should be processed together.

In short, provided commonsense is applied, test prints save time and money, for you only need to expose the test print to a representative region of the projected image for the information to hold good. And, with extreme enlargements you need only use a small off-cut of paper for your test print.

If the test proves that things are not going quite the way you thought then make another test print to help you finally decide what exposure gives the 'spot on' enlargement you are after.

Choosing the paper grade

Working out the right print exposure time is a basic skill of enlarging which is easily learned if test strips are used. But there is another aspect of print making which is important if you are to make top quality black-and-white enlargements. This is knowing how to control print contrast.

If you look at a strip of negatives—especially one with a variety of subjects taken over a period of time—you will see that the density often varies considerably from frame to frame. In addition, you will see that some frames will have a greater range of densities than others. The darkest parts of one frame may be much denser than those of the next frame on the strip.

When you print the negative, the dark areas become highlights in the final picture. You can expose two prints from negatives with different density ranges so that both prints will have similar middle grey tones—but the highlights of one print will be whiter and more washed-out than those of the other. Alternatively, you can adjust the printing exposure so that one will have deeper, blacker shadows than the other. This can cause important picture details to be lost

Contrasty subject *The appeal of the pattern of the barrels is the contrast between light and shade. Normal grade printing paper preserves sufficient detail*

in the shadows, and give you pictures that are too harshly black and white, which is unacceptable in most cases.

On the other hand, if you print a negative with a limited range of densities you may end up with a print that has no black or white tones at all, only a range of dull greys.

In order to overcome this problem, b & w photographic paper is available in various *contrast grades.*

Matching negatives and grades

The contrast of the negative is influenced by a number of factors. Choice of film, subject contrast, exposure conditions and development all play a significant part.

Ultimately, however, it is careful choice of paper grade which decides what the contrast of the final print will be. Skill is needed to match a particular type of negative to a particular grade of paper to give a result which is both realistic and pleasing.

Negatives that lack contrast—usually as a result of underexposure—appear flat and 'muddy' when printed on normal grade 2 or 3 paper. To inject sparkle and life into the print, you can expand the grey tones by using a contrasty (hard) paper—grade 4 or 5.

A very high contrast negative—usually the result of overdevelopment—has a 'soot and whitewash' appearance if printed on normal grade paper. This harshness can be toned down by using a low contrast (soft) paper—grade 0 or 1—which is more capable of handling the wider range of negative density.

Providing you are careful with the exposure and development of your films, you are unlikely to need more than three grades of paper to print all your work. You should adjust your film development times so that most of your negatives can be printed on normal grade paper. If your negatives give low contrast prints on normal paper, try adding 10 per cent to the manufacturer's recommended development time. If your negatives are generally too contrasty, reduce development time by 10 per cent. Manufacturers' recommended development times are meant to be starting points—they may need to be adjusted to take account of the conditions under which you took the photographs. If your exposures and processing are consistently the same for every film, you will soon learn to predict your final results.

It is worthwhile keeping some high and low contrast paper for the occasional 'difficult' negative. For economy, buy

Normal negative *Correct choice of film and correct development for a subject with a full range of tones should yield an easily printed negative*

boxes of 100 sheets of normal grade paper in the size you use most often, and packets of 25 sheets of high and low contrast grade paper for special occasions.

While one usually thinks of contrast control as a means of rectifying contrast 'errors' already present on the negative, it is worth bearing in mind other more

Paper grade choice

Negative lacks contrast

Negative shows good tone range

Negative has excessive contrast

Soft grade

Print on soft grade is far too flat

Print on soft grade shows all tones

Print on soft grade has best tone range

Normal grade

Print on normal grade is still flat

Print on normal grade has good contrast

Print on normal grade nears contrast limit

Hard grade

Print on hard grade is acceptable

Print on hard grade loses shadow detail

Print on hard grade is far too contrasty

Contrasty printing *To accentuate the form and composition of a photograph you can print otherwise normal negatives on a more contrasty grade of paper*

Temple detail *Soft grade paper is able to cope with negatives which have a very wide range of detail in the middle tones between light and dark*

subjective points regarding tonal reproduction. For example, there is no reason why you should not use a very hard grade of paper to print a normal contrast negative if you consider the resulting tones help the visual effect of the print.

On the other hand, some pictures, such as portraits, tend to look better when printed on a lower contrast grade of paper than normal. This is because soft grade paper can usually handle the fine shadow details and flesh tones, and the lower contrast improves modelling. High contrast, 'high key' portraits without deep shadows can also be successful with certain subjects.

As a rule, the higher the contrast of the picture, the more pronounced the detail and graininess of the image becomes; with lower contrast, the rendering of the subject becomes more subtle and the number of tones in the print increases, lessening the effect of undesired detail.

What you must decide is whether the end result on normal grade paper is any better than that given by using the 'wrong' paper grade. The decision can be a difficult one, and the simple answer is to make a set of comparison prints. As your experience increases you will learn to predict the likely effects of different contrast grades without making test prints.

Contrast change *Even 'normal' negatives can sometimes benefit from the extra punch of printing on to a higher contrast paper—quickly done if you use Multigrade. Note difference between two types of paper*

Variable contrast paper

To get around the problem of over-stocking rarely used grades of paper, you may prefer to use variable contrast paper. This entails the use of separate filters which are placed in the enlarger light path. When the colour of the printing light is changed, the variable contrast paper emulsion responds by changing its exposure range. The effect is to allow one sheet of paper to do the job of high, normal or low contrast paper, according to the colour of the filter in the enlarger. You only need to stock one box of paper for each size of print you make. Special enlargers are made for variable contrast papers, but normal colour or b & w enlargers are quite adequate.

Paper tone ranges

Soft grade *A full range of negative tones can be printed on soft grade paper. The printing range can be up to 1 :60, meaning that total blackening needs up to 60 times the exposure for the faintest grey*

Normal grade *The printing range of normal grade paper is between 1 :10 and 1 :20, depending on the manufacturer's rating of 'normal'. This grade of paper is suitable for the majority of negatives*

Hard grade *The printing range of more contrasty papers starts where some 'normal' papers leave off. Although the range can be as little as 1 :3, hard papers with a range of 1 :6 are more usable*

Controlled exposure

There are two basic ways of controlling the appearance of a print. By adjusting print exposure times you can control the lightness and darkness of the image, and by choosing the right grade of paper you have wide control over the contrast of the image. Between the two you should be able to get prints of acceptable quality from a great many of your negatives.

However, you do come across certain types of photograph—landscapes and portraits in particular—where no amount of juggling about with different paper grades and exposure times seems to yield a successful print. Normally, one part of the image has to be sacrificed in order to salvage detail in the more important part. In a landscape, for example, you may often have to forego detail in the sky area in order to obtain a realistic land area.

A close look at the negative may well show detail that does not print, which is clear evidence that print material cannot handle a very large range of negative tones. But without this additional detail, a landscape tends to look unrealistically bare and unacceptably stark.

You will find there are many other picture situations where a 'straight' print is less than satisfactory, but the basic problem remains the same. And the best way to deal with it is to give each part of the image its own correct exposure, either by holding back part of the image during an overall exposure, or by giving additional exposure to a small area afterwards.

This is not a technique for the occasional difficult negative, but a routine part of quality printing. Indeed, what often makes the difference between a master printer like the late Ansel Adams and the rest is his skill in controlling every tone in the print so that it gives precisely the right effect—even if it means spending hours on a single print.

Into the light *The type of shot that nearly always results in a negative which is difficult to print. Here, in a normal grade print, the sky and reflections require twice the exposure given to the sea portion of the image*

Shading a print

Gauge the effect *Try out the effects of using your hands, or shading tool, under the red swing filter of the enlarger before dodging the exposed print*

Holding back exposure

The technique of holding back or adding exposure of part of the image which prints too light or dark in an otherwise normal print is called *dodging*. You do this by shading the print during printing. In many cases this job is easily done using nothing more than your fingers or hands—but for more intricate and isolated shapes, and for greater control, it is an easy matter to prepare *dodging tools* from pieces of opaque card taped to stiff wire. You can build up a collection of the more commonly used shapes such as crescents, circles, squares and rectangles. Others can be cut to shape as required.

Elaborate dodging tool sets can also be bought but these are perhaps less suitable for individual requirements than easily adaptable home-made tools.

Before you consider using the technique, bear in mind several important points. In shading, you are simply interrupting the projected beam, causing a shadow to fall over the lighter area of the negative image which you wish to receive less than the overall exposure. Anything in the light path—such as the wire of a dodging tool—can also cause a shadow, which prints light.

For an experiment, turn on your enlarger to observe the effects on the shadow of moving your hands (or a piece of card) up and down in the path of the light beam. You can see that the outline of the shadow becomes more clearly defined the closer your hands get to the baseboard and the easier it becomes to form a clean, clear shape. The higher you raise your hands, the less clear the shadow border and area become. By twisting and angling your hands, all sorts of different shapes are possible. Again, try out the effects under the enlarger beam.

Using shading tools

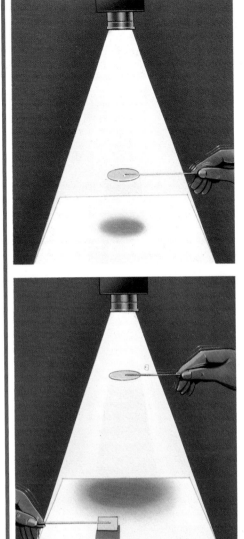

Dodging tools *You can make a dodging tool from stout wire and opaque card cut to the required shape. Plan to use the tool a little way above the print*

Shadow and movement *The tool shadow can be softened by raising the height of the tool above the print, or by movement of the tool during use*

Against-the-light portrait *In this type of situation a negative often requires dodging. A shading tool was used here to give less exposure to the face region*

Shading during exposure *When you have some experience of dodging, you can shade the lighter part of the image once the time for this is reached*

A 'straight' print *If you do not dodge, the exposure should be based on the most important part of the negative— the result here is a washed-out sky*

A shaded print *The sky area was given its full exposure, but the rest of the image was shaded when it had received enough exposure*

For most purposes, the best and most convenient dodging height from the paper is about a third of the distance between this and the lens. The shadow edge is reasonably blurred (to enable adjoining areas to 'fuse' together as inconspicuously as possible), yet the hand or dodging tool is easy to shape.

But to avoid the formation of a hard, clearly defined image between the normally exposed and dodged areas of the print, you must always move your hands or the dodging tool all the time you are dodging. This should be enough to prevent a shadow of the dodging tool wire from forming, and also helps to give a blurred edge to the shadow of the dodging tool itself.

Adjusting the combination of height and movement gives you considerable control over the effects of the dodging shadow and its ability to cut down exposure in a particular area. But although it may be possible for you to gauge the effects by attempting a dry run (under the red swing filter) before making the print, you can only get the essential practical experience by trial and error.

Increasing exposure locally

Sometimes you may want to give an additional exposure to a small, particularly dense area of the negative which prints too light in an otherwise normal print. This is called *burning-in*. It is just the opposite of shading, and is a technique useful for subjects which include bright light areas within the picture view—such as windows in indoor shots, and faces in the foreground of a flash photograph.

Once again, you can usually use your hands for burning-in, but shapes are easily cut from opaque card and the significant advantage of this is that it leaves a hand free to both start and end the exposure—important if you use a switch or swing filter in place of a timer switch.

The technique is readily interchangeable with shading in many instances, and because of the way the exposure is given it is worth looking at the difference between the two techniques. You may find it easier to burn-in one area where you would, on first impulse, have tried to shade out the rest of the area, and vice versa. The terminology and techniques each describe particular localized action in relation to one main exposure.

In shading, you are holding back the exposure in a local area for part of the main exposure time; in burning-in you are effectively shading the main part of the print for a period beyond the correct main exposure.

Manipulating exposures

If you are dealing with an unfamiliar negative, and guesswork or test strips indicate that a single exposure is inadequate for the print, make additional test strips to determine any necessary time variation. Usually, much of this information is obtainable from the original test print, such as shown on page 38. In this example the best 'land' exposure is 15 seconds while the best 'sky' exposure is 20 seconds—so for a basic 'straight' print one can choose a time at each extreme, or somewhere in between.

For the best print, however, each should receive its own 'ideal' exposure. A little extra to the sky area adds subtle detail to the highlights in the clouds, while holding back the exposure of the lighter (land) parts of the negative preserves most of the shadow detail. In effect, you either have to shade the land area, or burn-in the sky area. The resulting print (p45) is worth the slight additional effort required, and there are no telltale signs of the job having been done. You should always try to conceal 'work' done on a print.

When you have established the two times for your negative (there can be more if necessary), work out how you are going to give the exposures. When you have had some practical experience the most convenient way is to give one long exposure, part of the way through which you shade the lighter part of the negative image.

But to start with, you may find it easier to give two separate exposures, the first based on the requirements of the lightest part of the negative image, the second on the darkest. You must be careful not to jog or otherwise disturb the negative or print between the two exposures or you will get a double image on the print.

Burning-in

Burning in with your hands *You can shade the normally exposed portion of the print while adding exposure to a central area by using your hands*

Card masks *More precise shapes can be burned-in using cards which have holes cut in them. Height and movement affect the size of the projected hole*

Girl by window *A straight print from this negative gave a completely washed out window. Some detail can be added by burning-in the window area only*

Musician *Card masks can be placed on the print during exposure to produce a hard-edged vignette, or raised slightly above the print for a softer edge*

On-print masking

With clearly defined and regularly shaped areas where shading or burning-in is required, it is often better (and much more convenient) to make use of flat card *masks* cut precisely to shape and placed on the print itself during the dodging part of the exposure.

A typical example is a shot of a building in which sky detail or tone is required. The sky is burned in while the building itself is shaded.

You can produce the mask by projecting the image on a sheet of white (but opaque) card cut to match the size of printing paper you are using. Trace off the border line with the card held correctly in position on the masking frame, and then cut it accurately to shape. The card outline must exactly coincide with projected detail during enlarging or the border line will show in the print.

Having done this, expose the print in the usual way for as long as necessary for the building (the lighter part of the negative). Then very carefully open up the lens to its maximum aperture to improve viewing brightness. Again, you must be careful not to disturb the negative or print in the process. Swing the red filter into the beam and switch on the enlarger again. Now carefully rest the card mask over the print and register its edge with the projected image. The mask must lie in close contact with the print. You can use a sheet of clean glass (or a special copying easel) to keep the mask and print sandwich flat during exposure.

Stop the lens down and swing the filter clear to expose the sky detail for the required time. If necessary, you can use your hands to shade (or, indeed, burn-in) a further area of detail in the

Masks on the print

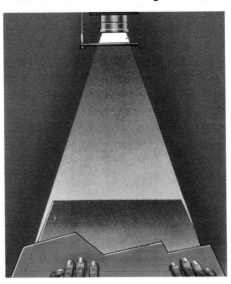

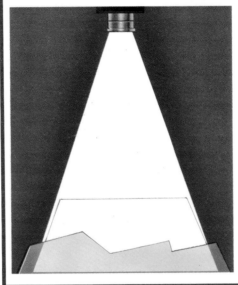

Cut and align *First cut the mask, perhaps using an old print as a template. After the main exposure, use the red swing filter to position the mask*

Second exposure *Switch off the enlarger, carefully swing the red filter aside, and then expose the dark area of the negative for the extra period*

With and without a sky *Even though there is no actual detail in the sky, burning-in tone here is much more effective and pleasing*

sky portion of the negative. If the technique is successful, the sharp edge of the card mask should not be noticeable against the clearly defined detail of the building itself.

Vignettes

You can use a variation of the burning-in techniques to produce a simple *vignette*—a portrait (usually) whose normally oval image gradually shades off to a uniform white background.

Cut an aperture of the required shape in a piece of card and hold this between the print and lens for the whole of the print exposure. Keep the mask moving around, remembering that the more you do so, the less clear becomes detail at the edge of the image.

Vignettes are particularly successful when combined with certain print treatments such as toning, which tends to give an 'aged' look to the photograph, in keeping with a technique which was once very popular.

Meaningful test prints *When you make a test print or strip, try and include areas which may need different exposures. A single test helps in easy comparisons*

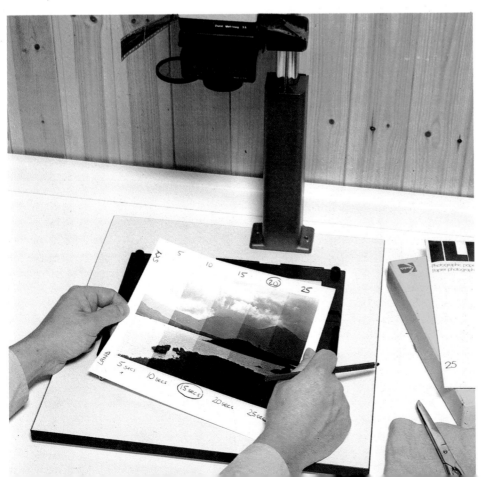

Contact proofs

Having learned the basic principles of black and white printing, it is tempting to move straight on to full scale enlargements, but even the most experienced photographer cannot always tell how a photograph will turn out simply by looking at the negative. To get the best from your negatives, you should not only make test strips but also contact prints before you make your enlargements. Contact prints are simple to make but provide a wealth of useful information. With the aid of a good set of contact prints you can:

● Decide which pictures on a roll of film are really worth enlarging.
● Choose the right contrast grade of paper for your enlargements.
● Estimate the exposure your enlargements need, and see if shading or burning-in is needed.
● Work out how to crop your pictures so that they have the greatest possible visual impact.
● Discover whether you need to make any adjustments to your film exposing or developing technique.
● Set up a filing system to help you locate the negative for any of your photographs quickly and easily.

Equipment for contact prints

The equipment needed for making contact prints is almost the same as that used for making enlargements and the only major extra item required is a contact printer. Most contact printers consist of a sheet of glass that hinges open like a book from a solid base. Strips of plastic or clips hold the negatives in place against the underside of the glass. A foam pad presses a sheet of printing paper against the negatives when the printer is closed. It is possible to do without a contact printer; you can make contact prints with a sheet of glass and a pad of foam or newspaper instead, but this is not so convenient. You will need to attach your negatives to the glass sheet with small pieces of cellulose tape if you use this method.

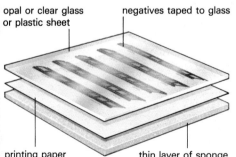

opal or clear glass or plastic sheet
negatives taped to glass
printing paper
thin layer of sponge

Contact printing *If you decide not to buy a purpose-made contact proof printer, a makeshift alternative can be made from a thick sheet of glass (with ground edges) and sponge*

Contact proof print *You can use a proof print to determine in advance which negatives are worth enlarging, and whether or not a special enlarging technique such as dodging is required*

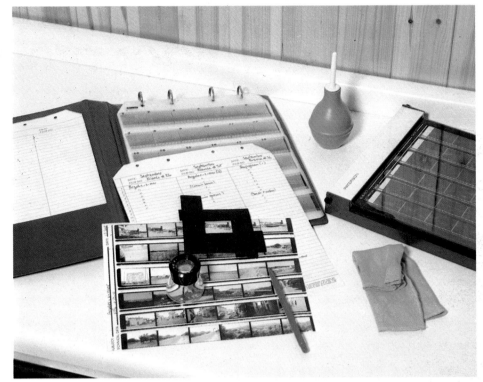

Filing system *One of the major uses of a contact print is to help you find a particular negative quickly once you have a filing system*

Another item you will find useful is a magnifier. A hand magnifying glass is suitable, or you can use an inexpensive loupe available from most photographic shops, or a fold-up thread counter.

Setting up

Contact prints do not need to look good; they only need to provide useful information. The most important thing is to be completely consistent in the way you expose and process your contact prints. If you take care to make them in exactly the same way each time, you can make useful comparisons between different rolls of film that you have to print in the future.

Before you begin to make contact prints, you must find out the proper exposure they will need. To do this, make a test strip for each type of black and white film you use. This is a test strip with a difference—unlike most test strips, this one should have no image on it at all.

Next time you load a roll of your usual black and white film in your camera, place the lens cap over the lens and fire off a few blank exposures before you start taking pictures. When your film is processed, this gives a strip of film which is blank except for the manufacturer's edge marking and frame numbers.

In the darkroom, take this strip and place it in your contact printer. Under safelighting, place a sheet of normal grade printing paper under the strip on the printer baseboard and close the printer. You do not need to use a whole sheet of paper for this test—a strip cut from the long edge of a sheet is enough.

Place the printer on the baseboard of your enlarger and, with the red safety swing filter in place, switch on the enlarger. Adjust the height of the enlarger head until the projected light just covers the entire area of the contact printer. If your enlarger has a height scale on the column, read off the height of the enlarger head above the baseboard. Otherwise, use a tape measure to find this distance. Record the figure in a notebook so that you can later mark this information on the contact print, along with all other exposure details. Close the enlarger lens aperture down two stops. Then switch the enlarger off and swing the red safety filter aside.

You are now ready to make a test strip. The procedure is the same as for ordinary test strips (see pages 38 to 41). Cover the strip of film and sheet of paper underneath with a piece of opaque card, and switch on the enlarger to make a series of exposures, moving the card to uncover 5 cm of paper at each step. Make a note of the exposure time given to each segment of the test strip, together with the lens aperture, enlarger head height, make and grade of paper, and type of film being printed.

Develop the strip of paper in fresh chemicals at 20°C for exactly the time recommended by the chemical manufacturer. Wash and dry the print as if it were an ordinary photograph.

You should now have a strip of paper with a series of dark grey patches printed on it. One end of the strip should be completely black. Now establish the first exposure step (the shortest exposure time) on the strip that gives a maximum black patch. This step lies between a dark grey patch on one side and another completely black patch on the other side. The difference between the dark grey patch and the black patches should be very slight.

If there are no completely black patches on your test strip, repeat the test using longer exposure times. If the test strip is completely black all over, use shorter times for each step.

Make a note of the shortest exposure needed to give a completely black patch. This is the minimum exposure through the unexposed film base that will give the maximum black on the print. You should give this exposure to all your contact prints made from this type of film. Repeat the test when you change black and white film or developer type, or alter your processing technique.

This test is essential because most black and white negative films have a slight grey base tint. This is a characteristic of the film base and of the emulsion layer itself. It is referred to sometimes as *base fog*—base level plus fog density.

Different films have different grey base tints, and fog level can be adversely affected by poor storage and over-development. But whatever the tint, you want the grey, unexposed areas of the film base to print as black as possible in your pictures since the lightest parts of the negative correspond to the deepest shadows of the original subject.

At the same time, you do not want to have to give the print any more exposure than the minimum necessary to produce this maximum black. When you make prints from your negative, the clear unexposed film base produces the deepest black on your final print, and any increase in negative density will print as a grey tone if you give this minimum exposure.

Making a contact proof print

Once you have found the minimum exposure needed to give the maximum paper black, you are ready to make a contact print. Clean the glass surface of the contact printer carefully with a soft antistatic cloth. Insert the negatives with their shiny base side facing towards the glass. The emulsion side of the negatives is slightly duller and should face towards

Making a contact proof print

1. *In addition to your normal enlarging and print processing equipment, you need a contact proof printer and a clear strip from the processed film*

2. *The strip of clear film is used to determine the exposure time of contact prints made from similar films. Place it in the printer along with a strip of paper*

6. *Before loading the printer with a film you wish to contact print, carefully clean both sides of the glass using a blower and antistatic cloth*

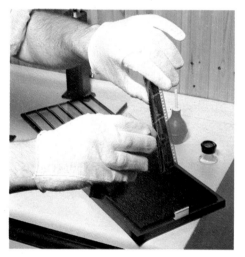
7. *Use a cloth specially set aside for negatives to clean off fingerprints and drying marks you may notice on the shiny side of the film*

the emulsion surface of the printing paper. You usually have to cut the film into strips of six of fewer frames.

Place a sheet of the same type of printing paper you used in your test in the contact printer. With the red swing safety filter in place, make sure that the contact printer is properly positioned on the enlarger baseboard. Switch off the enlarger and swing the safety filter clear before exposing the paper for the time determined from your earlier test.

Develop, fix, wash and dry the contact print properly.

Evaluating the contact print

Examine the contact print in normal room light. Most of the frames should be sharp, detailed, and have a good range of tones. If they are not, and you have carefully followed the method outlined above, then the problem is not with your contact printing technique, but with your film exposure or development.

If most of the frames on your contact print are too dark, you have underexposed or underdeveloped your film. You will have difficulty making good prints from such a film—you will probably need to use a harder than normal grade of paper and short printing exposure times. If most of the frames are too light, you have overexposed or overdeveloped your film and you will need to use longer than normal printing exposure times and perhaps a softer grade of paper than usual. But stick to normal grade paper for your contacts.

If your contact print has the correct density overall, but is too contrasty, you have overdeveloped the film. If this is a recurrent problem, decrease your standard film development time in future. If the contact print looks dull and grey, your film is underdeveloped. Again, if this is a common problem, increase your film development time in future. But severe adjustments to

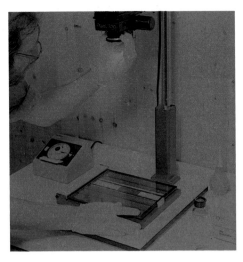

3. *Under the safety of the red swing filter, check that the enlarger beam covers the whole of the printer. Note the head height, then stop down*

4. *Cover all but one-fifth of the test strip and expose this for a set unit of time—5 seconds, say—and continue until a complete range of exposures is made*

5. *Take particular care to ensure that the test strip is correctly processed, washed and dried. Determine what exposure just gives a black segment*

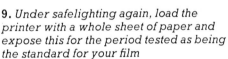

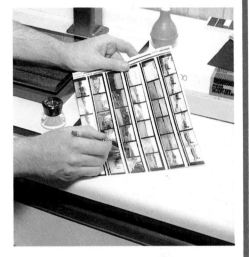

8. *Carefully slide the negs into place, shiny side towards the glass. It helps if the frames are in order and the images are correctly orientated*

9. *Under safelighting again, load the printer with a whole sheet of paper and expose this for the period tested as being the standard for your film*

10. *To enable worthwhile comparisons, make sure the contact print is properly processed. From the dried print you can plan your enlargements*

development time must be avoided. Experiment a little at a time to be on the safe side. Large adjustments mean altering exposure as well.

Your first few rolls of film are unlikely to give perfect results, but if you fine-tune your film exposure and development using your contact prints as a guide you will soon be producing negatives of excellent quality which are easy to print.

However, even when you find the best exposure and development combination for your film, you are bound to have a few shots which are not perfectly exposed, or in which the lighting contrast is too high or too low. Such pictures are immediately obvious on a contact print—they are noticeably lighter, darker, softer or harder than the other frames on the print. With a little practice, you can estimate how much compensation has to be made to print exposure or paper contrast grade.

You should use a magnifier to examine each frame on your contact print for signs of poor focusing or of camera shake. You can also estimate whether some areas of the print will be improved by shading or burning-in. Areas of the picture that are too pale need to be burned in; areas that are too dark to show detail can be dodged (for more about dodging see pages 46 to 49).

Sometimes pictures look better if unnecessary details are cropped out. A pair of small L-shaped pieces of cardboard can help you decide on the proper shape to make your print, and how much of the negative you should enlarge. Do not be too ambitious when you crop your pictures, however—the more you enlarge a small section of a negative, the more apparent becomes the graininess and unsharpness in the final print. Sometimes it is better simply to cut away the offending detail, to leave a smaller sized print. A chinagraph pen-

cil or a felt-tipped pen can be used to mark cropping lines and other exposure information on the contact print.

Your contact prints can form a valuable permanent record of your work. The most convenient way of storing your negatives is in specially-made filing sheets kept in a ring binder. If you file your contact prints in such a binder alternately with the negative filing sheets you can locate any negative you want simply by finding the corresponding contact print. Or, if you prefer, you can number your negative storage envelopes and write the same number on your contact print. As you build up a large collection of negatives, force yourself to weed out any films which are unlikely ever to be printed. With some experience, you will recognize badly exposed or developed films which are not worth enlarging or, for that matter, contact printing. But you might like to keep them as an awful warning!

Chapter 4
COLOUR NEGATIVE PROCESSES
Processing colour negatives

To the uninitiated, colour processing and printing seem discouragingly complex, but if you can handle black and white confidently there is no reason why you should not be able to tackle colour processing with equal success.

The only really important thing to remember when colour processing is that every process must be precisely controlled—there is not quite the room for error that there is with b & w. This is because each of the three emulsion layers of colour film will be affected differently by fluctuations from the norm —the resulting colour shifts will be difficult to correct. Special care must

be taken over every aspect of colour processing and before you undertake any colour work you must bear the following points in mind.

● Temperatures of the various process solutions must be accurately maintained at much higher levels than generally encountered in black and white processing. Special temperature control techniques are needed to keep solution temperatures at constant levels. The maximum allowable variation with some processes is measured in fractions of a degree.

● Some processes involve many individual processing steps and are lengthy, especially the low process tem-

perature methods, lasting over an hour.

● Some of the chemicals used in colour processing are extremely harmful and very great care must be taken in their preparation, use and disposal.

● Colour process solutions are generally more expensive than those used for black and white processing. They do not keep well once prepared and they should be stored carefully.

In black and white processing, one developer can be used to process different makes and types of film. In colour work, it is usual for a particular type of film to be tied to a particular process, although in some cases it may

Colour negative *Producing good quality negatives means judging exposure, as well as processing, absolutely accurately*

1 *Prepare processing solutions using the specific instructions supplied by the maker. Photocolor II developer is mixed 1 + 2 with water, bleach-fix 1 + 1*

4 *Check that the solution temperature is 38°C, discard the preheat water, then quickly pour in the developer. Note the precise time development begins*

be possible to use one set of chemicals for processing most of your colour negative films and prints.

Extra equipment

Very little additional equipment is necessary if you are already equipped for b & w processing and decide, for economy, to use these items for colour film processing. However, to eliminate any risk of cross contamination, it is worth buying separate equipment for colour work if possible.

Generally speaking, b & w and colour film equipment is the same, but a few points are worth bearing in mind when selecting equipment for colour work. First of all, a spirit thermometer is not sufficiently accurate and you should buy a mercury-filled type. Choose a thermometer with a comparatively short range so that temperature changes are clearly visible.

Secondly, it may well be worth buying a dishwarmer although they are very expensive. A dishwarmer ensures that the high colour processing temperatures are properly maintained.

Although a dishwarmer is not essential, it makes temperature control much simpler. Of course, the dishwarmer may be used for any form of processing—it would be particularly useful if ever you

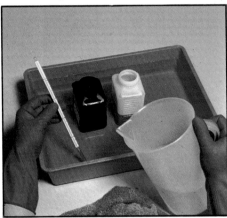

2 *Measure off a quantity of each solution and stand the containers in a waterbath until the contents reach 38°C. Keep the bath topped up with hot water*

3 *While the solutions are warming up, load the tank in darkness. Preheat the tank and film using clean water heated to 40°C*

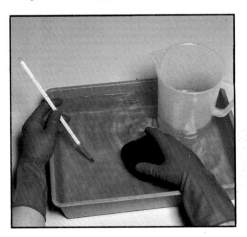

5 *Continue through stop-bath and bleach-fix stages according to the maker's instructions before using the waterbath water for rinsing the film*

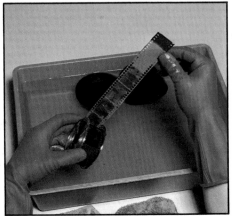

6 *Continue using separate rinses or, better still, running water at the right temperature until washing is complete— only then remove the film for drying*

Colour print *Although you can do (and undo) a lot during colour printing, a quality print is best made from a good quality negative*

want to dish process colour prints.

Alternatively, you may wish to buy one of the various types of processing machine designed for the amateur. These *tempering units* (designed to maintain temperatures) incorporate solution heating compartments warmed by an enclosed jacket of warmed water or air. More elaborate machines accept processing drums for both negatives and prints, and usually incorporate a rocker and roller mechanism to provide continuous agitation. Although both the tempering units and the more elaborate machines use the simple principle of a water bath, the added convenience of thermostatic temperature control combined with all the benefits of an enclosed jacket of water ensures a much higher standard of processing consistency.

Processing

Colour negative processing consists of two or three main stages: development and a bleach-fix; or a separate bleach and fix.

Colour negative film is coated with three emulsion layers, each sensitive to one particular colour. During development, silver is produced in all three layers to produce a negative with dense highlights and light shadow areas just like a black and white negative. However, during development dye images

are also formed in each of the three layers to form the colour component of the image. The dye image of each layer corresponds exactly to the amount of silver in that layer, and heavier dye deposits are formed in areas which have received more exposure.

Because the variations in dye strength show all the colour and density variations, the metallic silver of each layer serves no useful purpose beyond this stage and is therefore removed after development by a *bleach bath*. The third stage is a *fixing bath* to stabilize the image. In most modern processes these bleach and fix baths are combined to form what is known as a *bleach-fix*. Finally, the film is washed to remove the waste products and residue process chemicals.

Details vary from process to process, and there is no typical method, but one of the simplest and most widely available is the Photocolor II process and this is explained in detail. Other processes are outlined in the panel.

Photocolor II process

The Photocolor II process can be used for Kodacolor II type films instead of Kodak's own process C-41 but cannot be used for Agfacolor. For the amateur, the Photocolor II kit is especially attractive because it may also be used for processing colour prints.

Start off the processing sequence by preparing the process solutions. The Photocolor II colour developer concentrate is diluted with two parts of ordinary tap water. Calculate the capacity of your developing tank and divide this by three in order to determine just how much concentrate is required. You need about 100 ml for a typical 35 mm tank. If you have to use the same measuring cylinder, always mix up the developer before the bleach-fix is diluted, but to avoid contamination it is better to have separate plastic measures for each solution.

The bleach-fix concentrate is diluted 1 + 1 with tap water. Do not use stainless steel containers for holding or storing this chemical because it can be corrosive. If you do use stainless steel containers for mixing, wash them immediately after use.

Try to keep splashes to a minimum when mixing up these chemicals, and keep them well away from food and food preparation surfaces. Rinse down any splashes with plenty of water or stains may remain afterwards. Always wear gloves when preparing and using colour process solutions.

Pour the working strength solutions into the waterbath containers and bring the temperature of the solutions up to the selected process temperature, which is normally 38°C for the Photocolor II process.

While the chemicals are being warmed up, load your developing tank in complete darkness. But you must make sure that your hands are free of traces of chemical concentrate, other-wise fingerprints and smears may show on the processed film.

The tank, with film loaded, can be placed along with the solution containers in the water bath so that the tank and its contents are warmed up to the correct process temperature.

If, however, you can independently raise the temperatures of the solutions to the required level and decide not to use a water bath, you can use a pre-heat (or pre-soak) water bath of 40°C water to take the chill off the tank and its contents. This bath must be completely free of any contaminants. Drain this pre-heat bath completely after one minute.

Pour in the developer, agitating continuously for the first half-minute. As soon as the first period of agitation is complete, quickly measure the temperature of the developer within the tank if your tank has a facility for inserting a thermometer. Otherwise you must take extreme care to keep the tank in a water bath at the correct temperature.

If the developer temperature has fallen below 38°C, consult the temperature correction diagram supplied in the instructions, and obtain the new process time. For example, if the temperature of the developer drops immediately to 35°C when loaded into a tank that has not been properly warmed, development time should be increased by 35 seconds.

Agitate the film four times each minute by inverting the tank twice. For negatives of consistent quality and to simplify the printing of different films, take care to standardize processing procedures, times and temperatures as much as possible.

You should start to drain off the developer a little before the developing time is up because development will continue as the tank is draining. This is especially important in slow draining plastic tanks. It is worth working out how long your tank takes to empty and allowing for this. In the Photocolor II process, developer can be re-used, so store it

Colour negative processes

Different types of processing kits can be used to process your colour negative film, and the times for four of them are shown here. For convenience, use a short-cycle process if one is available for your film type

Agfa process N

This kit is for processing CNS and CNS2 Agfacolor negative film. It is packaged in powder form to make four solutions. Also shown is the Process F kit for C-41 film which is packed in liquid form

About the processes:

Processing stages:

	Temperature	Time (mins.)	Process notes
Preheat bath		—	
Colour developer	20±0.2°C	8	1
Intermediate bath	20±0.5°C	4	2
Wash	14—20°C	14	3
Rinse/Stop-bath		—	
Bleach	20±0.5°C	6	2
Bleach-fix		—	
Wash	14—20°C	6	
Fixer	18—20°C	6	2
Wash	14—20°C	10	
Stabilizer		—	
Dry	to 45°C	10—20	

Process notes:

1 Exact time depends on agitation method used and may need to be adjusted for your purposes. **2** Time not critical. **3** Time may be extended but not shortened. The working capacity per litre (without replenishment) of each solution is six 36-exposure films. The solutions are prepared from powder by diluting with water at about 20°C

carefully. Capacity depends upon circumstances, but 300 ml of developer can be used for processing three 36-exposure films—though you must process the other two within about a week of the first. Keep your stored bottles of developer completely full so that the solution does not go 'off'.

As soon as the developer has been poured out, rinse the tank with three 15 second washes using water at between 35 and 40°C. Providing it is clean, this water can be obtained from the water bath. Failing this, warm up some fresh water to the correct temperature.

An acid stop bath can be used instead of the water rinse, and this ensures that development is stopped instantly. If you use an acid bath, this should last 30 seconds, with continuous agitation.

The bleach-fix bath follows immediately. The bleach-fix solution should, like the developer, be kept precisely at 38°C. Agitate the tank continuously for the first minute and then every 15 seconds until the 3 minutes in this bath are up.

Once the bleach-fix process ends, remove the film spiral from the tank, and be careful not to splash bleach-fix. But before you pour the bleach-fix out of the tank, check that the negative image has bleached completely and evenly. If not the bleach-fix has not worked properly—possibly because you have allowed the temperature of the bath to drop below the minimum of 38°C.

To be safe always make a point of using fresh or almost fresh developer or bleach solution for negative processing. Save part-used solution for colour print processing.

Film washing times depend on the temperature of the wash water. Avoid a sudden drop to start with, and do not let it drop lower than 20°C. Use water from the water bath for the first few rinses and gradually introduce cooler running water into a tank full of this warmer water. Wash times range from 5 minutes at 35°C, to at least 15 minutes at 20°C. Afterwards, hang the film to dry in a suitable dust-free location.

Do not be unduly worried about the milky appearance of the emulsion when wet. This disappears as the film dries.

The key to success with colour negative film processing is consistency. You must always take great care to make sure that your procedure is identical every time you process a film—use fresh, accurately measured solutions, meticulously check temperatures and always agitate in an identical manner. Only change your technique if results are unsatisfactory.

Nevertheless, if you find yourself unable to guarantee consistent results with colour negative film processing, do not be put off colour in the darkroom altogether. Have your films processed commercially and concentrate on colour printing where mistakes only mean the waste of material, not the loss of your valuable, original photographs.

Kodak Flexicolor

This kit is for processing Kodacolor-II type negatives (Process C-41). It has a three-part liquid concentrate developer, three-part liquid and powder bleach, and a bottle each of fixer and stabilizer

Temperature	Time (mins.)	Process notes
	—	
37.8±0.2°C	3¼	1, 2, 3
	—	
	—	
24—40°C	6½	4
	—	
24—40°C	3¼	
24—40°C	6½	
24—40°C	3¼	
24—40°C	1½	
to 45°C	10—20	

1 Time as with all colour processes is critical **2** Use a waterbath at 38°C. **3** Agitate vigorously for first 30 seconds (by 30 complete inversions), place the tank in the waterbath for 13 seconds and then give two inversions, repeating this until 10 seconds before end of development. **4** Agitate for 5 seconds every 30 after initial 30 second agitation

Photocolor II

A very easy to use kit for Kodacolor II type negatives and Kodak or Agfa types of printing paper. Liquid concentrate developer and bleach-fix are diluted just prior to use

Temperature	Time (mins.)	Process notes
40°C	1	1
38°C	2¾	2, 3, 4
	—	
	—	
35—40°C	½	
	—	
35—40°C	3	5
20—30°C	5—15	6
	—	
	—	
to 45°C	10—20	

1 The water used for the preheat bath must be completely clean. **2** Continuous agitation first 20 sec, then two inversions four times per minute. **3** Times can be adjusted according to initial temperature drop. **4** Solution may be stored for re-use. **5** Six inversions first minute, then as dev. **6** Minimum times with running water, **7** longer for individual rinses.

Unicolor K2

For all C-41 process films. Kit consists of a three-part developer and fixer, and a stabilizer. With careful measuring these liquid concentrates can be used to make up small quantities of solution

Temperature	Time (mins.)	Process notes
38°C	1	1
38°C	3¼	2
	—	
	—	
	—	
35—41°C	6—7	3, 4
35—41°C	3—4	3, 5
	—	
	—	
20°C	½—1	
to 45°C	10—20	

1 Water must be clean. **2** Solutions may be re-used. Only developer requires additional time (+15 sec for second film, +30 sec for third film). **3** Time not critical beyond minimum. **4** Steps after bleach-fix may be carried out in normal lighting with tank lid off. **5** Use water flow sufficient to change water in film tank at least six times

Printing in colour

Although some amateurs feel that it is beyond them, making colour prints from negatives is relatively straightforward with modern processes and papers. Like all colour work, colour printing demands great care and precision, but it should prove well within the scope of anyone who can confidently handle black and white printing.

There are two major problems that you must come to terms with when learning to make colour prints from negatives. First of all, because colour print paper is sensitive to more than just blue light, you must not use a safelight intended for black and white printing when making colour prints. A special dark amber or brown filter is needed. Follow the paper manufacturer's instructions on the choice and use of a suitable type.

Colour print paper is extremely sensitive and fogs very easily giving the paper an overall coloured tint. You should be particularly careful not to use a safelight too bright or too close to the work surface. You must not leave paper out under a safelight for long.

At the correct intensity and distance, a colour safelight can do little more than guide you to your equipment. The level

of illumination is inadequate for judging print density. Because of the dangers of fogging and the low level of safelight illumination, it is worth working as much as you can in darkness, particularly when actually exposing the print.

The second problem is achieving the right colour balance in the final print. Ideally, every negative could be printed straight onto the paper. Unfortunately many factors prevent this from happening and without some adjustments, your prints might appear, for instance, too yellow or too red. The nature of the light when the photograph was taken, the colour of the enlarger light source, minor variations in the voltage of the electrical supply to the enlarger, the age of the enlarger bulb, variation in colour response of printing paper from batch to batch—all these may upset the colour balance.

To correct for these variations, the colour of every print must be carefully adjusted with filters placed between the enlarger light source and the printing paper. There are various methods of filtration (covered in a subsequent article), but for consistency and ease of working, your enlarger should be equip-

ped with a special *filter drawer* or, ideally, a *colour head*. Colour heads are normally only found on the more expensive enlargers.

Besides that needed for filtration techniques, little extra equipment is required for colour printing from negatives. Providing it has a good quality lens your normal enlarger should be adequate. Your standard containers for chemicals will also do—but they must be washed carefully after use. If you can afford it, it is worth keeping a separate container for use with each of the chemicals for colour printing. As with processing colour negative film, however, accurate temperature control is vital and a good mercury thermometer is essential. A spirit thermometer is just not precise enough for colour work.

As in black and white printing, you can process colour prints in dishes like those used for black and white, but it is generally much more convenient to use a special *print processing drum* for the job—especially if your darkroom facilities are limited. This is similar to a film developing tank but larger. It enables you to process a single print in normal room lighting, after the exposed

Using a print processing drum

1 *Mix up enough developer, stop bath and bleach-fix for several processing runs, and keep these solutions at the correct temperature using a waterbath*

2 *Expose the print and, in darkness, load it into the drum with the emulsion surface curved inwards. Handle the print by the edges only*

3 *If you use a preheat bath, pour in some clean warm water that is slightly warmer than the processing temperature. This bath lasts a minute*

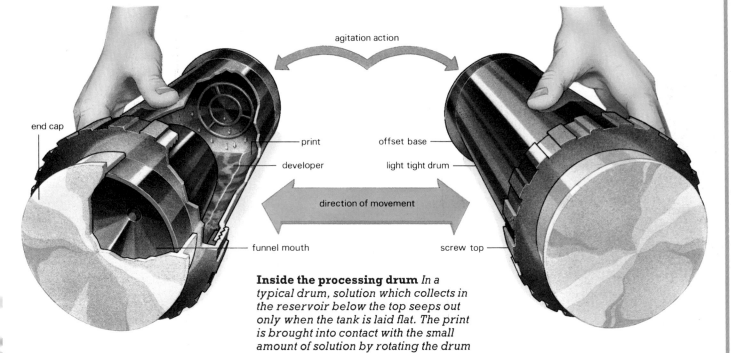

agitation action

end cap

print

developer

offset base

light tight drum

direction of movement

funnel mouth

screw top

Inside the processing drum *In a typical drum, solution which collects in the reservoir below the top seeps out only when the tank is laid flat. The print is brought into contact with the small amount of solution by rotating the drum*

4 *During the preheat, measure off the required amount of developer and bleach-fix. Discard the preheat bath, then pour in the developer. Cap the tank*

5 *Development starts only when the tank is laid down. Immediately, start agitating the tank to and fro. The tank must roll over more than once*

6 *Drain off used solution for re-use or discard it. Follow with the other process baths, remembering to include drain and refill times in the overall time*

Colour print processors

These are four of a number of widely available colour print processes which are designed for use by amateurs. All are 'short cycle' processes which involve just a few simple steps and brief processing times

Kodak Ektaprint 2

Process temperature: 33°C

1. Developer: 3½ mins
2. Bleach-fix: 1½ mins
3. Wash: 3½ mins
4. Drying: less than 85°C

This process is for Kodak Ektacolor type papers. It consists of three-part developer and two-part bleach-fix liquid concentrates which are simply diluted with warm water ready for immediate use. Another kit, the Ektaprint 3 process, contains in addition a stabilizer bath which follows the wash, but is essentially the same as this one. Processing must be carried out only at the recommended 33°C

Photocolor II

Process temperature: 34°C

1. Preheat: 1 min
2. Developer: 2/3 mins
3. Stop bath: ½ min
4. Bleach-fix: 1¼ mins
5. Wash: 3 mins
6. Dry: less than 85°C

This process can be used either for Agfa type or, using an additive, Kodak type paper. The first of the two times listed for the developer applies to Ektacolor 78 paper, the second to Ektacolor 74, Photocolor RC and Agfa papers. Process temperatures between 26°C and 38°C may be used. The makers recommend use of the preheat technique

Tetenal PK and PA

Process temperature: 30°C

1. Preheat: 1 min
2. Developer: 3/3½ mins
3. Stop bath: 1 min
4. Bleach-fix: 2½/3½ mins
5. Wash: 3 mins
6. Dry: less than 85°C

The PK process is for Kodak type papers, the PA process is for Agfa type papers. The developer and bleach-fix times are for the PK and PA kits respectively. A choice of process temperatures up to 40°C can be adopted. Agfa type 4 papers are processed in double-strength solution. Remember to include drain and refill times in overall times

print has been loaded under safelighting or in complete darkness.

Although you can normally only process one print at a time, the benefits of drum processing are obvious. Because processing is carried out in full lighting, there is much less chance of making a mistake. With dish processing, mistakes are easily made because you are often in a rush and have to operate in the near darkness of a colour safelight.

Unlike normal film developing tanks, print drums are used horizontally. A small quantity of fresh solution is used for each print, but the volume of this is insufficient to cover the whole print. The drum has to be rotated to soak all parts of the print momentarily but frequently during the course of each processing stage. After use, the exhausted solution is discarded. The drum must be cleaned and dried thoroughly before the next print is processed.

If you want to make a large number of prints in a hurry, it can sometimes be more convenient to process them in dishes. But you must be careful not to contaminate developer with bleach-fix, and you must time the process carefully. It is better to stick to drum processing when you first start colour printing.

Paper

There are two basic types of colour printing paper widely available: those based on the Agfa principle (type B paper) and those based on the Kodak principle (type A papers). You usually have to match the process chemicals with one or other of these two paper types. Some processes can be used for both, but for the best results, you should match paper and process types properly. Because manufacturers try to match their positive (print) material as closely as possible to the characteristics of their negative material, it is usually better to use Agfa type paper if your photographs have been taken on Agfacolor negatives; and Kodak paper with Kodak type film. Slight colour imbalance may otherwise result.

Processing chemicals

In the past, colour print processing could involve seven or more distinct processing steps and some professional processes are still equally complex. Modern processes, designed specifically for the amateur, are much simpler and shorter—they are often referred to as short-cycle processes.

Typically, short-cycle processes have only three or four steps. All of them begin with developing in a *colour developer* and follow this with a bleach-fix ('blix') bath. After the bleach-fix, the print is washed in water and then given a *stabilizing bath*, with some papers. The procedure for a typical process is shown in detail in the accompanying pictures but, to avoid problems, a few points need to be borne in mind.

Faults in print processing normally stem from three things: temperature fluctuations, variable agitation, and the degree of exhaustion of the developer. Even small errors can severely affect print quality.

Other methods of print processing

You can use other methods for processing your colour prints, starting with a simple dish arrangement of the various processing solutions. A thermostatically controlled dishwarmer is an essential item. The advantage of this method is that you can process a number of prints simultaneously—however, dish processing does mean you have to spend longer in near darkness. A tempering unit which includes a motorized drum agitator such as the Jobo model (right) is costly, but a really useful accessory if you plan to do a lot of colour processing. The Durst processor (far right), is very sophisticated—it is a continuous feed processor which takes much of the physical effort out of print processing

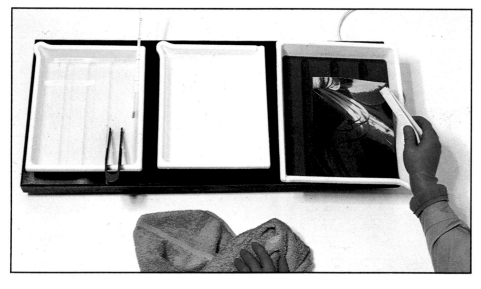

Temperature control *You can maintain high temperatures by using a water bath for both drum and dish methods of colour print processing*

Developer life

Most short-cycle colour print processes are 'one-shot' processes—that is, the chemicals are used once and then discarded.

Colour developers usually have a relatively short shelf life, especially when diluted to working strength or if partly-used. Bear this in mind when planning printing sessions to avoid unnecessary waste. Take care, also, not to use a particular quantity of solution to develop more prints than the manufacturers recommend. Mark on the solution container label just how many prints have been through the developer if you cannot use all the solution in a single printing session.

If possible, prepare fresh working strength solution just before printing begins. In processes that use a stabilizer bath, you may find the pungent smell of the formalin objectionable, so prepare and use this bath somewhere which is very well ventilated.

Always make a point of following the maker's specific instructions when preparing solutions, taking particular care over the order you add the chemicals.

You should also be careful about handling the chemicals. Not all the chemicals used in colour processing are irritants or poisons, but many are, and appropriate precautions must be taken. Always wear good quality rubber gloves when handling colour chemicals. If possible, wear thin cotton gloves underneath to prevent sweating, and, after use, neutralize any deposits by soaking the gloves for a while in a straightforward stop bath. Gloves are particularly important if you use dish processing.

Temperature control

Accurate temperature control is essential when working with colour materials, particularly when you use high process temperatures for short development times. Keep the made-up solutions in a water bath until you are about to use

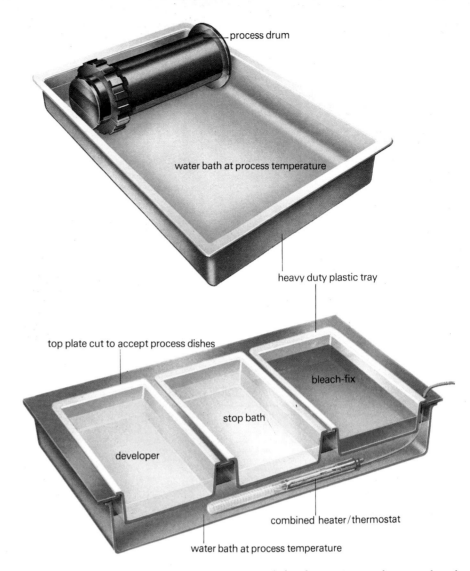

process drum

water bath at process temperature

heavy duty plastic tray

top plate cut to accept process dishes

bleach-fix

stop bath

developer

combined heater/thermostat

water bath at process temperature

them. It is also worth keeping the drum in the water bath—some drums are designed especially to be used in a water bath. When using a drum in a water bath, you must remember to dry it carefully before you load it with paper or go anywhere near your prints with it.

Although you normally have to control temperature very precisely, some modern processes are so quick that you can often dispense with elaborate temperature control and rely on simply *preheating* the drum in a warm water bath. Heat is then retained for long

enough for the process to be completed.

The idea is to heat the drum to a few degrees above the recommended processing temperature before starting. By the time the process is over, the temperature will have dropped to a little below the recommended processing temperature, but the average temperature for the process should have been right. Manufacturers give close guidelines for preheating techniques, but it is worth practising with water and old printing paper before you commit expensive chemicals and printing paper.

Controlling colour

Processing colour prints requires a little more precision and care than does processing black and white prints, but the real challenge of colour printing lies in making the exposure correctly. It is at the exposure stage that you must use filters to achieve the right colour balance. Yet although the theory behind colour balancing may seem dauntingly complicated, it is, in practice, surprisingly easy to master.

When you start to print in colour, it is useful to have a reference print. For your first print, use a negative that you know has been properly exposed and has a fairly typical range of colours. You may find it hard to identify such a negative simply by looking at it—even the most experienced darkroom technicians cannot always spot a poor colour negative instantly; so it is worth having professional prints made of a few of the most suitable negatives. This not only helps you to decide on the best negative, it also shows the kind of colour balance you should be aiming for. You might even be able to improve on the professional version.

Proper exposure of a colour print requires two main calculations to be made: the correct exposure time and the correct colour filtration for each negative—unlike in black and white printing where the main test is just for print

Filter pack *Coloured printing filters can be used to correct the colour balance of colour prints. A sandwich of several may be needed to correct a cast*

exposure. But you will almost inevitably have to make minor adjustments to the exposure time after you have decided on the colour filtration.

Timing the exposure
To work out the correct exposure time, you make a test print in much the same way as you would for a black and white print. This first test print is used only for calculating exposure time and needs no colour filtration—it is sometimes called a zero print or basic print because there is zero filtration.

Begin by inserting the chosen negative into the enlarger in the normal way. Then adjust the size, focus and composition of the image. Switch off all lights, take out a sheet of printing paper and place it carefully on the baseboard. If you are drum processing, it is best to use an entire sheet for the test since it can be difficult to process in some types of drum anything less than a full size print. Even if you use the dish processing technique, it is probably better to use a full sheet because your exposure estimates are more likely to be accurate if based on the whole photograph.

With the paper in place on the baseboard, you are ready to begin test exposures. These are made in exactly the same way as black and white test strips (see pages 38-41) except that colour print paper is more sensitive and needs less exposure. Exposure times for colour prints are roughly half those for an equivalent enlargement in black and white. Nevertheless, there is less margin for error with colour and you usually need to make two exposure test prints: the first embracing a wide range of times to give a rough guide; the second to give the precise exposure needed.

Once you have exposed your test print, process it in the manner described on pages 58 to 61, taking particular care not to cross-contaminate any of the solutions. You can pick out the segment that has the best exposure while the print is still wet, but, to be absolutely sure, wipe off surplus moisture and dry the print before deciding on the exposure time.

Just as in black and white processing, areas of the print that are generally too dark have been exposed for too long; those that are too light have not been exposed for long enough. The correct exposure time lies between these two extremes.

When you are assessing the exposure, you will probably notice that the colours on the test print are not quite right. This does not mean that you are doing something wrong. Almost inevitably, an unfiltered print is biased towards a particular colour—it has a *colour cast*. This colour cast is most obvious in those areas of the print that should be white or neutral grey. The ideal negative, in combination with the ideal enlarger and the ideal paper, might produce a print with perfect colour balance without any filtration, but such a combination is rare. To obtain good colour, filters are invariably needed.

Filters for printing
Filters are placed in the enlarger to alter the colour of the light falling on the printing paper. The actual exposure can be made in one of two ways—by using the *additive* or *subtractive* methods of colour printing.

For additive or *tricolour* printing, just three filters in the primary colours of blue, green and red—are used. Adjustments to the colour balance are achieved by making a separate exposure through each filter and varying exposure times. Because of the problems asso-

ciated with the triple exposure, additive filtration is less popular nowadays and this article concentrates on the widely used subtractive method. Nevertheless, additive printing is useful for some special darkroom techniques and is explained in a subsequent article.

For subtractive or *white light* printing, only one exposure is needed. Colour correction relies on combinations of filters in the complementary colours: yellow, magenta and cyan. It is called 'subtractive' printing because the filters subtract or filter out a particular colour—yellow takes away blue, magenta takes away green and cyan takes away red. Remember, though, that printing paper works in much the same way as colour negatives and the positive printed image is simply a negative of the negative. A yellow filter, therefore, reduces the blue light falling on the paper. Less yellow dye is therefore formed in the blue-sensitive emulsion layer, and so the print image appears more blue.

The amount each filter gives depends upon its strength. If you have an expensive enlarger with a *colour head*, you can dial in any correction value you want, but most amateurs use individual filters of different strengths slotted into a *filter drawer* on the enlarger. Each filter strength is given a number; a low number indicates a weak filter; a high number indicates a strong filter. Filters are very pale in colour, despite this

they take away a significant proportion of their complementary colours—for example, a 50 yellow takes away 70 per cent of the blue light—and this has a considerable effect on the print image. A typical filter set consists of about 20 filters ranging in strength from 05 or 10 to about 100. Combining two low density filters gives the same effect as one high— a pair of 10 magentas is the same as a single 20 magenta, but you should always use as few as possible.

The combinations of filters are arran-

ged into a *filter pack* for slotting into the filter drawer on the enlarger, and the delicate filters are often sandwiched between two glass plates.

The composition of the filter pack is usually described in the sequence yellow, magenta, cyan. A pack consisting of a 20 yellow and a 10 magenta, for example, might be written as (20 10 —), where the dash indicates that no cyan filter has been used. It is well worth using this form to write down on the back of each print information about

Exposing a colour print

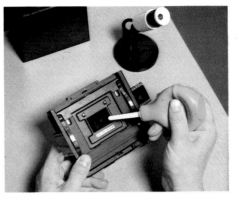

1 *Prepare your enlarger in the normal way taking the usual precautions to see that the negative and its carrier are free of dust and hairs*

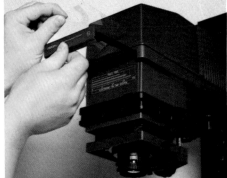

2 *Place a UV absorbing filter in the filter drawer of your enlarger. This can be left permanently in place here (or elsewhere if required)*

3 *Size up and focus the image, turn off all lighting and make a zero test print (— — —) for a range of exposures, such as 5, 10, 15 and 20 secs at f/8*

4 *Process the print. While you can judge print density quite accurately when the print is wet, colour balance can only be judged when the print dries*

5 *The correct exposure in this instance is about five seconds. This time forms the basis of all subsequent exposures, and so must be accurately established*

6 *The first filter pack should consist of filters which match the cast on the zero print. Alternatively, use the basic filtration printed on each paper pack*

7 *Process and wash this filtration test print carefully. Examine the dried print under good lighting—preferably daylight—for corrections*

8 *Continue making test prints until you are close to establishing the correct filtration, then make a fully corrected print (here, 145Y 85M 00C for 28 secs)*

Getting the right colour balance

If possible, spend a little time exploring the various filtration possibilities when making your first few prints. Here, starting with a zero print (— — —), you can see the gradual progression to a fully corrected print

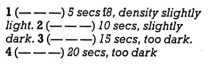

1 (— — —) *5 secs f8, density slightly light.* **2** (— — —) *10 secs, slightly dark.* **3** (— — —) *15 secs, too dark.* **4** (— — —) *20 secs, too dark*

Broad-range filtration to counteract orange cast: **5** *(80 60 00) 14 secs.* **6** *(90 60 00) 14 secs.* **7** *(100 60 00) 15 secs.* **8** *(110 60 00) 17 secs*

Further correction required: **9** *(110 60 00) 17 secs, to continue from quadrant.* **10** *(110 65 00) 23 secs.* **11** *(120 65 00) 24 secs.* **12** *(120 60 00) 21 secs*

Using segment **11** *for continuation:* **13** *(120 65 00) 24 secs.* **14** *(130 65 00) 24 secs.* **15** *(140 65 00) 24 secs.* **16** *(150 65 00) 24 secs—too much yellow out*

Improve on quadrant **15** *by removing more magenta:* **17** *(140 70 00) 25 secs.* **18** *(140 75 00) 26 secs.* **19** *(140 80 00) 27 secs.* **20** *(140 85 00) 28 secs*

With just a trace of additional yellow filtration—producing a new filter pack of (145 85 00), exposed for 28 secs—full correction is obtained

the filters you used. There are other notation systems, however, and you may see filter packs described in the form: CP20Y + CP10M. This is exactly the same as (20 10 —); CP stands for Colour Printing filters and 20Y stands for a strength of 20 yellow. Two scales of filter values are in common use. Values of the Agfa scale are approximately 50 per cent above those of the Kodak scale. For example, a 75 Agfa filter is equal in strength to a 50 Kodak filter. Unless specified otherwise, you can presume values are from the Kodak scale whenever a sequence of filter values is quoted. Do not presume, however, that all filter values are in the commonly used Y M C sequence (as used by Agfa, for example). Kodak quote figures in the reverse order, C M Y. Stick to one or other of these two orders.

An important additional component of the filter pack is an ultraviolet absorbing filter such as the Kodak Wratten 2B. This ensures that the small element of ultraviolet light from the enlarger does not affect the print. To save yourself the effort of inserting it into the pack each time you make up a new combination, the ultraviolet filter can be left in the enlarger permanently, taped to the top of the condenser or light box. If your enlarger tends to run hot, you should use a heat absorbing filter to protect the negative and the colour correction filters. Exposure to excessive heat over a long period may cause dyes to fade.

When you change paper

When you change to a new batch of paper there is no need to repeat all your tests. You can work out the new filtration by subtracting the old paper adjustment from your filter pack, then adding the new adjustment. Plus or minus values are quoted by Kodak, whereas Agfa quote a basic filter pack. If, for example, you used (145 85 —) filtration and paper with the adjustment +10Y —10M, a new batch of paper with the adjustment +15Y —05M requires (150 90 —) filtration. The new exposure is worked out by multiplying the old time (say 28 secs) by the new paper factor and dividing by the old factor (70, below). This gives a time, in this example, of 32 secs if the new paper factor is 80

Which combination?

The appearance of the test print made for exposure time—the zero filtration print—gives some idea of the kind of correction that may be needed. Once you are very experienced you may be able to gauge the combination of filters needed for correct colour on the basis of the exposure test print alone. But to start with, you will probably need to make further tests.

When deciding on the filtration that each negative needs, the most important point to remember is that you remove a colour cast by adding a filter of the same colour to the filter pack. A yellow cast, for example, would be reduced by a yellow filter. Colour casts in colours other than the complementaries are reduced by using appropriate combinations. Red is half way between yellow and magenta, so a red cast is corrected by yellow and magenta filters of equal strength. For an orange cast, a slightly stronger yellow and a weaker magenta is needed. To correct for a strong cast, strong filters are needed; for a weak cast, only weak filters are needed.

Every colour cast can be corrected by using just two filters out of a set of two out of the three filter colours; using three simply reduces the light intensity. If you find yourself with a combination of three filter colours, simply remove the weakest one and deduct the strength of the colour you have removed from the other two. A (60 20 10) should therefore be adjusted to a (50 10 —). This has exactly the same effect on the colour balance.

You should also try to use as little filtration as necessary. Make adjustments by removing filters if possible, because filters reduce the amount of light falling on the paper and so affect exposure. Adding a filter usually means increasing the exposure by an amount corresponding to the strength of the filter.

Try also to use a single high value filter rather than a number of low value filters. For a 50, for instance, a single 50 filter is better than a combination of 20 + 20 + 10.

Test prints

There are two factors to bear in mind when deciding what filters to use for the test. First, every batch of paper has slightly different colour response; the filter combination needed to correct any bias is usually marked on the packet. Second, uncorrected, the tungsten light of the enlarger bulb gives a red cast to the picture—yellow and magenta filters are required to correct this. Correction for the paper and the reddish cast, then, can provide your starting point for tests.

To save time and expense, you can make four separate filter combination tests on a single sheet of paper, using a quarter of the sheet for each exposure. In these *quadrant* tests, four separate exposures are made using different combinations of filters. For each exposure, three quarters of the print are masked off while the fourth is exposed.

Filtering aids

If you have real difficulty working out the filters needed to correct a cast, you may find so-called filter mosaics or matrices provide a useful short cut. The Unicolor/Mitchell Duocube shown below is typical and widely available. It is composed of two matricies of colour printing filters, together with an exposure scale. The device is laid on contact with a sheet of paper and is exposed to the diffused image of the negative. The theory behind the use of a device such as this one is that an ideal 'average' scene contains equal amounts of all visible colours (white light). In theory, if white light is used to print a negative the resulting image, when diffused, should remain white, or neutral grey. But the quality of the printing light normally has to be adjusted in order to produce this neutral grey. This is done using the appropriate correction filters. Devices such as the Duocube employ specific filter combinations (122) and one of these will normally be sufficient to correct the printing light. You simply read off the filter combination which corresponds to the most neutral looking grey on the contact print image, add this to your filter drawer and make a corrected print. Obviously the theory does not hold true if you use a shot containing a large area of one colour. But the makers point out that about 90 per cent of all scenes should diffuse to a neutral grey (which, incidentally, is regarded as a dark white). To be successful, you still have to make the first few exposure and filtration tests to establish the correct control prints for your later work.

Clear instructions are provided.

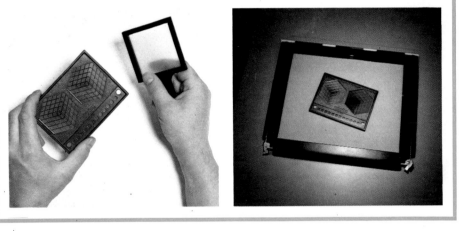

Two main quadrant tests are needed: one to establish the strength or *density* of the cast; the other to establish the precise colour of the cast.

When making these tests you must remember to adjust the exposure time to take into account the absorbtion by the colour filters. Manufacturers supply tables for various filter permutations and all you have to do is read off the exposure factor for a particular combination of values. Multiply the basic exposure by this factor to obtain a corrected printing time for each of these filtration tests. Later, whenever you change filtration, remember to apply any necessary exposure correction.

Process the print and wash and dry it carefully before making any assessment —if possible in normal daylight or under the type of lighting which will be used for viewing the final print.

Usually, one of the quadrants will show roughly the correct colour balance. If not, then you must repeat the density test with different filter packs until you find roughly the right combination. Once you have established roughly the right combination, you can move on to the second test using slight variations of this combination.

Fine tuning

The second test is essentially fine tuning to establish the precise colour cast. However, there is usually a hint of second cast in another colour and the second test also establishes the filter combination to correct this. This stage is explained in more detail in a subsequent article because, even although the principles of colour correction are exactly the same, the noticeable but slight colour casts can sometimes be extremely difficult to isolate and need special techniques to correct.

However, you can make a useful practical start by making simple, low value corrections to the filter pack which give the best density correction of the main colour cast. If, for example, a reddish cast is corrected for red but shows a tinge of magenta in the resulting print, you can either add a little extra magenta filtration or increase the proportion of magenta by removing a corresponding amount of yellow filtration. There is a slight difference if you compare the colour balance of the two prints that result. Try to keep your experimental corrections to low value filters (05 and 10).

The main print

When you have established the correct filtration for your negative, apply the necessary exposure corrections and make the print. If possible, produce two, and keep one safely stored for reference purposes. Make a special point of writing all the exposure information on a label stuck to the back of this print, including details of the paper you have used (see panel).

Identifying colour casts

In some cases, it can be difficult to identify the colours which make up a colour cast—even experienced printers can be misled. The problem is isolating the secondary colour which tints a cast predominantly consisting of another colour—you might have trouble, for instance, with red and magenta, or with blue and cyan. A mistake in this assessment can lead you in completely the wrong direction with your filtration adjustments.

It is helpful to look at the components of colour casts in terms of the filters you can use to correct them—bear in mind the principle of the subtractive printing system. The table on this page shows the breakdown of intermediate colours, formed by the combination of the colours above and below them. The six major colours require correction filters in equal proportions, whereas the intermediate ones require one filter in twice the proportion of the other—a yellow –green cast requires twice as much yellow filtration as cyan.

This makes correction of the intermediate colours simpler. For example, suppose you have a colour cast which you think might be violet or carmine. Since both these casts are partly corrected by magenta filtration, base your initial correction on this colour. The second test print will then show whether the cast was in fact carmine or violet—if it was violet, it will show a cyan cast, because cyan filtration was required, while if it was carmine, a yellow cast in the second print will show the need for yellow filtration.

The presence of a secondary colour cast helps you to cross check the original colour of the cast. If, for example, you are dealing with a cast which could be cyan based but looks blue, you can establish which it is in two steps. Blue requires the addition of blue (M + C) filtration, or the removal of yellow. Cyan requires the addition of red (Y + M). Always start with the smallest change in filtration, if possible—in this case, by assuming that the cast is blue, and removing yellow.

Make your next print—if this shows only a slight secondary cast, the assumption that the original cast was blue-based was correct. If, on the other hand, the second print shows a greenish cast, the first cast did have a cyan base. Go back to your original setting, and change filtration for cyan correction, noting down each successive stage, until you achieve colour balance.

Despite taking the utmost care in your testing, there will inevitably be some images where correction can only be made to some of the colours. This is often the result of failure in the reproduction capabilities of the film–paper combination. For this reason, it is usually a good idea to match films and printing papers of the same brand. Similar problems may arise when you change to a different brand of processing chemicals, or even to another batch of

Cast correction

Colour cast	Add	(or) subtract
Yellow (Y)	Y	M + C
Orange (Y + R)	2Y + M	
Red (R)	Y + M	C
Carmine (R + M)	Y + 2M	
Magenta (M)	M	C + Y
Violet (M + B)	2M + C	
Blue (B)	M + C	Y
Ice Blue (B + C)	M + 2C	
Cyan (C)	C	M + Y
Sea green (C + G)	2C + Y	
Green (G)	C + Y	M
Yellow green (G + Y)	C + 2Y	
Yellow (Y)	Y	M + C

This table shows how colours can be 'broken down' into meaningful colour mixtures so corrections can be made using yellow, magenta and cyan filters in subtractive neg–pos colour printing. The presence of a figure 2 indicates that approximately twice as much of this colour is present in the combination. For example, violet requires twice as much magenta correction as cyan

paper. In these cases, there is little you can do—but bear in mind that when there is a choice between a 'cool' and a 'warm' cast, the latter is almost always preferable.

Print viewing filters

You can estimate the effect of a given colour cast simply by placing a filter complementary to that colour over your colour test print. A print with a cyan cast, for example, looks better when viewed through a red filter—the great advantage of this system is that you can actually see the effects of a filter without going to the trouble of making a test print.

You can even make up packs for print viewing, which is an excellent way of determining in which direction your corrections should go. To do this,

Troublesome casts *If you have difficulty identifying the precise colour of a cast you can easily go wrong when making a correction. The table (right) plots the likely result and puts you back on the right track. For instance, many people confuse cyan and green, particularly if there is a trace of another colour in the cast. In the example (below left), assume that the first print has a green cast and make the appropriate corrections to remove this. Now, if the cast was indeed green, and you had made the right corrections, no major cast should be present on the second print. This is represented by the plain square in the green 'assumed cast' column in the table at right. But if a cast is present on the second print (below centre), locate this colour in the same column and trace left to find what was the actual cast on that first print. The presence of a blue cast on the second print means that the actual cast on the first print was cyan, not green. You can either correct the second print filtration or return to the first print filtration figures to make the necessary adjustment to balance (below right).*

Excessive filtration of the correct filter colour results in a cast in the complementary colour, whereas insufficient filtration will leave a cast in the same colour. So had we assumed correctly that the cast on the first print was cyan but had overcorrected, a red cast would result. To cross-check this on the table would suggest that the original cast was red, not cyan. But it is rather unlikely that anyone would confuse a colour with its complementary. If this happens, the corrective filtration used for the second print must be reduced.

The abbreviations in the table stand for the following colours: C, cyan; R-M, red-magenta; B-M, blue-magenta; B-C, blue-cyan; G-C, green-cyan; B, blue; G, green; Y-G, yellow-green; Y, yellow; O, orange; R, red; and and M, magenta

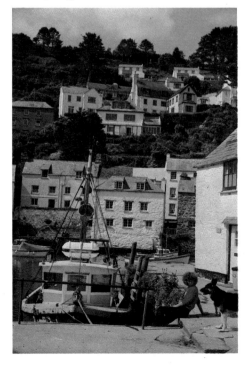

Cast identification table

Actual cast on first print	Assumed cast on first print						
	YELLOW	RED	MAGENTA	BLUE	CYAN	GREEN	YELLOW
	Colour cast on second test print						
YELLOW		G	Y-G	Y	O	R	
RED	M		Y	O	R	R-M	M
MAGENTA	B-M			R	R-M	M	
BLUE		B-C	C		M	B-M	
CYAN	B-C	C	G-C	G			B-C
GREEN	C	G-C	G	Y-G	Y		C

proceed in exactly the same way as you would in printing but subtract the colour which appears to correct your first print, or add the complementary. Then, make the change which seems acceptable in the filter pack for the actual exposure.

One problem with this method is that you have to gauge how much filtration to introduce in the enlarger, simply by viewing the print through a filter. As a rough guide, if the print looks right when viewed through the viewing filter, halve that filter value for the enlarger and use filters the same colour as the cast—complementary in colour to the viewing filter. Thus, if a strong cyan cast is corrected by viewing with a 20R filter, use 10 units of cyan correction when adjusting the filter pack or colour head for the next print. If the viewing filter overcorrects the cast, try a lighter one, or apply even less correction, say 5 units. If the filter corrects the cast when actually laid on the print, try using the same unit correction.

Making a ring-around
Making tests is the quickest way to produce a colour print. But the best way to get to know about colour casts is to print them deliberately, in a controlled way. One way of doing this is to make a *ring-around*—a range of possible casts —which you can use for reference when checking later on. For this, you need to make a number of colour prints.

To save paper, use a masking easel, such as the Durst Comask, which allows you to make four prints on a single sheet of paper. Choose as your standard reference negative one which has as wide a range of colours and tones as possible, and make a perfect print from this. Next, take a sheet of colour paper and make four exposures on it, all with correct filtration but with different exposures—one correctly exposed, the others with ¼, ½ and double the exposure.

On another sheet, make a correctly exposed and colour balanced print, and three more, with 10, 20 and 40 units of any colour cast—use a cyan filter, for example, to produce a red cast. Remember to adjust exposure for each of these prints. Make similar sheets for all five other colour casts. Remember to make a note of all information for each exposure you make. You should now have a range of seven prints, each with four exposures, and one each for yellow, blue, magenta, green, red and cyan casts.

If your negative is representative of your work, you can use this ring-a-round to determine filtration for future prints, by comparing them with the appropriate cast in your selection. It is then a simple matter, in most cases, to establish what filtration to use.

Processing routine
Even the most accurate filtration and exposure tests are useless if you do not take the same amount of care over your processing. This means scrupulous control over processing times and temperatures, as well as cleanliness of all processing equipment. Colour processing, especially drum processing, takes longer than black and white, and this can be tedious sometimes. Do not, however, be tempted to take any 'short cuts'—this can lead to contaminated solutions, and colour casts or blotches on your prints.

The most important aspect is the sequence itself. In each stage, you must decant small quantities of chemicals without spilling, and discard them after use—all this while keeping an eye on both temperatures and the clock. It is essential to practise the sequence—the more you are used to it, the less likely you are to panic, and spoil your results or contaminate solutions.

There are two methods of temperature control in colour printing: the pre-soak method, in which the tank, previously soaked in hot water, transfers heat to the developer; or the conventional waterbath method—which keeps solutions at a constant temperature. The first is convenient in that it does not require you to set up a water bath, but you can run into problems with temperature control because of the many variables involved. If, for instance, you do not take into account the room temperature, the accuracy of your whole process can be placed in jeopardy.

The best way to ensure accuracy is to make your whole procedure as simple as possible—prepare everything beforehand, so that when you start your run there is little chance that anything will go wrong—it will be all the easier to repeat your routine for consistently good results.

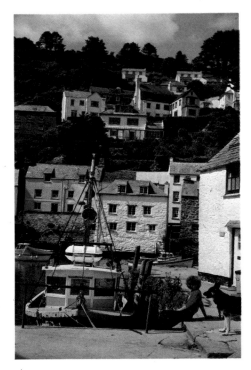

Chapter 5
COLOUR SLIDE PROCESSES
Processing slide film

There are two slide processes suitable for home use. One is matched to the Kodak Ektachrome system and is called the Ektachrome Process E-6 (which is shortened, simply, to 'E-6). The other is matched to the Agfachrome system and is called Process 41, or P41.

You can process any E-6 compatible film using either Kodak's own E-6 process kit or the E-6 kits from independent manufacturers, of which there are several. Suitable E-6 films include the Ektachromes, Fujichrome and a number of 'own label' brands. If you are in any doubt, check the processing instructions which accompany the film carton for mention of E-6. You cannot, for example, process Kodachrome, or films intended for E-4 processing.

The P41 process is used for Agfachrome type films. The choice of films varies from country to country but the true Agfachrome (50L, 50S and 100 Professional) are widely available.

Each system has its pros and cons. You might find that one process gives more faithful colour rendering, or that it produces more brilliant, saturated colours. Agfa takes longer to process, but the E-6 process requires higher temperatures, needing careful control. Even with E-6, a water bath is usually adequate for maintaining the correct temperature, but for complete reliability a processing machine has several advantages. Not only does it keep temperature constant, but it agitates the tank evenly, taking the drudgery out of the job, and guarantees absolute consistency.

The E-6 process

The latent image, recorded in the three emulsion layers of the film, is developed in complete darkness by the first developer. This produces a negative image composed of layers of metallic silver which is similar to an ordinary black and white negative. The action of this developer, however, is much more sophisticated than that of an ordinary developer. Ultimately, it is responsible for the overall density of the image, as well as governing the formation and reproduction of its colours. It is the single most important stage in the whole process—and one of only two where time and temperature are critical factors.

The standard processing temperature for E-6 is 38°C, with a maximum leeway during first development of plus or minus 0.3°C. The normal first development time is six minutes using the Kodak chemicals. All the usual precautions over time, temperature and agitation must be taken to prevent unintentional over or underdevelopment.

A brief two to three minute wash follows first development. You can use several changes of rinse water at between 33°C and 39°C if running water at this temperature is not available. You may use spare water from a water bath for this job, but it must be completely uncontaminated by process chemicals.

The wash removes excess developer and so prevents the development from continuing. The next stage is a reversal bath of two to three minutes duration, again using solution at a temperature of between 33°C and 39°C. In the reversal bath, the emulsion becomes laden with a potentially active reversal agent. This activity is triggered by the colour developer which follows. Fogging centres form on all the silver halides which were left unexposed by the camera exposure, and were therefore left untouched by the first developer. This is an essential part of the colour formation phase, and it is important not to give less than a minimum time in this bath.

It is safe at this stage for you to open the processing tank and continue with

Better colour *A transparency is viewed by transmitted light, and shows more brilliant colours and greater contrast than a print*

the remaining steps in full lighting. You may find it less troublesome, however, to continue with the film safely contained within its tank. The film now looks like a very dense but unfixed black and white negative film.

The residual silver halide, which is now developable, is converted to a dye image by the colour developer at 38°C ± 0.6°C. The duration of this bath is between six and eight minutes. To make sure that the colour developer acts quickly, agitate the tank continuously for the first half minute.

Colour couplers contained within the three emulsion layers react with the colour developer to produce the yellow component in one layer, the magenta component in another, and the cyan component in the third layer. Dye is formed only in those areas where no metallic silver formed during first development.

If you look at the film at this stage there is no sign of colour—all you see is dense black because the image dyes are still covered by metallic silver. The function of subsequent processing stages

is to remove the silver formed during the first and second development, leaving behind only dyes which combine to form a coloured image.

In some E-6 processes, including Kodak's own, an intermediate conditioning bath follows. This effectively neutralizes the actions of the colour developer as well as inhibiting undesirable secondary reactions, which can lead to streaks or patches of coloured fog. A more conventional stop bath is used in some other E-6 processes. The duration, in either case, is two to three minutes at a temperature of between 33°C and 39°C, a range used for all other processing stages which follow. If a conditioning or stop bath is not used, a one minute rinse in several changes of water should be sufficient to clear excess colour developer.

The bleach bath which follows converts the metallic silver and certain other waste products into compounds that are easily removed afterwards by immersing the film in a fixing bath. In some E-6 process kits, these two baths are combined. Whatever form is used it is important to bleach and fix for at least the time recommended. There is no harm, however, in prolonging this stage if you are uncertain about the strength of the solutions or if the temperature has dropped slightly.

The water soluble compounds can now be removed in the final wash. Wash the film for about four minutes using running water within the process temperature range. Use a succession of individual rinses if this is more convenient.

An optional but recommended final stage is to immerse the film in stabilizer before hanging it up to dry in a suitable dust-free position.

Uprating with E-6

By making small adjustments to the first development period, it is possible to obtain acceptable transparencies from films which have been exposed at other than normal film speed ratings. While this is true for all user-processed slide films, Ektachrome type films respond particularly well to this treatment. There is inevitably a loss of picture quality, but this is usually tolerable if the only alternative would have been not taking the pictures.

A film knowingly underexposed by one stop—that is, exposed as if it were a basically faster film—can be rescued by increasing first development from six to eight minutes. One and a half stops underexposure requires increasing the time to ten minutes; two stops underexposure by a further minute and a half. The limit of correction in the case of overexposure is about one stop, achieved by reducing the first development to four minutes.

In conjunction with the faster Ektachromes, increased first development can yield some impressive film speeds which are very useful for various fields of photography where low light poses a problem. If you intend to uprate your film for work of this kind, make a series of test exposures and try out various first development times before committing yourself.

Agfachrome processing

The Agfa P41 process differs from the E-6 process in one important respect. Whereas image reversal is achieved entirely by chemical means in the E-6 process, in the P41 process the film has to be re-exposed to white light at a point between the first development and colour development stages. This is done simply enough by removing the film from the processing tank and exposing it to a suitable bright lamp. All subsequent processing stages may continue outside the tank if this is more convenient.

The duration of this second exposure depends on the strength of the lamp you use and its distance from the film. It must be sufficient to fog all the unused silver halides which remain in the film after first development. If the lamp you use is sufficiently bright, you do not need to remove the film from a plastic spiral. A 150 watt bulb is ideal. Remove the spiral from the tank and expose each side for about a minute at a distance of about 30 cm from the bulb. Be careful not to splash the hot lamp as the bulb may

1 *Pour measured amounts of solutions into bottles and place them in the water bath or processing machine*

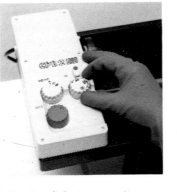

2 *Set the right temperature on the machine, or fill the water bath with water at the process temperature*

3 *Check the temperature of the water bath. A machine may take some time to reach the correct heat*

4 *Pour the first developer into the tank. If using a machine, quickly place the tank in its revolving mount*

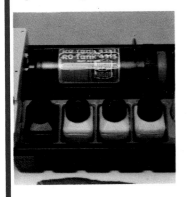

5 *Agitate the tank during the development time. Drain the developer and rinse the film ready for reversal*

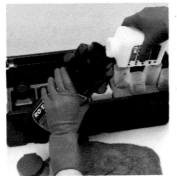

6 *With the E-6 process, pour in the reversal bath. Rinse, pour in colour developer and wash, ready for bleaching*

7 *With the P41 process, re-expose the film as shown. Replace it in the tank, give colour development and wash*

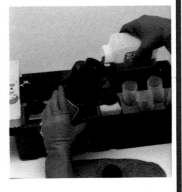

8 *Pour in bleach, rinse, fix and wash as instructed. Some kits combine bleach and fix, eliminating one stage*

shatter. If you use a more powerful bulb, keep the film far enough away to avoid scorching the film.

A stainless steel spiral cuts out too much of the light, so if you are using one of these, first remove the film. Do this carefully so you do not damage the emulsion which is very delicate when wet. For short lengths, hold the film taut, an end in each hand, and seesaw the film past the lamp. Make sure every part of the film receives at least a minute's exposure and, to be on the safe side, expose both sides of the film.

This technique can prove difficult for long lengths of film and a useful way to get around the problem is to unspool the film carefully into a white bowl containing water at, or near, the correct process temperature. Point the lamp into the bowl and give a two minute exposure, rotating the bowl so that every part of the film receives sufficient exposure. Afterwards, place the spiral in the bowl and carefully respool the film—you will find it safer, and easier, to do this under water.

This method has certain advantages and it is therefore worth adopting even when you are using a plastic spiral. The water protects the film from excessive lamp heat, and the bowl ensures all-round exposure. Simply place the loaded spiral flat within the bowl and expose each side in turn—again, for about a minute at 30 cm from a 150 W bulb.

Because of the varying colour output of different types of tube, fluorescent lighting is not always suitable for the fogging exposure. So use only tungsten lighting—or even daylight if a bright enough bulb is not available—to make sure that the colour balance of the film is not put at risk.

Whatever form of lighting you use, make a point of giving more exposure if you are in any doubt. Excessive re-exposure has little effect on final results —in fact all remaining processing stages may be carried out in full lighting, as in the case of the E-6 process.

In other respects, the Agfa P41 process broadly resembles the E-6 process, but it does not normally end with a stabilizer bath, in common with some of the independent E-6 process kits. Two process temperatures—20°C or 24°C—may be used, the lower one being suitable where temperature control may present problems. The whole P41 process, which includes more intermediate (washing) stages than the E-6 process, is particularly lengthy and this point should be considered when planning your working methods.

Uprating Agfachromes

The Agfachromes can be processed to correct for small errors in exposure. As for Ektachromes in the E-6 process, this is done by making small adjustments to the first development time. Although it is best to establish your own times, by trial and error, for future adjustments to the standard Agfachrome film speeds, as a guide you can correct under-exposure and overexposure of about one stop by lengthening or shortening first development by 20 per cent. This would mean, for example, increasing the normal first development time of 13½ minutes (in the 24°C process) to 16 minutes to correct for a known case of one stop underexposure—or shortening it to 11 minutes in the case of one stop overexposure. Fractional corrections can also be made—a half stop exposure error can be corrected by a 10 per cent change in first development.

Changes to first development do not affect the relative grades of contrast within a picture, but any increase of first development reduces the density of the darkest, least exposed areas of the film. Up to about a one stop correction has little significant effect on the colour quality of the image. It is possible, however, to raise film speeds beyond this point by making substantial changes to the first development time. If you can accept the inevitable loss of colour quality, such uprating techniques offer some intriguing possibilities, which are discussed fully in a subsequent article.

Capacity and storage

For consistent results you should always use fresh solution, but for maximum economy you can process several films more than recommended with a given amount. Beyond a certain point, however, quality of results inevitably suffers. Kits contain detailed instructions for re-using solution. Follow them closely when mixing chemicals, and always wear gloves, because some can cause skin irritation. Keep chemicals in clearly labelled bottles, out of harm's way, and only mix up what you need, because developer solutions do not keep well.

Colour slide film processing

Processing stages	Kodak Ektachrome Process E-6 Time mins	Temp°C	Photocolor Chrome-Six Time mins	Temp°C	Unicolor E-6 Time mins	Temp°C	Agfachrome P41 at 20/C Time mins	Temp°C	Agfachrome P41 at 24/C Time mins	Temp°C
Preheat	–		1	43	1	40.6	–	–	–	–
First developer	6	38±0.3	6½	38	6½	40.6	19	20±0.2	13½	24±0.2
Wash	1½–3	33–39	2	34–42	2–3	40.6	1/4	14–20	1/4	20–24
Stop bath	–		–		–	–	4	18–20	3	22–24
All remaining processing may be carried out in normal lighting										
Wash	–		–		–	–	10	14–20	7	20–24
Reversal bath	1½–3	33–39	2	34–42	2	40.6	–		–	
Re-exposure	–		–		–	–	see footnote		see footnote	
Colour developer	6–8	38±0.6	6	38	6	40.6	14	20±0.5	11	24±0.2
Conditioner	1½–3	–	–		–	–	–	–	–	–
Stop bath	–		–		1–2	32–43	–	–	–	–
Wash	–		1	34–42	2–3	32–34	20	14–20	14	20–24
Bleach	6–8	33–39	–		3–4	32–43	5	18–20	4	22–24
Wash	–	–	–		–	–	5	14–20	4	20–24
Fix	3–6	33–39	–		2–3	32–43	5	18–20	4	22–24
Bleach Fix	–		8	34–42	–	–	–	–	–	–
Wash	1½–4	33–39	4	34–42	2–3	32–43	10	14–20	7	20–24
Stabilizer	½–3	33–39	–		1–½	Ambient	–	–	–	–
Dry	Below 60									
Total time (ex dry)	27½–44 minutes		30½ minutes		28–34½ minutes		93¼ minutes		68¾ minutes	

Notes: a) For the re-exposure of Agfachrome, hold film 30 cm from 100/150W bulb for one minute each side
b) Another widely available E-6 kit is Tetenal's UK6. Use and times are almost identical to standard E-6

Cibachrome prints

Many photographers are put off making prints from colour slides by disappointing and expensive commercial results. But with thorough attention to detail, prints made from slides at home can be as good as the best prints from negatives.

If you are used to printing from negatives, you may think that making prints from colour slides involves complicated techniques. In fact, printing from slides can often be simpler than printing from negatives. Unlike negatives, though, slides give a positive image on the enlarger baseboard. So you can make your estimates for colour filtration on the basis of the colours as they appeared in the original scene, not as complementaries.

Paper for printing from slides also allows a far wider margin of error in exposure and colour filtration. In fact, you can dispense with the coarse and fine filter tests which are normal for negative printing, and make just a single exposure test and a single filter test. These two tests will serve for a complete batch of similar slides. Most slide paper can be also processed at temperatures anywhere from 20°C to 28°C.

There are two systems for home printing of colour prints from slides. This article explains the Ilford Cibachrome-A process: a subsequent article covers the Kodak Ektachrome R14 system and the similar Agfachrome PE system. Ilford market a special version of the Cibachrome-A system in a 'Discovery Kit'. This contains almost everything you need to make prints from slides in an ordinary darkroom. As well as a comprehensive and very informative manual on the process, the kit contains developer, bleach, fix, neutralizer, three measuring cylinders, a packet of paper, a developing drum and a selection of colour printing filters.

Paper for the Cibachrome process comes in two forms: a normal resin-coated paper; and a version that is not really 'paper' but a thin layer of plastic

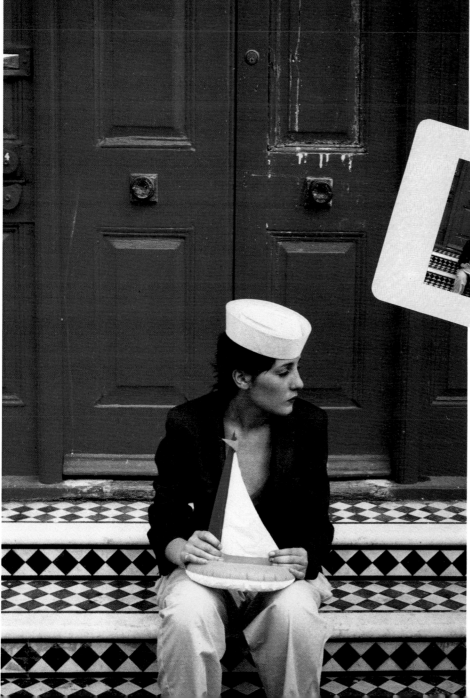

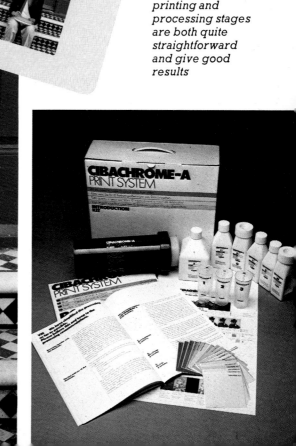

Slide print
Cibachrome can produce very good quality images. The kit (below) contains almost everything you need to make your own prints from slides. The printing and processing stages are both quite straightforward and give good results

Printing Cibachrome

1 *Clean the slide carefully before placing it in the negative carrier, if necessary removing the slide from its mount beforehand*

2 *Check the label on the back of the Cibachrome packet to find the starting filters for your slide film. Place these (+UV) in the filter tray*

3 *For a quadrant test, you need to use a mask. You can cut one from the piece of card supplied in the Cibachrome packet. Remove one corner only*

4 *You may find it worthwhile investing in a purpose-made four-flapped masking easel, such as the Durst Comask here, for making separate test exposures*

5 *In complete darkness, remove a sheet of Cibachrome and place it on your easel. Expose the first quadrant for, say, 25 seconds at f/16*

6 *Complete a range of test exposures (as shown opposite) simply by adjusting the apertures. The lightest quadrant (f/5.6) is best but too yellow*

carrying three emulsion layers. Colour dyes are produced in these layers after processing, and these combine to form a colour positive image. The emulsion side of the paper is dark brown before development. You can identify this side in darkness by stroking the extreme corner of a sheet with a finger nail. The underside 'rustles' slightly and does not feel as smooth.

Paper should not be stored anywhere warmer than 20°C and if kept for periods of a month or so should be stored in a refrigerator. Paper kept in a refrigerator should be sealed in its original package. Remove it from the refrigerator a few hours before use so that it slowly returns to room temperature.

Like all colour paper, Cibachrome paper is extremely sensitive to all forms of light. There is no 'safe' light and it should be handled only in absolute darkness. The only time it should see the light is during the actual exposure. Once opened, the bag should be double folded and taped. Try to prevent any stray light from the enlarger or timer reaching the paper.

The chemicals

The Cibachrome process involves three main stages—development, bleaching and fixing—and a final wash and dry. Cibachrome developer is similar to developers for black and white work and, in fact, is used to produce a black and white negative image. The colour image is actually formed in the bleach bath, which is really the key to the Cibachrome process. As well as reversing the image to positive, it also bleaches out the unwanted dyes in each of the emulsion layers.

Follow carefully the maker's instruc-

tions for diluting the various powders and liquid concentrates. For comfort, prepare the solutions in a well ventilated room. Some of the chemicals are harmful and you should wear rubber gloves while mixing and using the solutions. Put all the chemicals safely away in properly labelled bottles when you finish.

The bleach, in particular, is extremely corrosive and must be handled and disposed of with great care. Untreated bleach can severely damage exposed metal finish on sinks and worktops. You cannot simply throw used bleach down the sink, it must be properly neutralized. Each kit contains neutralizing powder for the bleach and a capful of this should be put in a suitable waste container each time a print is made. Used developer, fixer and bleach removed from the processing drum must also be put into

Start the processing sequence by holding the drum vertically and pouring in the measured quantity of developer. Check the temperature in the developer reservoir immediately, holding the thermometer bulb well below the surface. If the temperature has dropped at all, you must adjust the developing time accordingly.

Developing time is two minutes at 24°C but remember that this includes the time taken to empty the old solution and pour in the new. A tank such as the Cibachrome/Durst takes 10 or 15 seconds to drain completely, and there is a delay of about 5 seconds as the new solution starts to work. To allow for this, you must begin to pour out the developer after 1 minute 40 seconds. To start development, tip the tank on its side and then roll it evenly backwards and forwards, rolling it at least a full revolution in each direction. When the developing time is up, pour the used developer into a container containing neutralizing powder.

For the bleach and fix stages, follow the same procedure as for development, but beware of cutting short either of the two baths. It is usually better to allow the bleaching and fixing to go on slightly longer rather than risking incomplete processing.

While the neutralizer is at work on the discarded solutions, remove the print from the drum and wash it for 3 minutes in running water at 24°C. Take great care when removing the print from the drum as a fresh wet Cibachrome print has a very soft surface that is very easily scratched and damaged.

After washing, lay the sheet on blotting paper and remove excess water. It takes about two hours for prints to dry naturally as the emulsion layers are very thick. You can use a hot air fan, such as a hair drier, to dry prints in five to ten minutes, but do not damage the print by overheating. Only when it is completely dry can you assess the true colours of a Cibachrome print, since wet Cibachrome has a reddish tint.

Your enlarger

All the necessary filters for colour printing are contained in the Cibachrome kit and providing your enlarger has a filter drawer, a good lens and a fairly bright lamp (100 or 150 watts), filtration and exposure should prove simple. If your enlarger has no heat absorbing filter, however, it may be worth installing one to protect your slides and filters from the heat of the lamp. You can, of course, use a colour head for printing slides if your enlarger is fitted with one. A good quality enlarger lens is essential for top quality results. Cibachrome yields an exceptionally sharp image, and it would be a pity not to take advantage of this valuable characteristic by using a lens of poor quality. To maintain full colour saturation also make sure that you contain all possible sources of stray light in the darkroom. Make a special check of any temporary blackout.

this waste container for neutralizing. When you pour in the waste, it will start to froth. This is nothing to worry about—it is simply the neutralizer working. The waste can be thrown away only when the frothing stops.

You must also use neutralizer powder before mixing any of the discharged chemicals to prevent a foul smell from the sulphur dioxide that is otherwise unleashed.

The print drum

The Cibachrome process normally uses a print drum, like that for processing prints from colour negatives. It must be perfectly clean and dry before processing begins. The exposed print is loaded in total darkness with the emulsion side facing inwards. Once the top has been replaced, the print can be processed in normal room lighting.

Processing Cibachrome

With the Cibachrome kit, processing is relatively straightforward and, providing you pay close attention to detail, you should have no problems.

Mix and prepare the solutions in bulk to provide a reservoir for the whole session: draw off measured quantities of solution from these reservoirs for each individual processing cycle. Place the reservoirs in a water bath well before you start to bring them up to the correct processing temperature. The optimum temperature is 24°C but Cibachrome can be used at various other temperatures.

When you have loaded the print drum, measure out sufficient developer to process the print into the appropriate numbered beakers. The quantity required varies from drum to drum: the Cibachrome/Durst drum, for instance, needs 90 ml of solution.

Printing procedure

Slides that have a wide contrast range do not print very well and you should begin with a fairly soft looking slide—preferably one that is completely sharp and perfectly exposed. Try to select a slide that has a good range of colours, including skin tones and this print can be used as a reference for the future.

Before placing the slide in the negative carrier of the enlarger, remove it from its mount and use a blower brush to remove any specks of dust.

Like colour negatives, some colour correction is needed with slides to give good colour balance. This can be done either with normal colour correction filters in a filter drawer or with the enlarger's colour head, if it has one. Filters for printing from slides are, like those for subtractive printing from negatives, in the complementary colours:

yellow (Y), magenta (M) and cyan (C). They are usually referred to in this order. The filtration needed for a particular slide can be written in the form (50 30 00), which signifies a 50 yellow, a 30 magenta and no cyan. You should never use all three colours together, and use as few as possible in each filter pack.

A table of suggested starting filter values for different makes of slides are printed on each pack of Cibachrome paper. These batch values vary and Ilford carry out tests on each batch of paper to find out the closest starting filters to use. A typical filter pack combination might be (10 00 00) for slides taken on Kodachrome, (15 05 00) for Ektachrome, (15 10 00) for Agfachrome, and (20 05 00) for Fujichrome. Older transparencies and those taken under studio lighting will usually need stronger filtration.

Start the printing sequence by preparing the suggested filter pack. An ultraviolet absorbing filter (supplied in the Cibachrome filter set) must be incorporated within the pack to eliminate ultraviolet from the enlarger lamp.

The first test print is used to establish the correct exposure for the type of slide you are printing. Use a complete sheet of paper for the test rather than a small strip. This not only makes processing easier—because a full sheet fits more securely in the drum—but also makes judging exposure easier on a print with a wide range of colours. Because of the wide exposure latitude of Cibachrome, try fairly large exposure steps to start with.

Ilford recommend a 'four-square' test, altering the enlarger lens aperture rather than using different exposure times. A separate exposure of, say, 25

Processing Cibachrome

1 *Mix up the various process chemicals following the maker's instructions. Take care to avoid splashes and direct contact with the chemicals*

2 *Pour enough solution for your immediate needs into containers placed in a waterbath at the correct process temperature. Store the rest*

3 *Before each print, measure off a capful of neutralizing powder and pour this in your dump bucket which should be empty of previous solutions*

5 *Check that solution temperatures are at the correct level. Measure off some developer (typically 90 ml), charge the drum, and tip this to begin the process*

6 *Remembering to allow for draining and recharging in your timing, pour off the developer and continue with the bleach and fix, neutralizing as you proceed*

7 *Wash the print in the drum or, better still, in a dish for 3 minutes under running water. The print can then be blotted and dried as usual*

seconds, is made on each quarter of the print and for each exposure the lens aperture is changed, giving exposures at f/5.6, f/8, f/11, and f/16, for example. This is fine if you have a good quality enlarger lens and have focused the printing image sharply but may allow little margin for error if the correct exposure requires an aperture of f/5.6 or wider. If you find it difficult to achieve pin-sharp prints using this method, repeat the test but keep the aperture constant and try varying the exposure times. Avoid exposures longer than a minute.

The most convenient way to make four separate exposures on a single sheet of paper is to use a four-flapped masking frame. A cheaper alternative is a print-sized piece of card with one quarter cut away. The Cibachrome paper pack contains two suitable pieces of card. All

4 *After exposing the print, place it emulsion side inwards in a cleaned and dried print drum. Handle the print by its edges only*

Cibachrome filter factors

A set of printing filters is provided with the Cibachrome Discovery Kit. As any filter absorbs part of the light, a correction factor is used to maintain correct density during printing. This varies with the filter used:

Filter value	Yellow	Magenta	Cyan
00	1.0	1.0	1.0
05	1.1	1.2	1.1
10	1.1	1.3	1.2
20	1.1	1.5	1.3
30	1.1	1.7	1.4
40	1.1	1.9	1.5
50	1.1	2.1	1.6

If you make your first print using the suggested starting filters, but colour correction is needed, find the new exposure by multiplying the original time by the new filter factor and dividing it by the original factor

Abstract in shadows *Sharpness and good red and black reproduction are Cibachrome's strong points—capitalize on these by carefully choosing the slides you print and avoid using high contrast slides*

tests and exposures should be made in complete darkness. Make sure the print drum is ready, and can be easily and safely located once you have switched off the enlarger light.

After making the test print, process the print and examine it to establish the correct exposure. Unless you have the correct exposure, you cannot assess colour balance correctly. If none of the exposures gives the right density, you must repeat the test until you are sure of the exposure. An important thing to remember is that unlike neg-pos printing, if you want a darker image you give less exposure, and if you want a lighter image you give more exposure.

Properly dry the print before making any judgement on colour balance, and view the print and slide by daylight (reflected off white paper) whenever possible. If you have to make your assessments in artificial light, make a point of comparing the print and its slide under comparable conditions.

One substantial advantage of printing from slides is that you can compare your test prints directly with the original slide and judge more easily what corrections are needed. Quite the opposite of negative printing, for slides you remove a colour cast by reducing the amount of that colour in the filter pack. For example, a magenta cast is removed by reducing any magenta filtration (the same effect is achieved by adding complementary yellow and cyan filtration). Excess blue is removed by reducing magenta and cyan filtration or by adding yellow, blue's complementary.

If, on the other hand, you want to add a colour, you simply add filters of that colour or reduce those in its complementary. If you want more red, for example, you would increase the yellow and magenta or reduce the cyan.

Since filters absorb part of the printing light, the original exposure for the first print may have to be adjusted slightly according to the strength of the filters used in subsequent prints. These factors range from ×1 to ×1.1 for the yellow Cibachrome printing filters: between ×1 and ×2.1 for the magenta filters: and between ×1 and ×1.6 for the cyan range. These adjustments are made in exactly the same way as when printing from negatives (see panel on this page), but because of the wide latitude of Cibachrome, they do not have to be so strictly applied.

Once the right exposure and filtration have been established you can go on to make your main print. For subsequent slides, you may be able to use the same exposure and filtration, providing they are fairly similar. Even if this is not quite right, it may still be a good starting point.

If you do not like the black borders produced by masking frames, conventional white borders can be produced by cutting a card mask slightly smaller in area than the print and placing it on the print after exposure. Carefully position it before opening up the lens and exposing the border for several times the original exposure. The border is then severely overexposed and appears white on the print. However, to make sure you get a perfectly clear border, it is best to remove the slide from the negative carrier before making this second exposure.

During the printing sequence, take note of all relevant exposure information. You will find it helpful to label each print accordingly. This information can be extremely useful when making similar prints in the future.

Taking notes is really rather important in any form of colour printing and you will find it well worth your while to establish a routine that correctly links up a processed print with exposure notes made immediately after printing. Use a soft lead pencil to number the back of each print. Later, transfer the appropriate exposure information to the back of each print.

Colour reversal prints

Although the Cibachrome process (see pages 73 to 77) is very simple and easy to use when making prints direct from slides, you may find that the major alternative, the Ektachrome process, has distinct advantages if you use Ektachrome film.

Methods of exposure and filtration are the same and the main difference between Cibachrome and Ektachrome systems lies in the way the image is formed.

The Cibachrome system uses the silver dye bleach principle, where dyes in the print emulsion in those areas exposed to light are destroyed during development, forming a direct positive image.

In the Ektachrome system, the dyes are obtained in a similar way to those in colour slide processing. Processing begins with the first development stage, and this produces a negative silver image in each of the three colour sensitive layers of the emulsion. In a subsequent stage, colour development, the image is reversed to a positive colour image by dyes that do not form in the negative areas of the print. All the silver

Ektachrome 14 RC process kits

Tetenal UK 3 *A kit of concentrates which can be broken down into part quantities, if required. Instructions indicate various process methods and temperatures. Claimed capacity of the solutions is about 0.5 m²/litre*

Agfa prints from slides outfit *Kit has both paper and chemicals, each compatible with the Kodak process. Process times are quoted for 30°C and 38°C where total times are 18 minutes and 12 minutes respectively*

is removed in the last main stage of the process—that is, a bleach-fix bath to leave the final positive, coloured dye image on the print.

Setting up

The Kodak 'Starter Outfit' contains a packet of 10 sheets of Ektachrome 14 RC paper, a 1 litre Ektaprint-R three-bath processing kit, a measuring cylinder, and three plastic storage bottles. Besides the kit, however, you will need a container and stirring rod for mixing the chemicals, an accurate thermometer and a drum (or dishes) for processing the prints. For exposing Ektachrome prints you can use almost any enlarger providing it has either a filter drawer or an adjustable colour head. Ektachrome 14 RC paper is much more sensitive than Cibachrome and you must take particular care to eliminate any stray light in the darkroom. It is sensitive to all colours of light and must be handled in total darkness up to, during and immediately after exposure—no form of safelighting can be used. Nevertheless, this should present few problems if you use a processing drum, and even if you process in dishes—as you can for Ektachrome—the lights can be switched on soon after first development.

You can identify the emulsion side in the dark by moistening your thumb and forefinger and carefully pinching the extreme corner of a sheet of paper. The tacky side indicates emulsion.

Ektachrome paper should not be stored at temperatures above 20°C. Kodak recommend that if you keep it for longer than two months, storage tem-

perature should not exceed 10°C, otherwise colour characteristics may change slightly. You can store the paper in a refrigerator but, if you do, you must take particular care to completely seal it against moisture. To prevent condensation forming, allow several hours warming up before the paper is used.

Unlike Cibachrome, Ektachrome 14 RC must be processed immediately after exposure. If you have to make a large number of prints, do not expose more prints than you can process at once.

Exposing 14 RC

Ektachrome 14 RC is more sensitive than Cibachrome, and needs two or three stops less exposure. So for your first exposure test, stop your enlarger lens down further than normal for black and white printing (say, to f/11) and cover a range of times such as 5, 10, 20 and 40 seconds—about a quarter to a tenth the exposure likely for Cibachrome. For a typical slide, the best exposure on a zero filtration print (see page 77) is likely to be between 5 and 10 seconds. You must establish exposure accurately before proceeding with any filtration tests, so make a second test print using a shorter range of exposures, such as 2, 4, 6 and 8 seconds.

Do not attempt to judge exposure or colour balance until the test prints are completely dry after processing—wet Ektachrome 14 RC prints have a marked blueish tinge which makes correct assessment of colour balance impossible.

With the exposure time established, you can make the second series of test prints to find out the filtration needed to correct any colour cast. The zero filtration print should give you some idea of the colour cast, but you should start with the correction needed for the characteristics of the paper you are

using. Unlike most other papers, batches of Ektachrome produced by Kodak are not marked with initial filter packs to correct for batch characteristics, so you may have to make a new test for each batch of paper. However, Kodak suggest that you begin with a 20 cyan filter and this usually gives good results with Ektachrome slides. Agfa, on the other hand, give the initial correction needed with every batch of paper. Typically this is (30 10 00), otherwise 30Y + 10M.

Make corrections for colour cast in exactly the same way as for Cibachrome. Use as little filtration as possible and

Process stages

Process	Agfachrome Process R	Kodak Ektaprint R14	Photochrome-R	Tetenal UK3	Unicolor RP-1000
temperature:	38°	30°	25°	38°	41°
Process stages (mins):					
Presoak bath	½	½	1	1	1
First developer	1¾	3	5	1½	1½
Wash	1½	3	3	2	2
Colour developer	2	3½	4½	2½	3
Wash	¾	2	1	30s	½
Bleach-fix	2½	3	4	2	2
Wash	2	3	4	2	1½
Drying	do not exceed 70°C				
Total	11	18	22½	11½	11½
Part make-up		yes		yes	yes
Other process temps for which times are quoted	30°	38°	30/35°	24°	24/32°

Ektaprint R-14 *This kit is matched to Ektachrome 14 RC paper. A starter kit with both items, a 600 ml measure and three storage bottles, is available. Prepared solutions have a fairly restricted storage life, however*

Photochrome R *Another widely available alternative to the standard process kit is this easy to use five part kit. It contains very clear instructions and includes suggestions on processing and printing techniques*

Unicolor RP-1000 *Suitable for use with Ektachrome Type 2203 RC paper as well as 14 RC. A seven part, three-bath process kit, it can be broken down into smaller working quantities, and can be used at a range of process temperatures*

Choosing the slide *As with Cibachrome, you must take care to choose slides to match Ektachrome 14 RC's own characteristics to get the best results*

never use yellow, magenta and cyan together since this simply reduces the overall light output. To reduce a colour cast, simply remove filters of a similar colour from the filter drawer, or add its complementary. Yellow is rarely used when printing from slides, but cyan filtration is often needed to remove a red cast, or used in combination with magenta—making blue—to remove a yellow cast.

The Ektaprint R 14 process

Ektachrome paper is processed using the basic Ektaprint R 14 process. This is an updated version of the original process and is much easier to use because it includes a chemical fogging agent—with the old process you had to expose the print to white light after first development to achieve reversal.

The Ektaprint R 14 chemicals are all liquid concentrates and are prepared simply by diluting with warmed water. But, remember to wear gloves when you are mixing the chemicals and follow the maker's instructions carefully. Unlike Cibachrome chemicals, Ektaprint chemicals do not have to be neutralized before disposal but you should use plenty of water to flush away discarded solutions. Wipe up, rinse and dry any chemical spills to prevent staining.

The Ektaprint R·14 kit offers you a choice of two process temperatures: 30°C and 38°C. It is better to adopt the lower of the two temperatures unless you are confident you can correctly maintain the more awkward higher temperature. Whichever temperature you choose, place all the solutions in a water bath to bring them up to the required temperature. Also place in the water bath, a container holding about 400 ml of clean water.

If you are using a print drum for processing, place it in a water bath after loading the print to bring the temperature

Correct filtration

1 *This is the best possible corrected print, in that skin tones and subject colours are rendered accurately*

2 *This print is too blue. Correction is obtained by reducing magenta plus cyan filtration by about 30 units*

3 *Reduction of 30 units cyan, or the addition of 30 units each of yellow and magenta is required to eliminate this cyan cast*

4 *Excess green shown here can be removed by reducing yellow and cyan filtration by 30 units, or by adding 30 units magenta*

5 *This yellow cast can be removed by removing 30 units yellow, or, alternatively, by adding 30 units magenta and cyan*

6 *This magenta cast is removed by 30 units additional yellow and cyan filtration, or by removing 30 units magenta*

Colour corrections for reversal prints

For reversal printing you have to abandon correction routines used for conventional colour printing from negatives. However, correction of colour casts is fairly straightforward—simply remove from the filter pack or colour head filtration which corresponds to the colour of the cast. The options are shown in the table.

Remember:

● If you use filters in a filter pack, use as few filters as possible

● Make adjustments by removing filters if you can

● Do not use yellow, magenta and cyan filters together

	Necessary corrections		
the print is too light	use smaller aperture	OR	shorten the exposure time
the print is too dark	use larger aperture	OR	increase the exposure time
the print is too blue	reduce the magenta + cyan filtration	OR	increase yellow filtration
the print is too yellow	reduce yellow filtration	OR	increase the magenta + cyan filtration
the print is too green	reduce the yellow + cyan filtration	OR	increase magenta filtration
the print is too magenta	reduce magenta filtration	OR	increase the yellow + cyan filtration
the print is too red	reduce the yellow + magenta filtration	OR	increase cyan filtration
the print is too cyan	reduce cyan filtration	OR	increase the yellow + magenta filtration

of the drum and print up to the correct level. Once you think they have reached the right temperature, you can begin the first development. This is the only really critical stage of the whole process and you must take special care to ensure that the solution temperature and process time are strictly adhered to. You must also adopt a uniform method of agitation if you are to achieve consistent results. Roll the drum rapidly, but gently, to and fro, completing one or two complete revolutions every second.

Begin draining the developer just before the end of the development time and immediately rinse the drum with about half of the clean water from the container in the water bath. After a little agitation, empty the water out and refill the tank with the remainder of the clean water. At the end of this second wash, you can remove the drum lid and complete the rest of the process in the light.

Once the tank is open, give the print a third wash in running water. If you are processing at 38°C, this wash must last two minutes, but if you are processing at only 30°C, the wash need only continue for 90 seconds. After the third wash, remove the print from the drum for this stage, but take care to handle the delicate material only by its edges—the emulsion is easily scratched when wet.

Replace the print and reassemble the drum. Pour in the measured quantity of colour developer. Timing is not critical, but this stage must be carried to completion, so err on the generous side, continuing development a little beyond the recommended time.

Once colour development is over, wash in warm water from the remaining container, again using two separate baths. Start the bleach-fix bath but, again, be careful not to cut short the process. After another wash, lasting three minutes, dry the print in the normal manner.

Because many of the stages can be carried out in full lighting, it can be a nuisance to use a print drum for all the stages after the first wash. You can, if you prefer, switch to dish processing after first development if you can successfully maintain the recommended 30°C process temperature. In fact, it may be worth doing all the processing in open dishes, providing you can control timing and temperature accurately. But you must take special care not to splash and cross-contaminate the various processing solutions. This is a problem with any type of dish processing, but it is much more severe when you cannot see what you are doing.

Alternative process kits

One of the main attractions of using the R 14 system is that there are a number of alternative process kits available. Agfa, for instance, provide a 'DIY Prints from slides' outfit which contains two packets (20 sheets in all) of their own paper for

prints from slides, Agfachrome PE, plus the necessary process chemicals. The paper is fully compatible with the Ektaprint R 14 process, and Ektachrome 14 RC can be processed in the Agfa Process R chemicals provided—so Agfa components are readily interchangeable with those made by Kodak.

Other manufacturers supply kits of process chemicals only. The attraction of these is not necessarily one of initial cost, but the economy possible by mixing up only the amount of solution required for a particular printing session. All kits contain liquid concentrates and it is a simple matter to measure off a little at a time. Working strength solutions are normally used only once before being discarded, but some can be used more than once when economy, rather than quality is important. The manufacturers give precise instructions for reusing chemicals.

Process times vary only slightly, and all processes have the same number of stages but chemicals may differ slightly from manufacturer to manufacturer and this may cause small differences in colour balance and saturation: you may find you prefer the result from one particular process. But whichever process you choose, Ektachrome is essentially a straightforward printing system, and providing you take the necessary care at all stages, it should give excellent colour prints from your slides.

Chapter 6
BLACK & WHITE EFFECTS
Combination prints

Prints are normally produced from a single negative, but by printing two or more negatives on to the same sheet of paper you can add that extra detail that makes a good picture great. You can even create entirely new pictures in your own darkroom. Skilful combination printing opens up an entirely new world of creative possibilities.

Negative sandwiches

One of the simplest ways of making combination prints is to sandwich together a pair of negatives (any more makes printing difficult). You must choose your negative pair carefully. Match them for graininess, image contrast and other characteristics; other-

wise, it can be difficult to assess printing times and the correct paper grades.

Choosing pairs from your existing stock of negatives can produce some interesting results. If you enjoy combination printing, it may be worth going a stage further and deliberately taking your pictures with an eye to pairing the resulting negatives.

One of the difficulties of combination printing from sandwiches of paired negatives is that exposures tend to be very long, and when this is the case there is a temptation to accept prints that are rather light and do not have good

blacks. Furthermore, a pair of negatives has a much higher printing contrast than the individual negatives and prints, and prints can become excessively contrasty. For these reasons choose negatives which are a little thin and a little soft, so that when they are printed together in this way they can be made to yield a final image of normal contrast and density.

When printing a negative sandwich, you may find it difficult to keep both negatives sufficiently firmly together to keep the image sharp. A glass negative carrier is essential. If you have a glass-

Girl and spire *The sort of unusual combination which is possible by marrying two completely unrelated images. You can shoot scenes specifically to pair negatives*

less carrier which can be removed, you can make a suitable temporary arrangement by flattening the two negatives between two sheets of thin, optically flat glass, such as a 6 × 6 cm slide mount glass. Use a blower brush and an anti-static cleaning cloth to ensure that the sandwich remains clean and free of dust during assembly.

Successive combinations

Negative sandwich combinations are easy to make, but you have much more control over the appearance of the final image by exposing each negative separately. This technique can be taken to fairly sophisticated levels by using jigs specially made for masking parts of the image, but at its simplest level it is little more than an extension of standard dodging techniques.

If, for example, you wish to add clouds to uninteresting sky in a landscape, prepare a card mask such as you would if you were burning-in sky (see pages 46 to 49). Obviously, you can only do this where the horizon is a fairly simple shape. The mask must follow the shape of the landscape when raised above the print surface during use, so trim the card to shape under the projected image beam of the enlarger.

The next stage is to make test prints or strips to determine the correct individual exposure times for the main landscape negative, and for the cloud negative which is printed in afterwards. This also enables you to check quickly the compatibility of the two negatives, which is not always easy unless you have some positive images to go by. Prints of the right enlargement are especially useful.

Once you have established exposure times, you can start making the combination print. It is easiest to produce the landscape part of the print first. Put the landscape negative in the enlarger, check the focus and composition, and make your first exposure. Switch off the enlarger and swing the red filter beneath the lens before switching on again to inspect the image. Now carefully position the mask, and mark its position in relation to the baseboard with a pencil or tape. Switch off the enlarger.

Carefully replace the landscape negative with the cloud negative. Switch on the enlarger and check, through the safety of the red swing filter, that the negative is both in focus and correctly

positioned in relation to the landscape (position indicated by the mask). Switch the enlarger off and move the red swing filter aside. Carefully raise the mask above the print surface, staying within the locating marks you have made on the baseboard, and expose the cloud negative. Keep the mask moving very slightly to help prevent a sharply defined edge.

Although quite straightforward, this form of combination printing is rather hit or miss, simply because you cannot be sure that the mask is correctly positioned and does not wander during use. Inevitably there is some overlap of detail or a slight gap of relatively clear print. Since you can rarely achieve perfect masking, it is probably better to leave a small gap rather than have any overlap of detail. You can make errors in masking less obvious by slightly shading the border region when printing the cloud negative. This helps to fuse

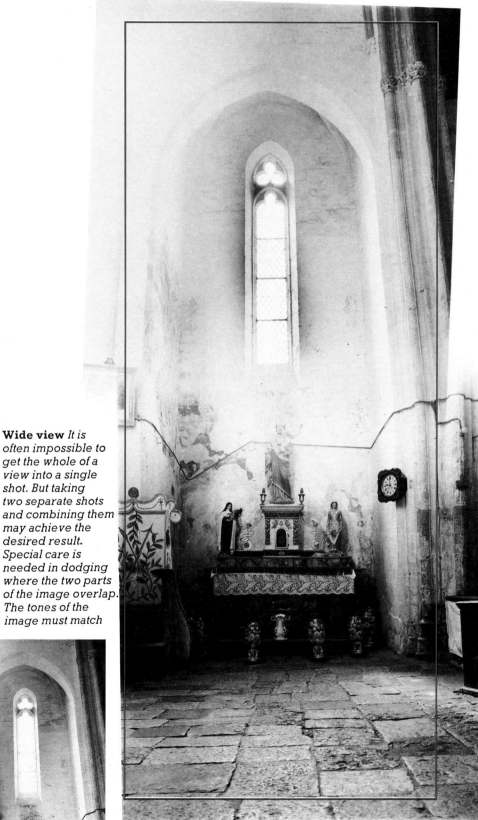

Wide view *It is often impossible to get the whole of a view into a single shot. But taking two separate shots and combining them may achieve the desired result. Special care is needed in dodging where the two parts of the image overlap. The tones of the image must match*

and fade border detail, and because the sky is ligher at the horizon, it looks reasonably natural.

Using a printing jig

While making a single two-negative combination print is fairly straightforward, it is difficult to achieve consistent results over a large run of repeat pictures. When more than two negatives are involved, the problems of combination printing become quite severe. If you intend to do a lot of combination printing, it is almost certainly worth constructing a purpose built jig. This considerably simplifies even straightforward cloud printing.

A jig holds precut masks in position a little above the print. If you make one, check that its size suits the size of paper you use most often. The jig can also be used for dodging. It is especially useful for applications where you may be tempted to use on-print masks (see page 49), but have difficulty in keeping the masks in exact register. Although the jig carries masks which remain still during use, the height of these above the print surface prevents a clear-cut shadow forming. Further softening in this region is possible by gradually shading the mask edges during printing.

To use the jig, focus and compose the main negative on the enlarger easel or masking frame. Stop the lens down as usual and place the jig carefully over the masking frame. Place a sheet of white, but opaque, card on the support glass of the frame, tape it into position, and make a register mark so you can correctly position it later.

Switch off the room light and inspect the projected image, now interrupted by the white card and out of focus. Trace a cutting line for the mask, remove the card and cut along this line. To prevent a white line forming in the boundary region, make sure that the trace and cut are taken slightly within the lighter of any two parts of the projected image. The lighter parts print dark, and there is more chance of disguising the edge of the mask in this way.

You should have a mask in two parts— one corresponding to the landscape, the other to the secondary area in which you plan to print the clouds. This secondary mask can be used to shade all unwanted detail in the sky and to prevent build-up of unwanted tone—if it becomes too dark, any highlights from the cloud part of the combination may be lost. If the cloud negative is very dense, the secondary mask is not necessary.

While the landscape negative is in position, remove the jig and make a test strip or print under normal printing conditions, but do not process it. Put it carefully away and make a separate test print from the cloud negative. Process both test strips together and establish the best exposure times for each.

Place the landscape negative in the enlarger, and load the masking frame with a sheet of paper before positioning the jig. Use the red swing filter to

Making a combination print

1 *Select the two images which are to be combined and make test prints to assess contrast, exposure and size*

2 *Focus the 'land' negative at the print level, position the jig, tape down the masking card and trace off the image*

4 *Under safelighting, load the jig with printing paper and carefully align the mask with the projected image*

5 *Now swing the 'sky' mask into exact register with the 'land' mask and flip the latter out of the way*

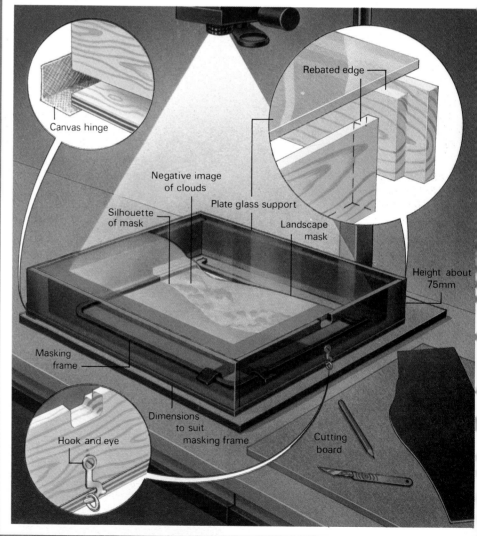

Canvas hinge

Rebated edge

Negative image of clouds

Plate glass support

Silhouette of mask

Landscape mask

Masking frame

Height about 75mm

Hook and eye

Dimensions to suit masking frame

Cutting board

3 *Carefully cut along the border between 'sky' and 'land' portions of the mask—a sharp scalpel is best*

6 *Expose the 'land' image. Weight down the mask edge with small coins, or another sheet of good quality glass*

7 *Carefully change over negatives and switch to the corresponding mask before exposing the 'sky' negative*

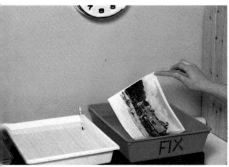

8 *Process the print normally. If masking lines show, the register has gone out of true and the print needs remaking*

Printing jig *Make a printing jig to suit your masking frame size, along the lines of the design shown left. This one allows the platform to swing out of the way, and so gives easy access to the print. Masks can be taped to the sides during use*

position the jig accurately, and tape down the secondary mask if you decide to use one. Then expose the main part of the print according to your test strip.

After the first exposure, use the red swing filter and carefully position the main mask. Switch off the enlarger and substitute the cloud negative for the landscape negative. Switch on again and check that the sky detail positioning is correct. Switch off and swing the red filter out of the way, and then expose the cloud negative according to your test print findings.

The print can now be processed. Evidence of an overlap or gap shows that you have either knocked the jig during use, or you have positioned the masks inaccurately. Take care, when aligning the masks, not to change the print and negative relationship.

As you become used to the jig technique, other creative possibilities open up. Some of these are examined closely in subsequent issues. The jig can be used for complicated dodging techniques involving filter changes in both colour and b & w printing, as well as more straightforward applications which can be just as effective as combination printing in certain cases.

Stockpiling negatives

A stockpile of 'cloud' and other types of negative for combination printing are probably already in your existing selection of negatives. But once you are familiar with the various combination printing techniques, it becomes almost

second nature to look for various pleasing cloud photographs, for instance, when you are out with your camera. Take several shots of any potentially useful subject.

Building up a collection of negatives allows you great leeway in combination printing. You can match film type with film type, and subject type with subject type. You can also begin to match features such as perspective, relative subject size, and the type of lighting. Backlit clouds, for instance, do not look quite right when printed in combination with a scene which is obviously frontlit, nor do steeply banked clouds taken with a wide angle lens look convincing when printed in combination with a telephoto landscape shot.

If you decide to produce negatives specifically for use in combination printing, shoot to exclude all irrelevant and unwanted detail from the photo. This saves you having to crop it later—and unwanted detail may not only be visible but also actively blocks out any pleasing detail from the other half of the combination. But try not to create 'impossible' perspective distortions.

Once you have mastered the art of combination printing, the darkroom becomes a much more exciting place. Simply filling in cloud detail can turn a mediocre landscape shot into a beautiful picture. There are many other possible combinations—you could add textural detail, for instance. Eventually, you may want to create entirely new pictures in the darkroom.

Cottage and clouds *Perhaps the most common application of combination printing for improving a picture is adding clouds to an otherwise 'bare' landscape view—but take care that the lighting of clouds and landscape match*

Toning prints

With modern processes, black and white prints always show the image in tones of grey, but there is no reason why they should stay this way. By immersing a normal print in chemical toners, you can change the image to any of a wide variety of different colours. Applied subtly, toners can enhance the effect of a good, moody print. Applied boldly, they can transform a dull image into a winner.

One of the main attractions of toning is that you can alter the colour of the image to suit the subject. In portraits, for instance, you could use sepia or warm brown toners to overcome the rather cold appearance of a straight black and white print, giving skin tones extra warmth. Moonlit scenes, on the other hand, could be given a cool, evocative atmosphere with blue toner, or sunsets given a vivid red hue. Or you can recreate the look of early photographs by sepia toning—an approach which might suit a picture of an old cottage or an overgrown railway station. The possibilities are limited only by your imagination and your command of toning techniques. One point to remember when choosing a print for toning, however, is that it is usually more effective with simple subjects.

Toning is carried out after the print has been made in the normal way and, with most toning processes, the work can be done in daylight. You can buy toners in ready made packs of chemicals that are simply dissolved in water for use, or you can make up your own toning solutions. Ready made toners are available in various colours, but the most popular are sepia and blue. The advantage of these commercial toners is that they are widely available and easy to use. If you intend to tone large numbers of prints, though, you may find that they become rather expensive.

Toners can often be made up from raw chemicals far more economically and, if you do make up your own toners, you can experiment with various combinations to produce exactly the effect you want. Unfortunately, it can be difficult to obtain the necessary chemicals in small enough quantities. If you do wish to make up your own baths, look for the necessary chemicals at one of the more traditional chemist's shops or one of the large photographic dealers in the photographic press.

Whether you buy ready made toners or mix your own, certain preparations are essential. Because different toners affect the density and colour of a print in different ways, you must adjust exposure and development to suit the tone. When making the basic print for sepia toning, for instance, an overexposed and underdeveloped print gives a yellowish tone, while an underexposed and overdeveloped print turns out a colder brown. To establish the right combination of exposure and development, make a test strip showing various exposures in the normal way and run this strip through the toner. Conduct a number of development tests as well with small prints. It is also worth preparing a number of identical prints before each session so that you can experiment to achieve precisely the right effect.

Each print must be washed very thoroughly before toning because residual chemicals can react with the toners to give a very blotchy image. The need for thorough washing varies from toner to toner but with many you should use a hypo clearing agent as a preliminary to the usual water wash. On the other hand, when using hypo alum toner, described below, a brief rinse after fixing is adequate as the toner itself contains fixing agent. If prints have been dried they should be soaked in cold water for half an hour before toning to ensure even action of the solutions.

Sepia toning
These portraits, although very different in style, both benefit from sepia toning which softens contrast and brings out shadow detail

Abstract *Blue toner gives a cool, moody effect* **Girl in colour** *By careful masking while applying different tones, you can combine a number of tones on a single print. For this picture, selected areas were masked while the print was sepia toned. Different areas were masked for red and blue toning* **Green ripples** *An experiment using sepia bleach with blue (iron) toner for a green tone*

To tone the print, immerse it in the bleach solution in a normal processing dish and rock the dish gently until the image is changed completely to a pale yellow–brown or buff colour. Remove the print from the bleach when no trace of black silver can be seen—this should take less than a minute unless the bleach is near exhaustion. Wash the print for two minutes if you are using RC paper and for about five minutes with fibre-based paper.

The stock sulphide solution must be diluted 1 + 19 with water for use. The working solution can be used only once, so do not make up more solution than you need. Place the bleached and washed print in a dish containing the dilute sulphide solution to change the buff image to a rich brown or sepia colour. Rock the dish continuously, processing the print until no further change in colour is evident. Finally, wash the print

Toners take different forms. There are many different formulae for producing sepia or brown tones and nearly all of them work by converting the black metallic silver in the image to silver sulphide, which has a brown colour. Its precise colour depends on a number of factors and variations of tone can be obtained with basically the same chemical process. There are also toners containing metals which give blue and green tones, dyes and colour developers.

Both dye toners and colour developers require careful handling and are dealt with in a subsequent article.

Sepia toning

Because of the extra warmth it gives monochrome pictures, sepia is one of the most popular tones, particularly for portraits and sunny scenes. Although there are many ways of achieving a sepia tone, there are two common and easy methods: indirect sulphide toning and direct sulphide toning with a hypo alum solution.

Indirect sulphide toning involves bleaching the silver image of the print to a buff colour in one solution and, after a brief wash, darkening it to brown silver sulphide in a second bath of sodium sulphide. The chemicals given off by the second bath have a very unpleasant smell, like rotten eggs, and are also highly toxic. For your own comfort and

safety, tone your prints in a well ventilated room.

Indirect sulphide toning is also very susceptible to impurities in the water supply. Small particles of rust from iron pipes, for example, can give blue marks. If you are troubled with these you must filter the water.

Sulphide toners are generally available in kits containing a bleaching solution and a sulphide darkening solution, but you can make up your own two stock solutions if you wish. There are many different formulae for a sulphide toning bleach but all of them have much the same effect. The following bleach and sulphide stock solutions are typical.

Sulphide toner

Stock bleach solution

Potassium ferricyanide	50 g
Potassium bromide	20 g
Water to make	1 litre

Stock sulphide solution

Sodium sulphide	50 g
Water to make	250 ml

The bleach solution is used undiluted and may be used again a number of times until it no longer bleaches completely. It is important to include only the quantity of potassium bromide stated—any excess can produce yellowish tones.

Toning effects

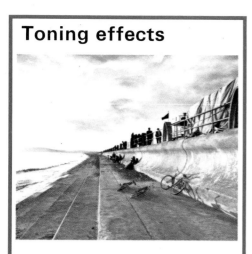

Basic print *Any black and white print can be toned but it must be clean*

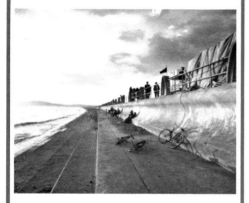

Sepia *For a warm, soft look, you can tone in sulphide or hypo alum*

Red *Varying toning procedure and mixing tones gives many different tones*

Green *Less popular but often effective, green toning requires a two part bath*

for ten minutes in running water.

Do not pour the used sulphide solution down the sink, since the extra dilution increases the potency of the odour and your sink will smell foul for days. Instead, you should pour a solution of potassium permanganate down an outside drain and dispose of the sulphide solution here. The potassium permanganate effectively kills the odour.

Hypo alum toner gives a more purplish sepia tone but slightly reduces the density of the print image, so you should give the print slightly more exposure than normal. This toner is easily made up using the formula shown here; the solution is used undiluted.

Hypo alum toner

Sodium thiosulphate (hypo) crystals	150 g
Potassium alum	25 g
Hot water to make	1 litre

The hypo crystals should be dissolved in hot water at about 75°C and the alum slowly added. The solution will turn cloudy as a whitish precipitate is formed. Boil the solution for several minutes and make up a second solution. To make this second solution, add 0.14 g of silver nitrate to a little water. When the silver nitrate is dissolved add liquid ammonia drop by drop until the precipitate first formed dissolves. This second solution is then added to the toner solution. If no silver nitrate is available, the toner can be made ready for use by immersing waste prints in the solution until the highlights are no longer bleached. This toning solution should last almost indefinitely if kept in a corked bottle.

Toning in hypo alum has to be done at a high temperature, otherwise the process is extremely slow. The most convenient way of maintaining high temperatures is to stand the dish containing the toner in another larger dish filled with water at about 45°C. If you keep prints on the move with plastic print forceps, toning should be complete in 20 to 30 minutes.

After toning, fix the prints in normal fixer to remove any silver compounds taken up from the hypo alum solution and then wash in the normal way—five minutes for RC papers and at least 30 minutes for fibre based papers.

You can obtain warmer sepia tones by adding 1 g of potassium iodide to one litre of the hypo alum toner and using it as before, at a process temperature of about 40°C.

Blue toner

A single blue toning bath containing iron salts gives prints a blue tone, but because it also darkens the image, you must adjust the original print exposure and development by making the tests outlined above. The iron toning bath is made up from two stock solutions mixed without dilution immediately before use. The working solution should be discarded after each session.

Iron toner

Stock ferricyanide solution

Potassium ferricyanide	2 g
Sulphuric acid (concentrated)	4 ml
Water to make	1 litre

To make up this solution add the acid very slowly to the water; NEVER add the water to the acid. Then dissolve the potassium ferricyanide in the dilute acid.

Stock iron solution

Ferric ammonium citrate	2 g
Sulphuric acid (concentrated)	4 ml
Water to make	1 litre

To make the iron solution, again add the acid very carefully to the water (not the other way round). Then dissolve the ferric ammonium citrate in the diluted sulphuric acid.

Iron toner is very simple to use but the print must be prewashed for about an hour. To be certain that the print is completely clean, use a hypo cleaning agent. For toning, the print is simply immersed in the solution while the dish is rocked.

Green toner

Green toning is slightly more complicated than blue toning and involves one bath containing three stock solutions mixed immediately before use, followed by a second bath in the toner itself. The first bath turns the print blue and the print only acquires a greenish tone in the second bath.

Green toner part 1

Stock Solution A

Ferric ammonium citrate (green)	50 g
Cold water to make	1 litre

Stock solution B

Potassium ferricyanide	25 g
Cold water to make	1 litre

Stock solution C

Hydrochloric acid (concentrated)	10 ml
Cold water to make	1 litre

To mix up the three solutions for use take 550 ml of water and then add 75 ml of solution B and 300 ml of solution C.

Tone the print in the first bath for about half a minute at 20°C and then wash it until all the highlights are clear.

Green toner part 2

Water (very warm)	500 ml
Sodium sulphide	75 g
Sodium thiosulphate (crystals)	500 g
Cold water to make	1 litre

Dilute this solution 1 + 10 with water to use it and, just before you begin toning, carefully add 300 ml of ten per cent hydrochloric acid to each litre of diluted toner. Once mixed, this bath will not keep.

To continue the green toning process, immerse the blue toned and washed print in the part 2 solution until the print is the colour you want. Finally, wash the print in running water for 30 minutes.

Using sulphide toner

1 *The Tetenal sepia toning kit is widely available and easy to use. It consists of concentrated liquid toner and a bleach solution*

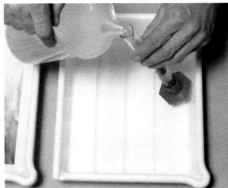

2 *Start by diluting the bleach 1 + 4 with water, just before use. Prepare only as much solution you need to cover the print in the dish*

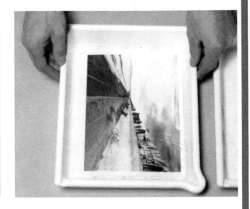

3 *Soak the print in warm water for five minutes before toning. This helps to ensure even toning and prevent blotches and streaks*

4 *Slide the print into the dish containing the bleach, gently agitating either with your fingers or by lifting opposite corners of the dish alternately*

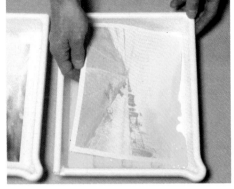

5 *Continue bleaching until all the black silver image has been turned to a light yellow–buff colour—if in doubt, go on bleaching, since this can do no harm*

6 *Wash the print thoroughly in running water. If the dish is placed in a large sink for this stage, drainage should present no problem*

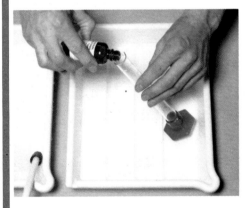

7 *Mix up a similar quantity of the toning solution, diluting it 1 + 4 with water. Filter the water first if it contains impurities*

8 *Place the bleached and rinsed print in the dish containing the toning solution. The toner acts gradually on the image, turning it sepia*

9 *Finally, wash the print thoroughly and dry it in the normal way. Dispose of the used sulphide solution in an outside drain*

Combining tones

By covering different areas of the print while using different tones, you can give a print quite a few different tones. You could, for instance, cover the sky in a verdant landscape while toning in green toner and then remove the sky cover and cover the landscape while toning the sky blue.

The best material for covering the areas to be protected from toner is stabilized rubber latex—one of the commonly available latex glues will do. Paint the milky white latex on to the appropriate areas of the print and wait for it to dry to form a waterproof rubber coating. You can speed up the drying process by breathing on the latex.

Once the mask is dry you can begin to tone, applying the toner with plugs of cotton wool or a fine sable brush. When the toning is complete wash and dry the print and clean the latex off the print by rubbing with the fingers. Repeat this process to apply tone to other areas.

As with many darkroom techniques, the potential for toning is limited only by your imagination once you have mastered the basics. But beware of the temptation to tone every print—once all your prints are sepia toned, they will be no more exciting than if they were all black and white. Choose your prints carefully, and only tone those that would really benefit from it. On the right print, toning can make all the difference.

Lith and posterization

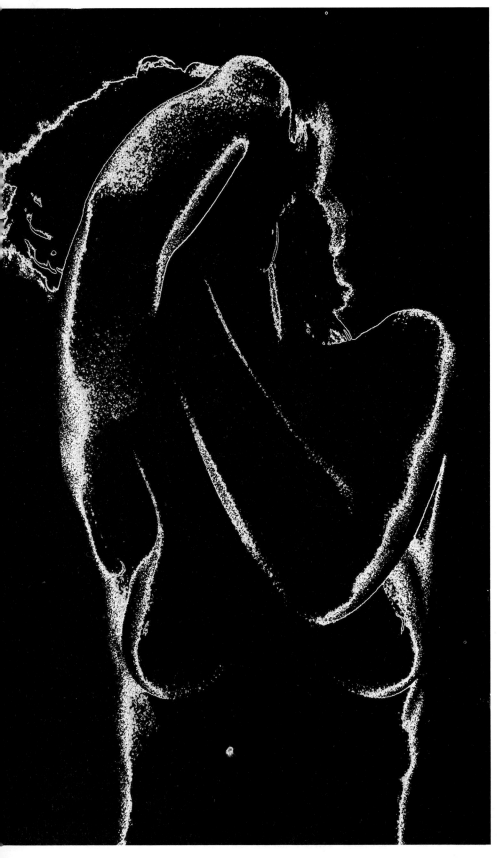

Some of the most creative darkroom effects, in both black and white and colour, are achieved by using lith film. The material is basically a high contrast emulsion which, when developed in special lith developer, gives results of the highest possible contrast—pure black and white, with no intermediate tones.

By controlling the exposure, it is possible to vary the tone at which black changes to white. This makes it possible to produce a wide variety of different copies from a single original, each showing different effects. And by printing the results in different tones or colours, any original can be transformed.

Lith film is also invaluable for producing special effects, and for copying *line* originals—that is, subjects with no tones in the original, such as print or line drawings. The high contrast makes sure that the edges of the lettering stay sharp, and avoids the risk of grey backgrounds on the copies. The material is therefore useful for anyone who is regularly called upon to make prints of text, such as producing the labellings or headings for exhibitions. The material often called line film—high contrast sheet film—should not be confused with true lith film, which has a thinner emulsion.

The word lith comes from the film's original use—as a negative material for making the lithographic plates used in printing. (It stems from the Greek word lithos, meaning 'stone'—from the stone plates originally used for printing.)

While lith film itself is a high contrast material, and will give a contrast of about 3 in ordinary developer (compared with a contrast of about 1.5 of conventional camera films), it is intended for use with lith developer. This produces the phenomenon of infectious development. To start with, a faint image appears. The most heavily exposed parts of this image then act as development centres—a dense black speck appears and rapidly grows in size. Thus the heavily exposed areas appear dense black, while the less heavily exposed areas are virtually clear. As development proceeds, the densest areas grow in size, rather than getting blacker, and new development centres appear.

Lith film is available in two forms orthochromatic and panchromatic.

Nude *Shots with a wide range of tones make suitable subjects for lith prints. This nude shows characteristic rough edges between areas of dark and light*

Orthochromatic film is insensitive to red light and can be handled under a red safelight. It is therefore ideal for black and white darkroom use—though for colour work it may give poor results. Panchromatic film must be handled in total darkness, as it is sensitive to all colours. It is preferable to orthochromatic material where you are using colour negatives or slides as your originals.

The material is not suitable for use in the camera, though it is available in 35 mm form to order for special purposes. The most common format is sheet film, and it is available in a range of different sizes. It is not normally stocked by most dealers, but is usually available to order or by mail from special suppliers. The cost is comparatively high—about the same price as a couple of boxes of colour paper—but it may be possible to cut costs by sharing a box of the material with others, or by using it in a small format. This, however, tends to compromise the quality for many purposes, and ideally lith film should be used as a contact material the same size as the final print.

As an alternative, where economy of material is important to you, make the lith film positive either by contact or by projection to the largest size of film that your enlarger will accept. For example, you may make 6 x 6 cm positive and negative lith copies by enlargement from a 35 mm negative, if your enlarger will allow you to print 6 x 6 cm negatives. A disadvantage of this is that the more advanced printing techniques, with several images printed in register, will be much more difficult to achieve.

Not all negatives are suitable for lith printing. In general, those with distinctive areas of dark and light are preferable. Shots showing clearly defined detail, patterns, silhouettes and abstract shapes are ideal. However, originals where the subject has similar tonal values to the background—a Dalmatian dog in dappled sunlight, for example—may prove difficult. Portraits can be effective on lith film, but bear in mind that wrinkles are emphasized by the high contrast, which may be unflattering.

Making a test print

1 *When you have lined up and focused the image, expose the lith sheet in steps using a black card mask in the same way as for a paper print*

2 *Slide the sheet into the developing dish, emulsion side up, rocking it slowly. At first, no image will appear on the film*

3 *Once the image appears, it becomes denser very rapidly. Wash the film, then fix it for at least twice the time it takes to become transparent*

4 *When the film is dry, examine it by daylight or a good artificial light. You can now choose which exposure most suits the effect you want to achieve*

Processing lith film
Sheets of lith film are processed in dishes in the same way as paper. It is advisable to use a developing dish only slightly larger than the film size, as developer is expensive. Develop the sheets one at a time, as they scratch very easily.

Lith developer is essential for infec-tious development. Like lith film, it is not on most dealers' shelves, and you may find that you have to order large quanti-ties at a time. Again, it is worth sharing a supply with others. Ask at your photo-graphic club, or at an evening class, to see if there is anyone interested in sharing the expense with you.

All lith developers are caustic and

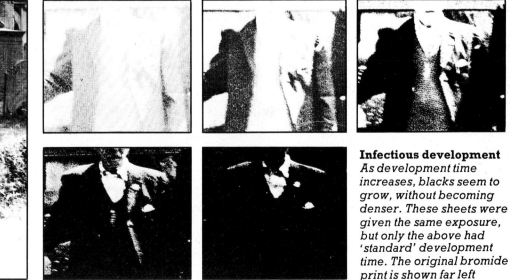

Infectious development
As development time increases, blacks seem to grow, without becoming denser. These sheets were given the same exposure, but only the above had 'standard' development time. The original bromide print is shown far left

should be used with care. To avoid dermatitis, wear rubber gloves if there is a risk of your hands coming into contact with the solution.

The developer is mixed in two parts, A and B. The working solution, consisting of equal parts of A and B, has a very short useful life, so mix only what you need immediately before use. The developer oxidizes very quickly once mixed, and you should not keep it for more than 10 minutes. Throw the solution away as soon as it begins to look yellow. It is cheaper to do this than to risk spoiling your pictures, so to achieve consistency between your test exposures and the final results, use fresh developer for each.

When you have exposed the film, slide the sheet into the developing dish emulsion side up and rock it gently to make sure it is fully covered by the developer. A typical development time is 2¾ minutes at 20°C.

During processing, you will find that the image looks blacker than it actually is, so always develop for the recommended time and examine the results by white light after fixing.

Some photographers give continuous agitation of the dish for the first two minutes of the process only, then leave the dish stationary for the rest of the time. This tends to give sharper edges to the black areas.

A stop bath is the best way to halt the development and avoid dichroic fog—a lightly coloured fog which may appear as a result of misprocessing. If you have no stop bath, washing the film in running water for 10 seconds is satisfactory.

You should then fix the film in fixer with acid hardener for at least twice the time it takes to clear—usually a minute or

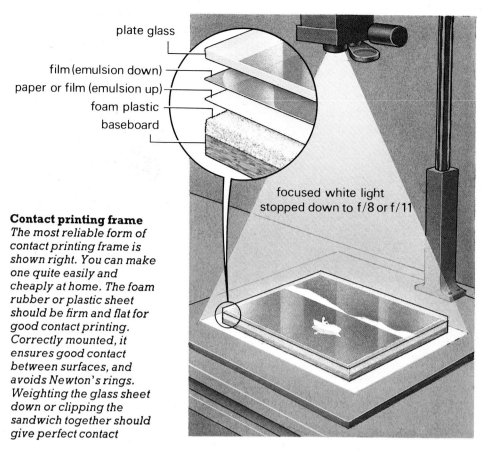

plate glass
film (emulsion down)
paper or film (emulsion up)
foam plastic
baseboard

focused white light stopped down to f/8 or f/11

Contact printing frame
The most reliable form of contact printing frame is shown right. You can make one quite easily and cheaply at home. The foam rubber or plastic sheet should be firm and flat for good contact printing. Correctly mounted, it ensures good contact between surfaces, and avoids Newton's rings. Weighting the glass sheet down or clipping the sandwich together should give perfect contact

less. Wash the film in running water for at least two minutes. Add a little wetting agent to the final rinse, and hang the sheets up to dry in a dust free area.

Printing procedure
Before beginning to print, make sure that your safelight is truly safe. Lith film requires a red safelight, rather than the amber colour of a safelight designed for paper, as it is more sensitive. You may

find it necessary to tape red paper over an amber filter, and to carry out a safety check (see page 33).

Start by making a test strip, as you would for paper, using your chosen negative. But since lith film is faster than paper, close the enlarger lens down by one or two stops more than usual. Process the film and choose the exposure which gives the range of blacks and highlights that you want.

Contact printing

1 *To make the contact print from the interpositive, sandwich the two lith sheets, emulsion to emulsion, under a glass sheet and expose as planned*

2 *Process the internegative as shown, and examine it under a good light. This internegative was given standard exposure and normal development*

3 *Sandwich your negative, emulsion side down, with a sheet of bromide paper, under a glass sheet. Make sure that you keep your exposure consistent*

Also carefully examine the edges of the black areas. They should be sharp, with no hint of fuzziness. If they are not, then check that your developer is correctly made up and used at the right processing temperature. Poor edge definition also arises if you are tempted to compensate for underexposure by overdeveloping.

Having selected your exposure, you can now make a lith positive—known as an interpositive. This must be contact printed on to another sheet of lith film to make an internegative before you can make your final print on paper.

You must always contact print emulsion to emulsion. If you do not, the thickness of the film separating the two emulsions can cause rays of light to be scattered, giving loss of detail.

When contact printing, it is important to make sure that the two emulsion surfaces are in perfect contact. The simplest method is to use a plate glass sheet which has been thoroughly cleaned beforehand. Make sure that there is no dust on either the film or the negative, as this can cause 'pinholes' in the image. Always watch for 'Newton's rings', caused by imperfect contact between surfaces. With the enlarger at the same height and aperture as when making the interpositive, you should be able to use the same exposure when making the internegative, though this is not critical.

You are now ready to print the interpositive on to a sheet of film, using your predetermined exposure. Process the resulting negative and print it directly on photographic paper to produce your final print, processing it in the normal way in paper developer. For extra effect, try printing your lith negative through a brightly-coloured filter onto colour paper.

Experimenting with lith

By printing with lith, you are in effect dividing a continuous gradation of tones into just two—black and white. All areas lighter than a certain tone are reproduced as white, and all areas darker than that tone are reproduced as black. You fix the point at which the division comes by controlling the exposure.

By exposing lith film for a longer or shorter time, you can determine the 'cut-off point' at which a mid tone becomes black. For example, if you are working with an image of a face, a short exposure will record only the darkest parts of the eyes, the nostrils and the mouth, which will all print as black. A medium exposure will produce a result with more detail—grey tones may well reproduce as a fine stipple, lending some moulding effect. A long exposure will pick up all the shadows, and when printed may yield a sombre, mysterious image. Only the brightest parts of the original will print as white.

In such a case, where you are making lith positives from a continuous tone negative, the underexposed film is called the shadow positive, since only the shadows and black areas are reproduced. The overexposed film is the highlight positive, as only the brightest areas will print. Standard exposure gives a mid-range positive.

When making lith positives and negatives, the most important stage in choosing the point at which the tones are separated is the test strip, as this gives you vital information as to how the negative reproduces with different exposures. The 'standard' exposure for lith is that which reproduces full blacks and clear whites. If you already have an idea of what that exposure is, you might try exposing the lith sheet for a range of times above and below this. If you do not know what standard exposure is then it is best to expose a test sheet over a wide range of times, to obtain as comprehensive a sample as you can of the possible tone combinations.

When you have exposed the test sheet, develop it as normal and let it dry. You should view it by daylight or a good room light, as the blacks appear misleadingly dark under a safe light. When you have selected your exposure, make your positives as normal, but make sure that you always use fresh developer and develop for the correct time, or you will get a different degree of tone separation from that in your test sheet.

Your final prints will show black and white tones, but you can also reduce the exposure on the bromide paper to obtain a grey and white print. This is still a two-tone print, but you can control the intensity of the greys, so that the tone separation is maintained but the effective contrast is reduced.

As well as using negatives as your originals for lith work, you can also use transparencies. To produce a black and white positive print only one intermediate film is needed, as you are already working from a positive. The first lith print is a negative, and can be used to print directly on paper. By making a further lith contact print, you produce a positive which gives a negative effect on paper.

Bear in mind, however, that as there is only one intermediate stage, the final print will be laterally reversed if you always print emulsion to emulsion. The simple remedy is to place the transparency back to front in the enlarger when making the internegative.

4 *Process your print in paper developer and dry it. The result should show clean blacks and whites. If it shows spots, your negative may need retouching*

A posterized print, *made from a normal black and white original, owes its unique quality to separate areas of flat tone rather like those in a poster*

Making tone separations

30 secs at f/16

12 secs at f/16

5 secs at f/16

The three separation positives above are, from left to right, the highlight, the midtone and the shadow positive

4 secs

4 secs

4 secs

The separation negatives correspond to the positives above but reproduce the same tone ranges inversely

1 *The separation positives are printed using exposures selected from the test print. Notice how each sheet reproduces a different tone range, the highlight print showing only the highlights, and the shadow positive only the shadows*

2 *Each separation negative is printed directly from its corresponding positive. Exposure is the same for each separation, as the different tone ranges have already been separated at the positive printing stage*

3 *The final posterized print is made from all the negatives printed in register on bromide paper. Make a test print to find which exposure gives medium grey on the paper, and use that exposure for each separation. Notice the flat areas of grey, black and white, and the absence of any tone gradation. Although you can theoretically print any number of separations, the more you make, the closer you get to a continuous tone print, so it is better to make only a few separations for the best effect*

Whereas from a black and white negative either orthochromatic or panchromatic lith film produce the same results, in printing from transparencies you have added control over any red areas of the photograph. Panchromatic film gives the same effects as a monochrome negative, but orthochromatic lith reproduces all red areas as very light in the first (negative) print, and as very dark in the final paper print or the lith positive.

By printing either the lith negative or the lith positive on paper, you can reproduce the red areas of a photograph as either unnaturally light or unnaturally dark. This can create striking, unreal effects, with falsified tone values. In practice, what you are doing by printing on orthochromatic film is introducing filtration.

When you are working from a trans-

parency, the procedure is exactly the same as with a negative, and you must make a test sheet to determine your tone 'cut-off point'. When selecting transparencies for use on orthochromatic lith film, you should bear in mind that the more red there is in the subject, the more unreal and falsified the final result will be. Experience will tell you which colour combinations lend themselves most readily to this kind of treatment.

Negatives made on ortho film are more grainy than those on pan film, as the blue-sensitive emulsion records only one layer of the film rather than all three.

Multiple tone printing

When making a tone separation, you convert a continuous scale of tones into just black and white. However, this same continuous scale can be split up into more than two tones. You can, for ex-

ample, make a print in which the shadows are black, the highlights are white and the mid tones are an intermediate shade of grey. Indeed, there is theoretically no limit to the number of intermediate tones you can introduce into a tone separation print. The more intermediate tones you print, the closer the final result will be to a continuous tone image, but it will still consist of separate, flat tones.

The images you obtain by making multiple tone separations have a pleasing, graduated quality. The introduction of intermediate grey tones produces a softer effect than a straight two-tone separation, but you can still control the effective contrast by controlling the shade of grey. You also maintain control over what you include in the picture, and what emphasis is given to the various features.

Multiple tone separations are made by printing several different lith negatives on the same sheet of paper, one after another. Each negative has different areas of black tones, and acts as a mask for a given part of the print. At the end of the printing process, different parts of the paper will have been exposed for different times, and will show different tones of grey or black.

For example, if you expose three sheets of lith, underexposing one, correctly exposing the next and overexposing the third, each will show a tonally different positive when developed. One will record only the deepest shadow areas as black, another will record mid tones and shadows as black, and the third will have all tones black except for the highlights. You can then contact these on lith to make negatives for printing.

The three negatives are then printed on a single sheet of paper to produce a tone separated image. To do this they must all fit over the paper in register—that is, they must all be exactly aligned—otherwise the image will not be clear and the edges of tone areas will not fit over each other properly.

A punch system is the best method of registration. This makes two or more holes near the edge of each sheet of film or paper. These holes correspond exactly to pins on the enlarger baseboard, on to which the film will fit. You can punch the material before exposure, and then locate it on the pins in the dark, knowing that the projected image will fall exactly in the same place each time.

After you have processed your lith negatives, you can print them in sequence on the same sheet of paper, as the pins ensure exact registration. A

screws — two hole paper punch recessed into board

film stop

good economy technique is to tape a strip of old film along one edge of each lith sheet, and punch holes in this, so as to make the most of your valuable material.

The simplest registration technique is to use an ordinary office punch and a two-pin board which you can make yourself quite easily. Alternatively, you can buy a special photographic punch and a pin bar which can be taped to the enlarger baseboard. Although this is a much more accurate system, it is also much more expensive to buy. However, if you plan to do a great deal of tone separation work, it might be worth the expense.

For the cheaper system, buy a good quality office punch, strong enough to punch holes in a sheet of plastic film without tearing it or buckling it. As you will have to use it in the dark, set it into a board as shown, so that the film remains level during punching. You can make your pins from wooden dowelling, or by cutting the heads from thick nails and filing them down smooth. The pins should be fitted into a piece of board larger than the largest piece of material you are likely to use. A photographic punch cuts two differently shaped holes, so you cannot load the film the wrong way round in the dark. Sets of precision-mounted pins are available, which can be taped to the baseboard.

Before beginning to make your multiple tone separation, you should punch all the material you need in the dark and put it back into light-tight boxes or envelopes. Orthochromatic film and paper can be punched under a red safelight.

When you have selected your negative for printing, place it in the enlarger and project it onto the baseboard. You should leave a wide margin for the registration holes. Having lined up the image, place a register pin bar close to the image and tape it into place.

You are now ready to make a test sheet, which will allow you to select the tones you want to print. You need not register the film for the test sheet, and you should expose it as you would for a single tone separation. Process the sheet and decide which tones produce the tone differences you want. As a general rule, it is advisable to choose the exposure times which produce the most distinct differences. You could choose to make any number of negatives, but for

Registration *To keep the film exactly level when punching, set the punch into the board as shown left. The method of registration and contact printing shown below gives good results if used with care. If your sheet of film is the wrong size for the pins you can still register it as shown right*

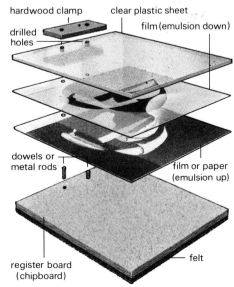

hardwood clamp — clear plastic sheet

drilled holes — film (emulsion down)

dowels or metal rods

film or paper (emulsion up)

register board (chipboard) — felt

the first separation it is probably best to use only three.

Take a punched sheet of lith film and position it over the pins on the enlarger baseboard. Expose it for one of your chosen times. Repeat with the other two sheets, giving your other two exposures.

Process all three sheets, then contact print them on three more punched sheets. You should give each of these a normal exposure, to reproduce your positives as faithfully as possible.

You can now contact print each negative in turn on to a single sheet of normal grade bromide paper. You should give each negative just enough exposure to produce a mid grey tone on the paper. First, make a test print to find out what this exposure is. With the darkroom light on, tape a piece of bromide paper, emulsion side up, next to the pin register bar. Place the first negative, emulsion side down, on the paper, and make a test strip. Process the paper and examine it in the light.

Tape down another sheet of paper, and place the first negative over the pins. Expose, then replace this with the second stage negative, then repeat the process for the third. Always keep to the same exposure, and remember to contact print emulsion to emulsion.

If you have registered each sheet correctly and exposed properly every time, your finished print should now show black, white and two intermediate tones of grey. Using two negatives, you produce only one grey tone; using four, three grey tones and so forth.

As well as printing from three negatives, you can try different combinations of negatives and positives. You might, for example, try printing the shadow positive first, and then print the mid tone negative. Somteimes, when printing both positives and negatives together, you produce thin line effects which are very pleasing. These are caused by the dark areas of a negative being slightly different in size from the corresponding areas of the positive. This allows a little light to pass, forming a very thin line on the paper.

This process of tone separation is in fact a form of posterization. The simplest poster printing method can only reproduce uniform tones, so all images must be reduced to basic tones, which may then be superimposed. A tone separation, or posterization, has the same appearance, as graduated tones and colours have been replaced by flat

discarded film

adhesive

areas with distinct borders. Colour posterization, dealt with in a subsequent article, offers even more possibilities than black and white, and once you have mastered monochrome you can easily progress to colour work.

Chapter 7
COLOUR EFFECTS
Solarization

If by accident you very briefly expose a print to light during development, it is normally ruined. But before you throw the print away, examine it carefully and you will notice that fogging has a peculiar effect. Instead of simply darkening the whole print, as you might expect, the darkest areas actually become lighter. Indeed the image becomes partially negative. You can exploit this phenomenon, known as the Sabattier effect, or pseudo–solarization, to transform mundane pictures, particularly, into striking impressionist images.

Prints produced using this phenomenon are often referred to as being solarized. This is a misuse of the term, since true solarization is very difficult to achieve with modern photographic materials and it is more accurate to call them Sabattier effect prints.

Although in theory you have to do very little to pseudo-solarize a print—simply fog it during development—it is not always easy to achieve satisfactory results in practice. The problem is that it is difficult to fog a print in exactly the same way every time and the balance between positive and negative can vary from print to print. One of the problems is that the effect of fogging is influenced by the duration of not only the fogging exposure but also the original print exposure. It also depends at just what stage in development the fogging exposure is made. Even the age of the developer may affect the result.

Naturally, then, producing Sabattier effect prints can be a rather hit-and-miss affair and you must be prepared to make experiments and waste a few prints before you achieve satisfactory results. Nevertheless, with practice and experience, you should be able to come to terms with the rather unpredictable nature of the technique and regularly produce good prints.

B & W Sabattier
Although the results are perhaps slightly less striking than with colour, Sabattier effects with black and white prints are simple to produce and require no extra equipment. You can produce perfectly acceptable Sabattier effects using normal, fresh developer.

A controllable white light source is, of course, essential for the fogging exposure and a basic enlarger is perfectly adequate for this. Simply switching on the room light during development will not do—this would probably give you just a black sheet of paper.

Any photograph can be given the Sabattier effect, but it may be better to select a fairly simple image so that the print does not become a confusing mess of light and dark. To make a Sabattier effect print, first make a normal, correctly exposed print from the selected negative and put it aside to act as a reference.

Then take a new sheet of paper and expose this in exactly the same way—as if you were going to make a second normal print. But instead of developing this second print, put the exposed paper away carefully in a light-tight envelope or drawer—keep it separate from any other paper, though, to avoid confusion.

To establish the fogging exposure, remove the negative from the enlarger so that it projects white light on to the baseboard. Switch off the enlarger and take out a small strip of unexposed printing paper. Place this strip on the enlarger baseboard and make a series of test exposures in exactly the same way you would make a test strip for a normal print (see page 40). Make the exposures in five second steps and keep a careful note of the exposure given at each step. Process the test strip normally but remove it from the developer after only half the normal time has elapsed.

Under normal room lighting, examine the test strip and work out the exposure that gives a mid grey tone. If there is no mid grey, repeat the test with adjusted exposure steps. When you have established the exposure time for the mid grey tone, make a note of it. This will be the time for the fogging exposure.

For the next stage your enlarger must be protected from water and developer. Cover the baseboard with an old towel or several thicknesses of newspaper and place a dish of water on top. Take out the exposed sheet of paper, and develop it for half the normal time. Then carefully move the print to the enlarger and slide it gently into the dish of water with the minimum of disturbance. When any ripples have died away, make the fogging exposure found by the test strip. Transfer the print back to the developer dish and complete development by developing it for half the normal development time. Complete other processing steps in the usual way until you have your final print.

If you are not satisfied with the result,

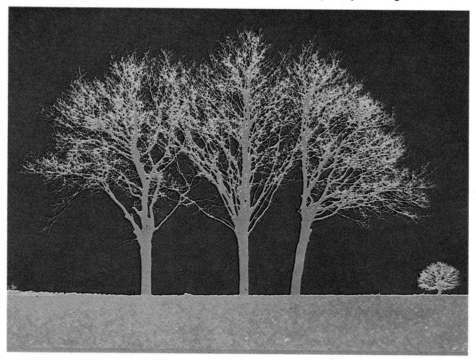

Trees *Choose a clearly defined, boldly shaped original for your solarization experiments.*

Black and white and colour solarizations

1 *Begin by making a test print of the original image. Here, a transparency is being printed on to lith film, but you can use paper, and colour or B & W*

2 *If you prefer, work directly from a strip of negatives or slides (colour or black & white). Use sponge and glass to keep film and print material flat*

3 *Develop the test print and, if you have a useful range of exposures along your strip, repeat the test and place the undeveloped print in a paper safe*

4 *Expose and then process a test print to determine which fogging exposure (plain light from the enlarger) just begins to darken the same material*

5 *Take the first print from its light tight box and develop it for about half the normal time, draining it well but avoiding streaks of uneven development*

6 *Slide this print carefully in to a white dish, containing cold water, which is placed directly beneath the lens of the enlarger, ready for re-exposure*

7 *Expose the partly developed print to plain light from the enlarger. The solarization effect on colour materials can be altered by changing filtration*

8 *Return the re-exposed print to its developer and continue for the remaining period of development, after which fogging should be clearly evident*

9 *Examine your test print to check which combination of original exposure plus the fogging exposure gives the most pleasing result, and repeat this*

there are a number of variables that can be altered next time you make the print. The density of the negative image can be changed by altering the fogging exposure, for instance. If the print is too light overall, increase both the original and the fogging exposures. If the positive areas of the print lack contrast, reduce the original exposure and give the print more development before you make the fogging exposure.

Another factor that can be adjusted is the stage in development at which the fogging exposure is given. If you make the fogging exposure close to the end of development, leaving the print in the developer for almost the full time before exposing to white light, the negative image will be very weak. If you were to re-expose at the beginning of development, the Sabattier effect would again be weak. But in between these extremes, you can adjust the stage at which fogging takes place to get the effect you want.

The problem is that even if you do achieve the right effect, it is very difficult to repeat it using this method. Prints given the Sabattier effect in this way also tend to be rather gloomy in appearance. If you want to make a number of identically 'solarized' prints or achieve a brighter image, you must use the more elaborate *indirect* technique.

Sabattier negatives
The indirect Sabattier effect involves fogging a film negative from which you can make any number of positive prints. A Sabattier effect negative gives prints that are predominantly light rather than dark.

You can make a Sabattier effect negative by taking the film you have exposed in your camera and exposing it to light part-way through development. However, since solarization is unpredictable, you risk ruining your valuable

Waterfall *This is the result of fogging the original slide film. You may find it better to work on copy slide or negative film if the originals are to be spared*

pictures irredeemably.

A better method is to choose a suitable black and white negative and make a film positive by contact printing on a blue sensitive film such as Kodak Fine Grain Positive type 5302 which is sold in 17 m lengths of 35 mm format. You can then contact print this positive on to another piece of type 5302 film to produce a negative that can be safely given the Sabattier effect. Type 5302 film can be handled under ordinary darkroom safelighting, so it is relatively easy to make contact prints using your enlarger as a light source (see page 50) but make sure that the film positive is properly dry before you attempt to contact print it to make the negative.

The Sabattier effect is then produced in the same way as for prints. Make a test strip and re-expose the duplicate negative in a dish of water in exactly the same way as for prints. Note that when you print a Sabattier negative, the 'Mackie' lines around each tone, being clear on the film, print black on the final photograph. Sometimes the line is very

clear, at others it is indistinct, depending on film type, development and agitation technique.

A further refinement is to solarize both the copy negative and the intermediate positive from which it is made. Such multiple solarization effects can be repeated to give an enormous range of different if unpredictable images.

'Solarizing' in colour
Sabattier effects can be even more striking in colour than in black and white but the process is more complicated.

One problem with producing the Sabattier effect in colour prints is that it is difficult to interrupt development when you are using a colour print drum. It is therefore simpler to process colour prints in dishes. Dish processing of colour prints is not as easy as processing in a drum, is less economical and less consistent, but can be mastered with practice. Make a few normal colour prints using dish processing before you attempt to make a Sabattier effect colour print.

A second problem with colour is that processing of colour materials takes place in nearly total darkness, so it is harder to make tests to establish the ratio of printing to fogging exposure. Nevertheless, the procedure for finding the correct fogging exposure for solarization is almost the same with colour prints as with black and white. The main difference is that when you work with colour you have a choice of what colour light you use for the fogging exposure. A good choice is a colour that complements the predominant colour of your final print. For example, if you are working with the negative–positive colour print material and the picture is predominantly blue, a blue fogging exposure gives highlight areas an interesting magenta solarized appearance that can be very striking. You may have to make several attempts before you achieve a result that pleases you.

The development given to the paper

Roof tiles *The original for this image was a colour slide. This was projected on to lith film to produce a very high contrast negative which was given a fogging exposure four times as long as its initial exposure. The solarized image which resulted (left) was contact printed on to colour paper to produce the greenish image (right)*

after the fogging exposure is too short to give really saturated colours, but this is not a disadvantage since it tends to enhance the solarized effect. If you want more saturated colours you must make the fogging exposure earlier in the development phase, but be careful: too early fogging exposure gives nothing but a dense black print.

It is possible to use similar techniques to solarize most types of reversal colour film material. Unfortunately, the pro-

cess does not work very well with reversal print material and the cost may be too prohibitive for the amount of experimenting that is needed to find the best combination of development times and fogging exposures.

Combinations

If you combine black and white solarization with colour printing it is possible to achieve some very dramatic effects while maintaining complete control over the final image.

The first step is to contact print a colour negative or slide on to panchromatic black and white film. Make the contact print with the original negative or slide emulsion side up—that is, facing away from the emulsion of the copy film—so that both pieces of film can be placed in the enlarger emulsion side down when you make the final print.

Fog the contact print to give the Sabattier effect in the usual way.

Next make a normal colour print from the negative or slide. This serves two purposes: it tells you what the correct filtration and exposure is, and it gives you a reference against which you can align the images from the original and the solarized copy when you make the final print. Since this process involves making two exposures on a single sheet of paper, you must have an enlarging easel that allows a sheet of paper to be removed and replaced in exactly the same position.

You should also make a test print on colour paper from the film contact print to find a suitable exposure and filtration.

Make the final print by exposing the negative on to a sheet of colour paper. Put the exposed sheet in a light-tight drawer. Place the reference print in the enlarger easel to make sure that the image you have just exposed on to the sheet of colour paper is properly in register with your reference standard. Replace the negative with the solarized film contact print and align the projected image with the reference print. It is not necessary to be completely accurate when you do this—alignment by eye is quite sufficient. Replace the reference print with the sheet of exposed paper and make a second exposure. Process the print normally.

Printing this way allows you to alter variables such as colour and density over a wide range, while still retaining control over the final effect. You can use either positive–negative or reversal colour printing paper according to whether your original image is a print or a slide. The resulting prints can be uniquely effective with the right choice of subject, and can have an appearance unobtainable in any other way.

Bannisters *A duplicate of the original image was fogged to white light*

Contact copy *By contact printing the centre image, another effect is obtained*

Colour change *A different effect was obtained by re-exposing to coloured light*

99

Colour posterization

A black and white posterization (see pages 93 to 95) produces a picture made up of black, white and a few intermediate shades of grey. In colour posterization, the tones of the original picture are translated into any brilliant colour you choose.

To make colour posterizations, you must know how to make ordinary colour prints and black and white posterizations. If you have already mastered these techniques, progressing to colour posterization is not hard. You need to have the usual equipment for making colour prints. Ideally, you should use an enlarger with dial-in colour filtration. Gelatin colour printing filters can also be used, but your enlarger filter drawer must slide in and out smoothly, since minor vibrations can create registration problems when you are making enlarged separations. A home made pin register board, as described on page 101, is also a great help. You also need lith film and developing materials as used for making black and white tone separations.

Either negative–positive or reversal colour print materials are suitable for colour posterization. Reversal materials are slightly easier to work with, since they make it simpler to follow the effects of filter changes.

Whatever type of print material you choose, you should have a full set of both positive and negative lith separations of each image you wish to print if you are to take full advantage of the range of variations allowed by colour posterization. If you want your final result to be as bright as possible, you should have a set of three tricolour red, green and blue filters, preferably gelatins that can be held under the enlarger lens to give the least vibration.

How it works

Most methods of producing colour posterizations involve printing various combinations of lith negatives or positives in register on a sheet of colour paper. The sheets of lith film may be sandwiched or printed in register, depending on the effect you want. Basic procedures for using lith materials are dealt with on pages 93 to 95, while those for registering sheets of film are described on page 95.

When a black and white posterization is made, each sheet of lith film is printed on black and white paper in such a way that it produces a particular shade of grey. In colour posterization, you print each lith sheet in a particular colour, according to your choice. Each sheet of lith film acts as a mask. If you print each sheet of film in succession and change the colour of the printing light for each exposure, you colour in a different area of the print each time.

Preparing the separations

The individual tone separations for colour posterization are prepared in just the same way as those for black and white work (see page 94). If you wish, you can use the same separations for colour as for black and white. But while a black and white tone separation results in a picture with the same general appearance as the original, though with more limited tones, colour posterization can make a subject look totally different —often surreal. You should take this into account when making the separations.

A picture of a face, for example, may have its original tonal rendering when posterized in black and white, with dark eyes, grey shadows, and bright highlights. In colour, however, it would be possible to produce a face with green eyes, red shadows and yellow highlights, or any combination you please. When you make the separations, therefore, it would be a good idea to plan the result and choose the areas for each colour accordingly.

Having made your positive separations, contact print these to make lith negatives

Original transparency *Just about any photograph can be posterized but a simple image is usually more effective*

Basic negative *A b & w negative must be made by enlarging the original transparency on to suitable film*

Colour posterization *can give many different results. This is a positive print on Cibachrome*

Negative and positive separations

Tone separations *These are tone separations produced by contact printing enlarged basic negatives to yield positives corresponding to the highlights (1) mid tones (2) shadows (3). An overexposed tone separation (4) and an underexposed, overdeveloped tone separation (5) may be found useful in addition to the standard group of tone separations*

Drop out masks *These are for masking off large areas of detail. They can be made by pinning a sheet of acetate over an existing enlarged negative, and using photo opaque to paint out the areas not required (1). A negative mask (2) and then a positive mask (not shown) can be made simply by successive contact printing on lith film, using a suitable jig*

Fine detail masks *A second type of drop out mask can be made to exclude (or colour) fine detail. To make large area drop out masks, pin acetate on to a final size image (one of the separations, for example), and use suitable opaque material to mark the acetate where required. By successive contact printing, make negative (1) and positive (2) lith masks*

Combination drop out mask *By binding together the positives of individual drop out masks and contact printing them, you produce a combined negative drop out mask.*

The colour posterizations shown overleaf were made from the tone and colour separations shown here. Although it is possible to make your prints on normal neg–pos colour printing paper, a direct positive material such as Cibachrome is preferable as it makes it easier to work out the effects of using a particular combination of separations. Additive colour printing methods using separate exposures to blue, green and red light enable the separations to be changed after each colour has been printed

Colour separations *These are produced at the same time as the basic negative if only to ensure that the enlargement remains the same. Project the original transparency on to suitable film, printing through a red filter for one negative image (1). Then make negatives through blue (2) and green filters (3). Contact print these to produce positive colour and tone separations (4)*

Colour permutations

Blue exposure through the shadow tone separation positive + green exposure through highlight tone separation positive + red exposure through mid tone positive

Green exposure through dense positive tone and colour separation + red exposure through overexposed tone separation. No blue exposure

Green exposure through dense positive tone and colour separation + red exposure through the green colour separation negative. No blue exposure

Green exposure through drop out negative mask + red exposure through underexposed tone separation with drop-out positive mask

Blue exposure through drop out positive mask with dense positive tone separation + red exposure through drop out negative of large and fine detail

Blue through dense positive tone separation and combination drop out mask + green and red exposures through negative masks + transparency

as in black and white, when working with negative–positive colour paper. But unlike black and white posterization you will need both sets of separations.

Printing lith separations in colour
The key feature of colour posterization is the way the colours mix when successive separations are printed. For black and white posterization, the different sheets of film are each printed as distinct shades of grey. But when you print lith separations on a sheet of colour paper with coloured light, each new exposure combines with those that have already been made to give a new colour where the separations overlap. So every time you add another colour exposure, two more colours are formed—the colour of the exposing light, if you are using positive colour material such a Cibachrome, and a colour formed by the combination of the new colour with the others on the print. If you use positive

printing paper and expose each separation to light of the primary colours red, green and blue, the secondary colours yellow, magenta and cyan are formed where the light passed by the various separations overlaps.

In theory, you could end up with red, green, blue, yellow, magenta, cyan and white after only three exposures on positive colour printing paper. In practice, the colours in the final print are usually somewhat degraded when prints are made using a normal colour enlarger with yellow, magenta and cyan filters. The colours may either lack saturation, and tend to be slightly pastel, or else they may be slightly grey. This is not necessarily a disadvantage, since it means that the prints you make have more subtlety than those with brilliantly pure colours. But if you want very pure colours, it is possible to produce them by using tricolour printing techniques. The reason why prints made with the

subtractive filters yellow, magenta and cyan have less than perfect purity is because the enlarger filters themselves tend to pass more light than they should. Each subtractive filter has to pass light to expose two layers in the colour print, and it is virtually impossible to make filters with sufficient purity over two parts of the colour spectrum. Red, green and blue primary filters, on the other hand, can be made with the necessary degree of purity. The red made by mixing magenta and yellow, for example, is simply not as pure as that transmitted by a tricolour red filter. Such filters are incorporated in enlargers such as the Philips Tri-One series, and these are therefore ideal for making prints that need very high colour purity. But pure red, green and blue filters made of acetate or gelatin are also available.

Since you need to make a separate exposure through each filter, few printers bother to use them for normal

Green exposure through the green colour separation negative + red exposure through the mid tone tone separation positive. No blue exposure

Blue exposure through red separation negative + green exposure through green separation negative + red exposure through shadow positive

Blue exposure through individual negatives of masks + red exposure through positive fine detail mask + masked normal printing of original

Green exposure through green colour separation negative + red exposure through mid tone tone separation positive + normal printing of slide through mask

from visual reality can be accepted.

When you make a black and white tone separation print, you need only use a set of negative separations. The tones are built up by additive exposures, each of which would produce grey, so that the black areas of the print are the result of these successive grey exposures. However, when you are working in colour, you may need to use both positive and negative separations in combination to have control over the final colours.

For example, think about a colour posterized portrait. The original face may have light tones on the front of the face, middle grey tones on the side, and black hair. If a set of positive separations were printed on reversal colour printing paper, a possible result could be as follows: the positive highlight mask might be printed in green, the middle tone mask in red, and the low tone mask in blue. But only the hair areas would end up with a primary colour—in this case blue. The middle tone areas would have blue plus red exposures, giving magenta, and the highlights would receive all three primary colours, giving plain white. While this could be attractive it might not be what you want.

The answer to the problem is to use negative lith separations as counter-masks to prevent light of unwanted colours from reaching some areas of the print. These must be very precisely registered, otherwise lines of secondary colour may be formed where opaque areas on two masks meet—but once again, this effect may prove to be visually useful. In the example above, the highlight areas on the face could be coloured green by placing a negative mask over the highlight areas after the first exposure is made, and leaving it in place during the subsequent exposures.

Combining lith negatives and positives that do not correspond to each other—for example, a positive shadow density lith and a negative highlight density lith—can lead you to an infinite number of colour and density variations. Such effects can look similar to pseudo-solarization, since they combine both positive and negative areas.

You may only want to print a part of a particular lith negative, or alternatively make a part stand out against a flat background. Although this can be done to a certain extent by normal tone separation, the only way to eliminate a part of a print which is in the same tonal range as the part you want to include is by retouching the negative. A negative treated in this way is in practice a mask, and this technique can be very effective for making the subject stand out.

If, for example, you want to eliminate the background in a portrait, you can block it out by hand with opaque retouching solution. If this is done on one of the separation positives the background will be clear on the negative allowing it to be printed as black or as a flat colour in the final print. If you retouch the negative in this way, the background will print as white in the final print.

colour printing. But colour posterizations require separate exposures in any case, so there is less of a disadvantage in using separate primary filters. It is possible to buy optical quality gelatin primary filters that can be held under the enlarger lens for each exposure. You must be very careful how you handle these filters, since they are easily damaged and almost impossible to clean.

Whether you use red, green and blue or yellow, magenta and cyan filters, the basic working procedure is the same. A sheet of colour paper punched to fit on your register board is exposed by contact printing similarly punched and registered sheets of lith film. Each sheet of film is exposed to light of a different colour, after which the sheet of paper is processed normally. Since enlargers, filters and colour papers vary so much, it is impossible to give precise exposure or filtration recommendations; you must find the correct exposures by trial and

error using test strips where necessary. In general, tricolour red, green and blue filters need somewhat longer exposures than those made with subtractive filters because of their more restricted light transmitting properties.

Colour posterization experiments

There is no reason why you should limit your posterizations to those made with only three lith separations from a black and white original, or to those made by printing in three primary colours. For instance, you might try printing two or three separations in different shades of blue by varying the filtration and exposure with only two filters instead of three. Although colour posterization is a relatively complicated process, it does lend itself well to such experiments. Even pictures that do not turn out quite the way you intend are often visually striking. A colour posterization never looks 'normal', so extreme departures

INDEX